URBAN IDENTITIES

ISBN 0-942604-66-0
Library of Congress Catalog Card Number 98-065647

Book and cover design by Bernadette Evangelist
@ 1998 by Robert Anthony, Inc.

Distributed throughout the United States and Canada by:
F/W Publications
1507 Dana Avenue
Cincinnati, Ohio 45207

Distributed throughout the rest of the world by:
Hearst Books International
1350 Avenue of the Americas
New York, NY 10019

Published by:
Madison Square Press
10 East 23rd Street
New York, NY 10010
Phone (212) 505-0950, Fax (212) 979-2207

Printed in Hong Kong

URBAN IDENTITIES

GAIL DEIBLER FINKE

MADISON
SQUARE
PRESS

TABLE OF CONTENTS

FOREWORD

Much has changed in the four years since I wrote *City Signs*. The projects it contained heralded a change in urban graphics. Bold, fresh, and most of all, effective, they showed what a visionary urban planner and an experienced environmental graphic designer could do to revitalize streetscapes—and parks, festivals, and other urban environments. They demonstrated how attractive graphics that direct and inform have a place in public life, not just in private shopping malls and amusement parks. "The Green Book," as many people call it, became a fixture on shelves in urban planning, graphic design, architecture, and landscape architecture offices around the world.

When I started gathering projects for this book, I knew I would see many exciting graphic programs. But when the couriers began knocking at my door, I was overwhelmed by what I found. In less than five years, the face of urban graphics had changed. The quality and scope of urban graphic programs has grown far beyond what I expected. And I expected a lot. From international cities to tiny parks, planned communities to transit systems, clients are expecting more from their signs and graphics. And designers are delivering it.

What accounts for this change? It's hard to say. Momentum, certainly—planners looking to other cities for inspiration now find much to inspire them. Innovative funding methods make design easier to afford. And let's not forget serendipity. Leslie Gallery Dilworth, who wrote the introduction to this book, began her odyssey with urban graphics on the way home from a trip to Spain. Though she had found her way through many small Spanish towns without speaking a word of Spanish, she got lost between the airport and her Philadelphia home.

Soon, she had become the driving force behind Direction Philadelphia, a pioneering project teaming an internationally renowned design firm, Culver City, CA-

Photo © Donald Meeker

based Sussman/Prejza & Co., with a coalition of government and private entities. Together, they raised money to put up and maintain a comprehensive sign program throughout downtown Philadelphia and its parks. You can find the story in The Green Book.

Since then, Leslie has gone on to work with other public/private coalitions in Philadelphia (the Walk! Philadelphia pedestrian wayfinding program) and Newark, NJ (Connection Newark). In early 1998, she became director of the Society for Environmental Graphic Design. All from getting lost at the airport.

There are many similar stories. Donald Meeker, who helped develop the first new official typeface for U.S. highways in 50 years, initially got involved because he was sure there was a better solution than the unwieldy official "Highway Gothic" faces. But what sign designer isn't? Todd Pierce, who developed the first pictogram system officially adopted by a U.S. city, suggested the project in part as a way to get new work for his new Portland, Oregon, design firm. But that doesn't explain Portland's enthusiastic acceptance of the idea, eagerness to keep it going, and verve to encourage its use by area businesses.

So no, I can't explain the sudden explosion of environmental graphic design on the streetscapes of cities around the world. But I can document it. In these pages you'll find a broad spectrum of urban design programs of all types and sizes. You'll find an ADA-compliant sign system for a new Washington D.C. memorial, comprehensive sign systems for major cities from Glasgow to New York, small sign systems for neighborhoods, two public parking systems, and even a set of holiday decorations. You'll find three university programs, and a few private programs that blur the boundaries between public and private graphics—including one of the U.S.A.'s oldest mixed-use complexes, and one of Japan's newest.

You won't find any festivals. I wrote a book on that subject, *Festival Graphics*. And you won't find 10 intriguing urban sign programs that will be in my next book, an in-depth look at urban sign design and how urban sign programs function. What you will find is plenty of outstanding programs to inspire and encourage you in your quest to help make cities function better.

They say that those who can't do, teach. I am not a designer or urban planner. I thank all the talented designers whose work appears here, and all the urban planners who hired and worked with them. It's my privilege to help "raise the bar" for urban sign design everywhere by sharing your hard work with the world. Thanks, too, to my editor for giving me the forum to do so. Heartfelt thanks go to my husband, who kept with me until we hammered out a schedule for both of us that allowed me to both stay home with our children and write books. Scott, I think we finally got it down. And finally, thanks to Meghan and Marshal Finke, who never let me forget that houses, jobs, and cities exist for the people in them—not the other way around.

GAIL DEIBLER FINKE
Cincinnati, 1998

INTRODUCTION
PLANNING AN URBAN SIGN SYSTEM

WORK AND TIME—BUT NO FLAMINGOS **by Leslie Gallery Dilworth, FAIA**

When I came up with the idea for Direction Philadelphia, a vehicular directional sign system for Philadelphia's streets and parks, there was no public outcry for one. Individual businesses, attractions, institutions, and government officials agreed that better signs would be nice, but there was no consensus (or effort to get one) on how or if it could ever happen. There was no money—in fact, the city was bankrupt. As far as new signs were concerned, there didn't seem to be much hope.

Today Philadelphia has, not one, but two premier directional sign programs. The first, Direction Philadelphia, is a vehicular sign program for Philadelphia's streets and parks. Planned by a coalition of public and private groups, it has become a model program for cities everywhere.

When we started working on Direction Philadelphia, we weren't following a plan. There was no plan to follow. Traditionally, American cities have not thought of themselves as an attraction or a product to be packaged. When someone finally recognizes their city needs signage, it's usually someone in the highway department, who is thinking of engineering problems, or someone from a specific attraction like an arena or performing arts venue. No one is thinking of the city itself.

I tried for a long time to interest people in improving signage in Philadelphia. Old signs were up all over the place—who knows where you'd end up if you followed them? They were all at different heights, in different styles and colors. Then I went to Spain. For two weeks I drove all over, not speaking Spanish, and never got lost. On my way back from the airport, I got lost. I thought that was outrageous. I'd lived in Philadelphia for years. What did strangers do?

I approached the tourism department, the department of commerce, the streets department. No one was interested. I organized a luncheon for a number of city entities doing projects involving signs. It didn't go anywhere.

The Foundation for Architecture, which I headed, used to hold forums for public, business and cultural leaders, so I organized one on getting to downtown—if you could fund it. I invited people from around the country and Canada to talk about their sign programs.

I knew that the person in charge of signs for the Street Department would never be in the audience, he just chuckled whenever I talked about hiring a designer. So I invited him to give the introduction and talk about what Philadelphia was doing, even though it wasn't doing anything.

At the end of the forum, the head of one of Philadelphia's major foundations asked me what I would do if I wanted to change the city's signs. I thought and came up with four issues that are really the key to an urban sign program:

1) Who pays? Philadelphia was bankrupt. When a city has many things to support and no money, I really couldn't see signage being one of them. When you have hospitals to fund, it's really not that important.

2) What gets signed? How do you decide what destination gets on a sign and what doesn't, and who makes that decision?

3) Who maintains signs? Realistically, maintenance is low on a city's priority, and the thing that gets pushed off first.

4) How could we show that good design does not cost more?

I didn't know anything about signs at that time. But I thought if we could solve all four issues by making certain that the stakeholders—anyone who ordered signs—were part of the process, then they'd support it forever. That middle level had to feel that this was their project, not my project or the Mayor's project or a manager's project.

So we got started. We were given $900,000 to do it, and no one was more surprised than I was. The Foundation for Architecture had never done a "project." We had influenced projects, held public forums on projects, but we'd never done one. Now we began a three-year program aimed at changing the public's perception of design. We wanted to do more than just change the city's signs. We wanted to change the public environment, change the way it was administered, and the way it was maintained.

I made some mistakes. The biggest is that I kept talking about graphics and good design. Coming from a design background, where "design" is a good word, I didn't realize that in many circles design was a bad word. Many people think it means something frivolous,

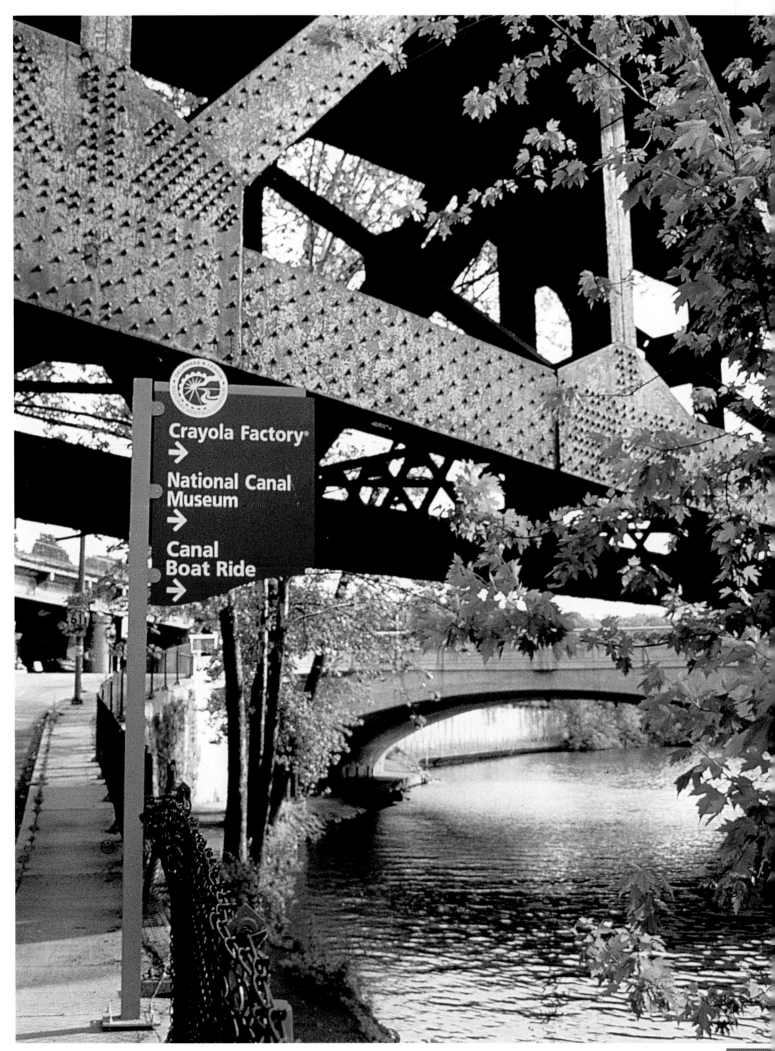

Crayola Factory®
→

National Canal
Museum
→

Canal
Boat Ride
→

something that costs more, and it means working with moody artists. I started listening carefully to the way the traffic engineers talked, and then one day I said, "What I'm talking about is an integrated public information system."

They stopped and stared. Then someone said, "Oh, I didn't realize that's what you were talking about. I thought you were talking about putting pink flamingos on the signs."

It's important for graphic designers to understand that people think that way. And it's important to know that they're not entirely wrong. As I began to look into other sign programs, I saw that graphic designers have their blinders on, just as engineers do. Too many designers don't understand the purpose of civic signs. They see sign design as a work of art, something that has to have their signature on it.

But the purpose of signs on a civic scale is to help people, not to create 100 works of art. By and large, graphic designers do not understand the difference. They don't understand that these signs are meant to be read at 40, 50, 60 miles an hour, and they can't have too many "flamingos."

I didn't know that then. And I didn't know all the complexities of an urban sign program. It's not like a project for a mall or a theme park, where one client makes a decision and is then responsible for maintenance and financing. A city sign program has many "stakeholders," uneven funding, and questionable sources for maintenance. It needs legislation from city council and it needs to meet federal, state, and local regulations. Civic sign programs are not to be taken lightly or quickly.

And that's where the client really has a problem. Often, people who instigate a program are not any of the people I just mentioned. For instance, a new stadium or performing arts center goes up, and the board decides to put up signs so that people can find it. A city ends up with lots of this—people putting up signs everywhere. Usually, they'll have someone drive around and decide where the signs should go, and usually they'll pick the most direct route, not the one that's best for traffic control, or for comfort, or for packaging the city.

What's really best is not the fastest way, but the most attractive. This kind of sign is really for tourists. People who know a city will take their own shortcuts, but tourists are primarily looking for an attractive and safe drive.

Then there's the issue of what you call things. What is the downtown? Where is it? Do you call it Center City, City Center, or Downtown?

We started, not with these questions, but by asking who the stakeholders were. We decided they were anyone who could keep the project from happening, and anyone who had a vested interest in it. We came up with a list of 90 people, agencies, organizations, and businesses. Those were our first stakeholders, and the Stakeholder Group is still going strong.

The Wharton School of Business interviewed them for us, and had them describe their ideal sign system for a fictitious city—not how it looked, but how it worked. They all had their own special interests, and we needed to respect them. The issues they deal with are real. We had them all present their ideal systems, so that everyone else would respect their issues as well. Then they worked together to discover what the critical issues were, and what could be let go. We wanted everyone to understand the whole problem. I didn't understand the whole problem myself, so we discovered it together.

Then we did an audit of where we were: who all the entities influencing signs were, what they did, and how much money they had. All city departments and agencies, and the state and federal government. That was the pool of money we had to work with. By doing it with the available money, we wanted to prove that good design doesn't have to cost more. And finally, we had a planning firm look at other sign programs around the world, in terms of design and financing.

Then we started planning. Together, we came up with seven questions to resolve. First, who is eligible to be signed, and why, and who makes that determination? Second, how many signs can they appear on, and who determines that? Third, how should the signs be organized? Fourth, who will determine standard names for things? Fifth, what other sign programs—state, local, federal—could we plug into? Sixth, who would pay for the signs? And seventh, who will maintain them and how?

We had a lot of heated discussions over districts and neighborhoods, whether for-profit or non-profit destinations got priority, whether stores could appear on signs or they should be kept for cultural destinations. Then we spent a lot of time looking at good graphics from around the world, working with our designers, Sussman/Prejza & Co., to achieve the graphic approach that would best package the city as a local product.

The whole process was very expensive and time-consuming. Most of the time, cities don't think about, budget, or allow time for the underpinnings. They just hire a designer. And when the designer asks those questions, they'll just make a quick answer, not one based on a real consensus.

Another typical problem is maintenance. Our stakeholders agreed not to put up one sign until we knew who would maintain it and how. We came up with our own solution—in Philadelphia, although the city pays for construction and installation, the stakeholders pay for maintenance. Every institution named on a sign signs a five-year contract and pays a yearly fee for each mention. That money pays for maintenance.

Installation for Direction Philadelphia began in 1992, and will continue until 2002. Once they saw how well it worked, the remaining neighborhoods began clamoring for the signs. But that's not the only way it's been successful. People love it. When the signs began going up, people started saying, "I had no idea that attraction was here!" Just seeing the signs gives people an enormous sense of pride.

The sign project has also given the city a structure for looking at related issues, such as safety concerns, lighting, and trees. They've got people realizing that signs are just one component in wayfinding. But most of all, the Stakeholders have created a sign program that is really theirs. They made the decisions. The Foundation for Architecture simply provided information, structure, and leadership.

I don't know of anywhere else that has a sign program that's so systemic and integrated into a city's thinking. But I know that any city can do it. All it takes is the time and opportunity to ask the right questions, and answer them, before anyone touches a

drawing pad or sends out an RFP. City sign programs are full of challenges. But planning them correctly means that people can live, work, and take pride in their cities more than ever before. And once those crucial questions are answered, attractive and effective sign programs are no more difficult, or expensive, to design than ineffective ones.

If you want to see for yourself, visit Philadephia. You won't get lost.

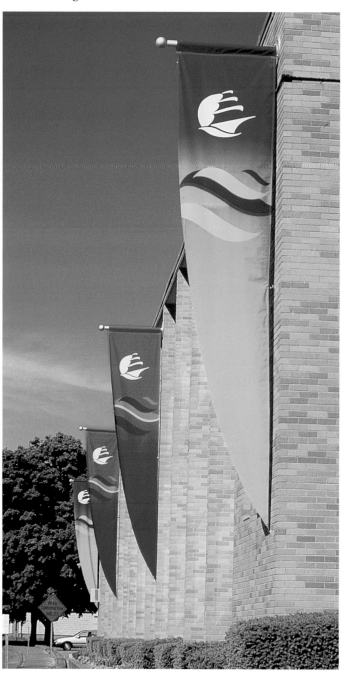

GLASGOW, SCOTLAND
PEDESTRIAN WAYFINDING SYSTEM

OFF-THE SHELF BASE; CUSTOM LOOK; VANDAL-PROOF

This information-heavy system, the largest pedestrian wayfinding system in Europe, is as vandal-resistant as technology can make it. Its face, the modular mss system available worldwide, is designed to be tamper-proof. The crash barrier base, new anti-graffiti coatings, and customer sign cap all make these signs as invulnerable as possible. The modular panels hold vast amounts of copy, including maps, historical information, direction, and transit information. All are designed to make this industrial city, 1990's European City of Culture, easy to navigate on foot.

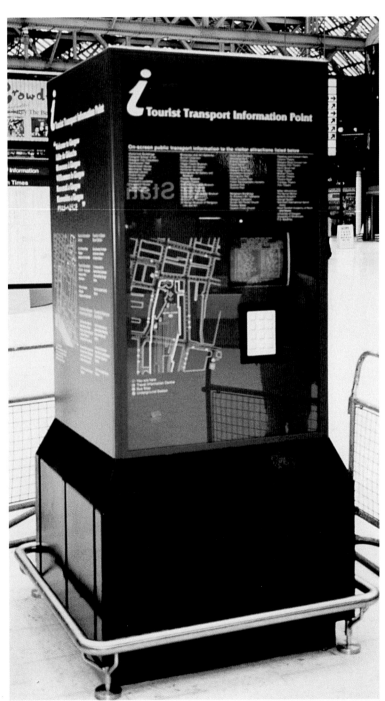

The only sign of its kind, this interior electronic sign was designed to match the outdoor signs. Strategically placed in Glasgow Central Station, it provides transportation information in several languages and includes a touch-screen.

Design
Gillespies, Glasgow

Developed by
Strathclyde Regional Council; Glasgow City Council; Glasgow Development Agency; Scottish Tourist Board

Approvals from
Above

Funding
The system was paid for by the four agencies above, and by a European Regional Development Fund. It will be maintained by the Strathclyde Regional Council.

Fabricator
The HB Sign Co. Ltd., London

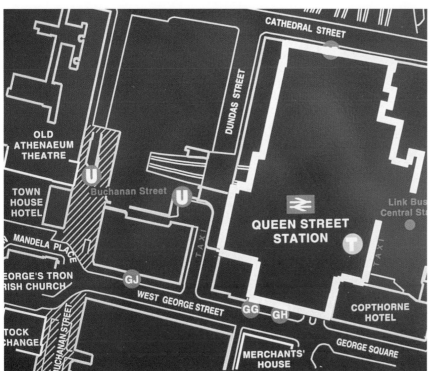

On highly detailed maps, Glasgow is broken into 14 districts. Each has its own color, which is repeated (as a colored bar) on all signs in that district.

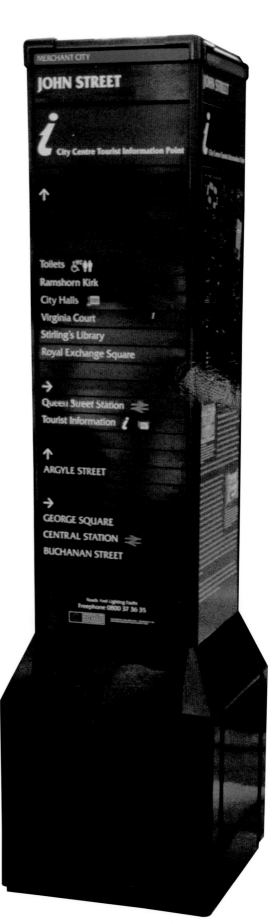

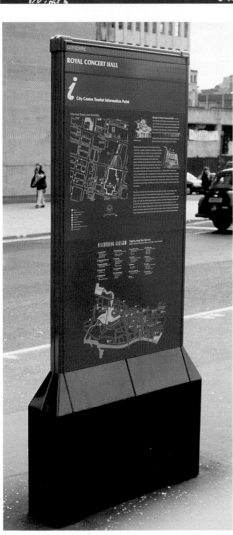

Primary orientation signs hold maps, information on local attraction, directions, logos, and other information on modular panels. The two-sided signs are 7.5 ft. high and 3 ft. wide, and are located at primary intersections.

Secondary orientation signs have four sides, two holding maps and information, and two holding directional information on simple slats.

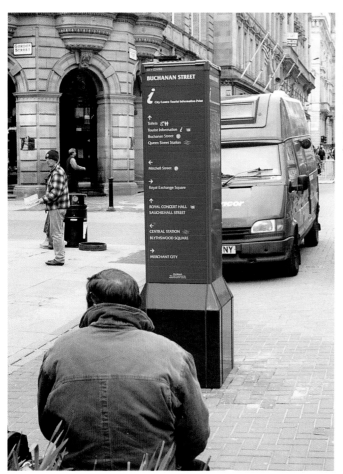

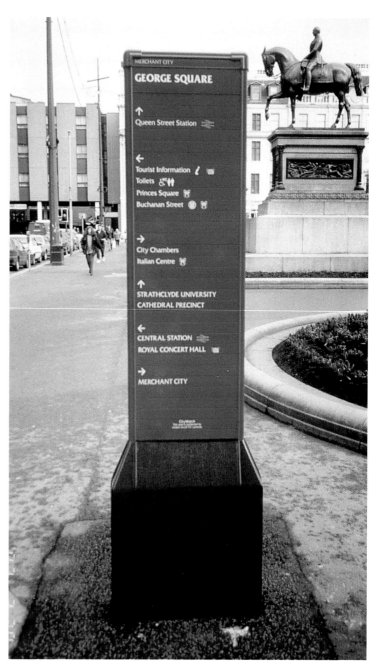

All the sign pylons are simple to change, but difficult to vandalize. The crash barrier bases, made from sand-cast aluminum, hide the sign foundations and fixings. Once the sand-cast aluminum corner caps and specially-shaped top extrusion are removed, then the dove-tailed pieces slide up for easy changes. The signs themselves slide in and out of "sleeves" sunk in the concrete, and can be changed in minutes without hydraulic equipment.

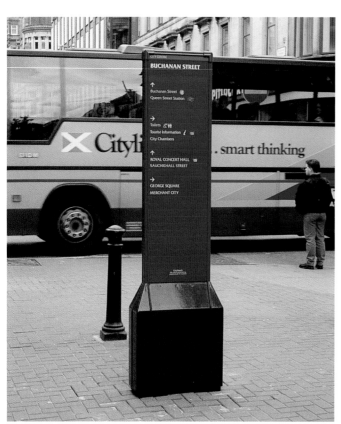

Two-sided directional signs have ample room for words and arrows. Because all the signs are close to streets, they are impact-resistant. The aluminum frames are reinforced with galvanized steel subframes, and graphic panels are fitted on Nylon blocks instead of attaching directly to the frame. If hit, the panels pop off the Nylon blocks and leave the fixings undamaged.

Designers chose the dark blue base color both to harmonize with many different neighborhoods and to be readable by the widest number of people. The typeface, Friz Quadrata, was also chosen for readability. New paints and coatings were designed to keep the signs from fading and to make them resistant to graffiti, while conforming to new environmental laws.

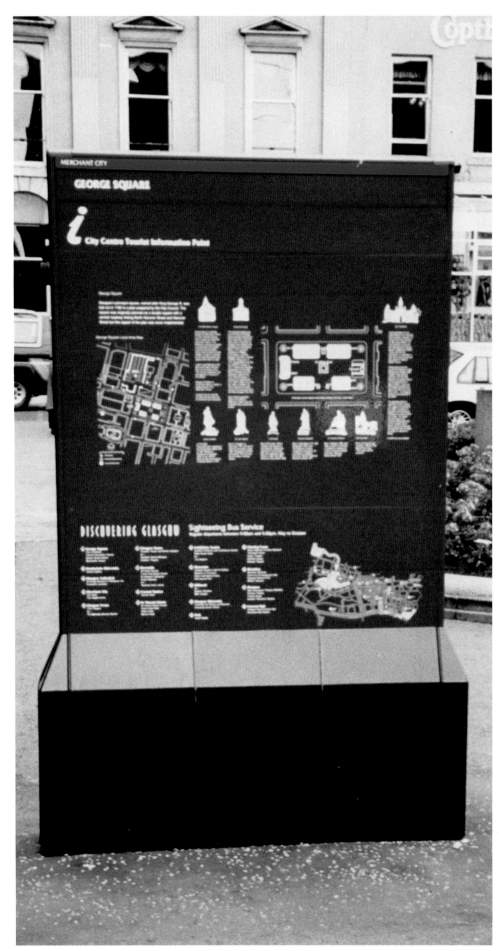

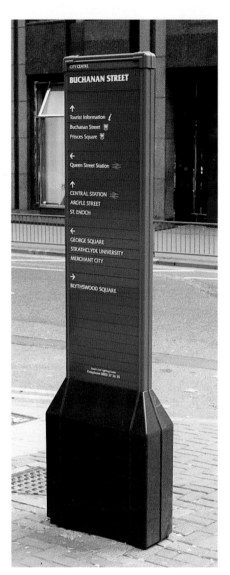

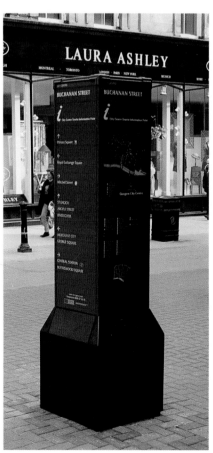

Deceptively simple, these signs contain numerous technical innovations and required the fabricator to manufacture within 0.5mm tolerance. Even the smallest deviations would mean that the entirely modular system would not work.

SALEM, MA
SALEM STATE COLLEGE CAMPUS SIGNS

22 MEETINGS; TWO LINKED CAMPUSES

This project gave the college, which has two linked campuses, a new identity and a unified look. New, festive signs work with landscaping and merchandising to change the college's public face, and give students a different impression about alma mater. Playful sign shapes and colors look at once hip and professional.

Design
Selbert Perkins Design Collaborative, Cambridge, MA

Client
Salem State College

Approvals from
Salem State College

Funding
The $1 million project was paid for with money from the college budget committee and the president's office, not state money. It will be maintained by the Facilities Department and the fabricator, with money from college funds.

Fabricator
Design Communications, Boston

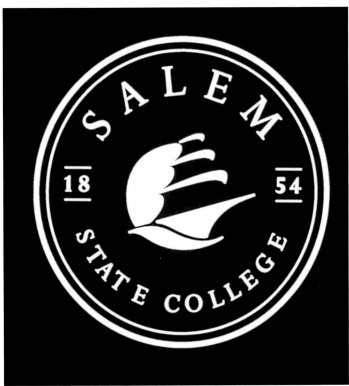

The new identity and college seal have a bold, graphic look.

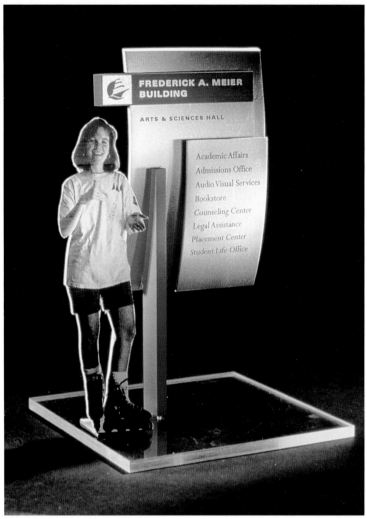

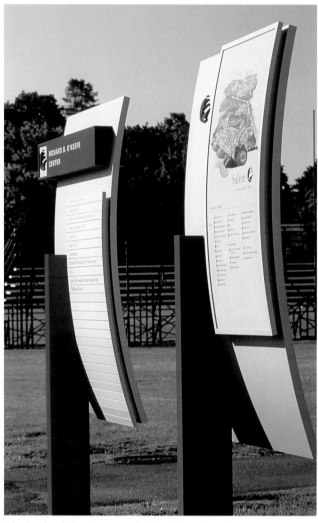

A model of the sign shows its colors and dimensions, but doesn't capture its impact at the site.

The back of the sign reveals that the pole, which spears through the sign face, is not a clever illusion.

The signs have a corporate sleekness that gives them importance. The project typefaces, Univers Extended and Perpetua, are easy to read and timeless. The modular text panels can be changed easily when departments change.

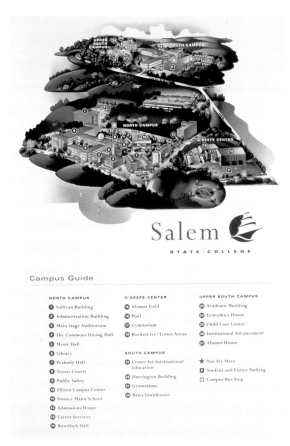

The new map shows the two linked campuses.

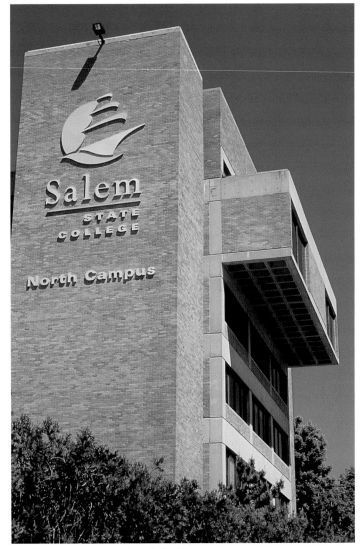

Simple exterior signs identify buildings.

Banners provide color at a small cost.

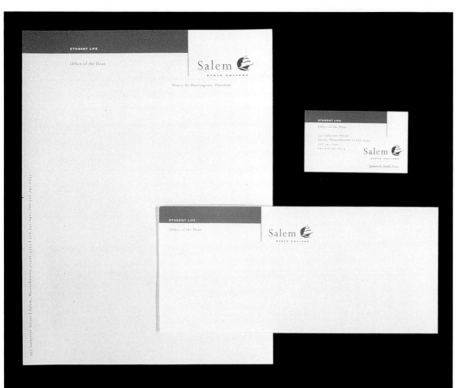

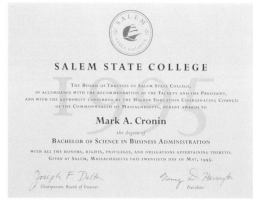

Print collateral, from letterhead
to diplomas, incorporate the new
graphic standards.

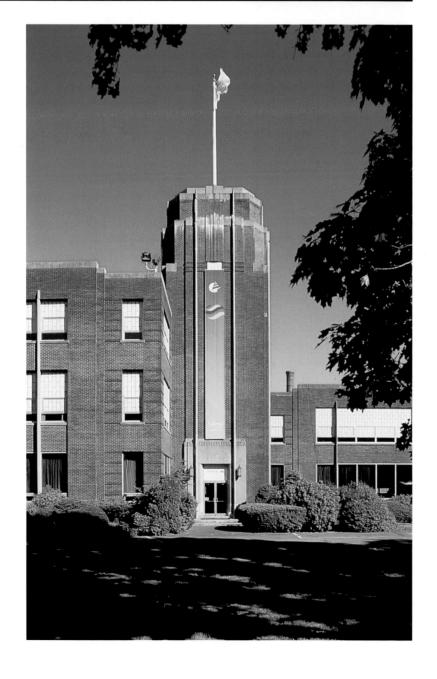

MAMARONECK, NY
STREETSCAPES & GATEWAYS

SMALL SCALE; BIG IDEAS

For more than a decade, the town of Mamaroneck, NY, had worked to improve its streetscape and gateways. With a major sports tournament coming, planners hired the designers to create understated, but upscale signs that would both beautify streets and reduce clutter. Designers gave them entrance signs that emphasized the town's concern for its environment, and road signs that would arrange information efficiently. The new signs work with new, cast-iron light fixtures to help humanize the scale of the streetscape. Town planners are working with merchants to encourage smaller, but effective commercial signs appropriate to the area. The designers are working on commercial sign guidelines to help with that task.

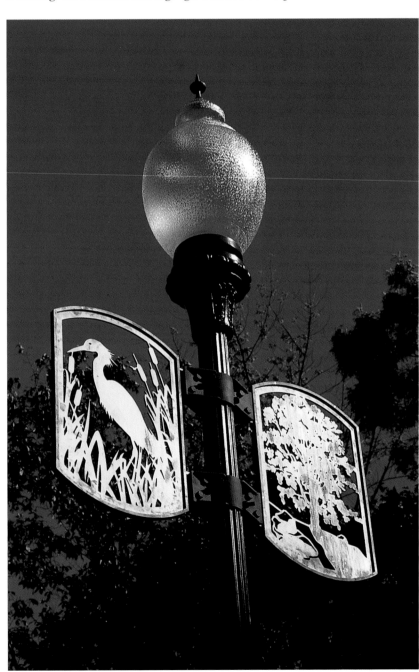

Entry signs proclaim Mamaroneck's concern with "protecting our environment."

Design
Meeker & Associates, Larchmont, NY. Donald Meeker, design director; Christopher O'Hara, project designer; R. Scott Lewis, P.E., structural engineer

Clients
Mamaroneck, NY; U.S. Department of Housing and Urban Development

Approvals from
Above

Funding
Signs were paid for with local and federal money.

Fabricator
Morgan Signs, South Norwalk, CT

Photos
Alan Orling

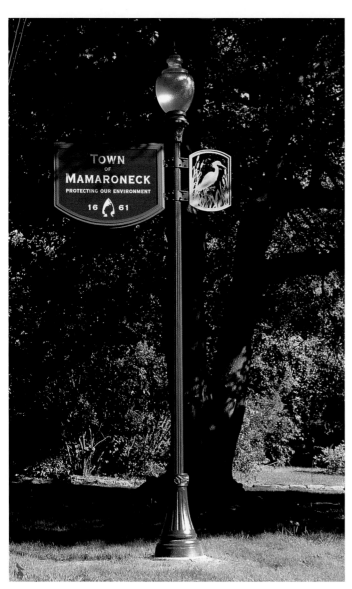

Gleaming bronze cutouts of tranquil, natural scenes will age to a classic patina.

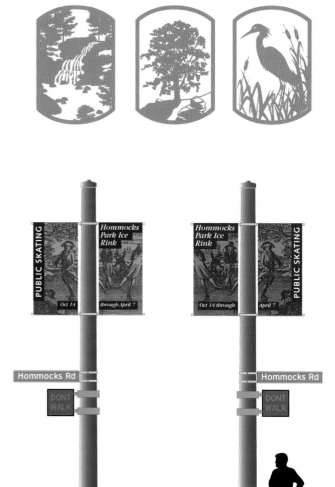

Fabric banners at the town's recreation center advertise seasonal activities and events.

Otherwise like standard DOT road signs, Mamaroneck's signs use effective layout to break information into separate modular units. Tests have proved the typeface, Clearview, to be more readable than U.S. standards. The result is a clear, efficient design.

For more information about Clearview, see page 64.

NATIONAL PARK STANDARDS; ADA STANDARDS

Forty years in the making, the new memorial to President Franklin Delano Roosevelt covers 7.5 acres and consists of several outdoor "rooms" devoted to his four terms of office. Statues by artists Leonard Baskin, Neil Estern, Robert Graham, Tom Hardy and George Segal, integrated landscaping and chiseled granite walls, make this memorial unique. Planners wanted signs to direct people without distracting them. Designers created bronze signs with special patinas designed to create an ADA-compliant contrast between background and graphics.

Design
Biesek Design, San Luis Obispo, CA, with Lawrence Halprin (landscape architect)

Client
The National Park Service

Other planners
The National Park Service

Approvals from
Office of Lawrence Halprin, National Park Service (Washington); National Park Service (Harpers Ferry, WV)

Funding
Signs were paid for with National Park Service funds. They are designed to be maintenance-free.

Fabricators
Karman Ltd. (signs); Robert Graham Studio (specialty bronze patina)

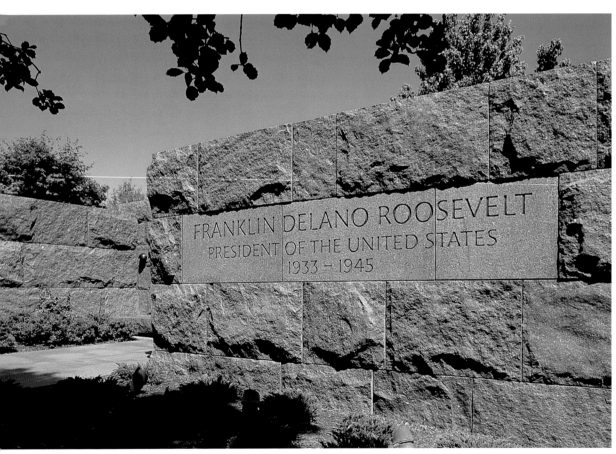

Washington's newest monument, only the fourth dedicated to a president, is an outdoor building made of granite walls. Integral carved "plaques" combine interpretive graphics with architecture.

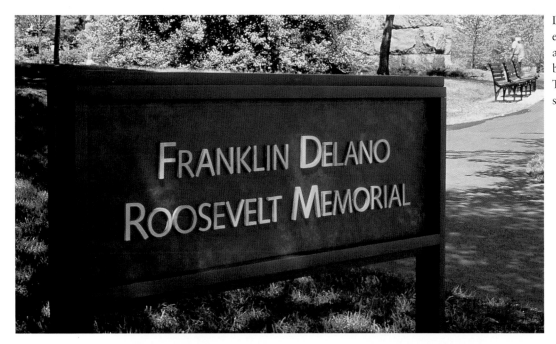

Designed to be unobtrusive and easy to see and use, most signs are made of bronze with applied bronze lettering and graphics. The typeface, Syntax, was chosen for its quiet elegance.

Signs meet all National Park Service codes, and coordinate with standard NPS furniture such as this drinking fountain.

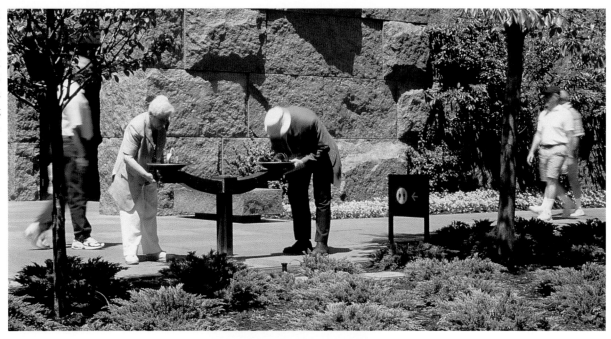

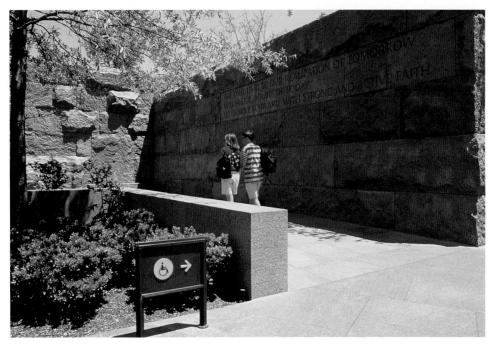

Special patinas, applied by the studio of Robert Graham (one of the sculptors who worked on the memorial) ensure that letters and graphics will continue to maintain ADA-mandated contrast with their backgrounds as they age.

Cast bronze
restroom signs
contain tactile let-
ters and Braille
messages.

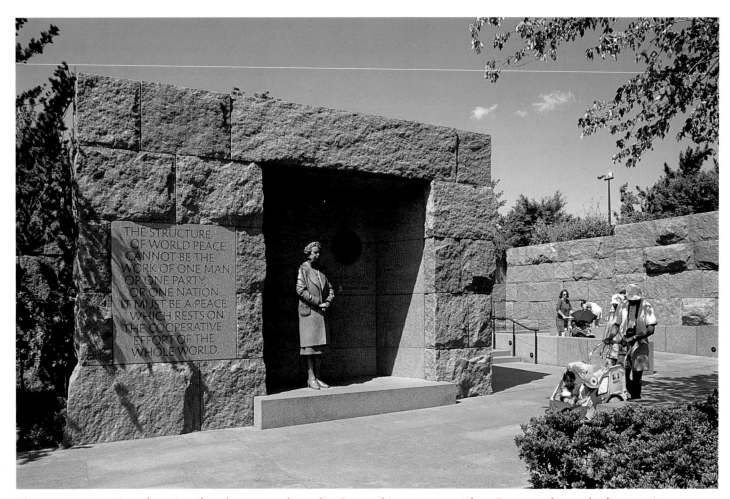

The monument consists of a series of outdoor rooms devoted to Roosevelt's terms as president. Bronze sculptures by five prominent artists are complemented by walls made of Dakota red granite. Roosevelt's own words appear on the walls, chiseled by stone carver John Benson.

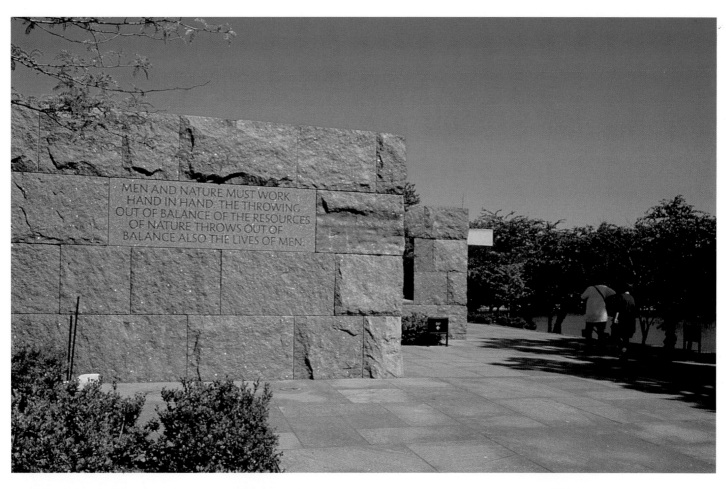

MEN AND NATURE MUST WORK
HAND IN HAND. THE THROWING
OUT OF BALANCE OF THE RESOURCES
OF NATURE THROWS OUT OF
BALANCE ALSO THE LIVES OF MEN.

Visitor Information

EXIT

FRANKLIN DELANO
ROOSEVELT MEMORIAL

WOMEN

MEN

ST. LOUIS, MO
GRAND CENTER DISTRICT PARKING SIGNS

HEARINGS AND MEETINGS; VARIANCES FOR FLASHING NEON

St. Louis commissioned a 10-year master plan to revitalize its arts and entertainment district in 1987. The art deco streetscape inspired the look of street lights, landscaping, public art, and other improvements. The parking sign system, first developed in 1992, features exuberant art deco details. All giant neon parking signs for the district-owned lots sport flashing arrows and chasing lights, banned by the city's sign code and requiring many variance hearings and meetings. When St. Louis received the grant in late 1993, the designers had only four months to design, get approvals and variances, fabricate and install the entire system.

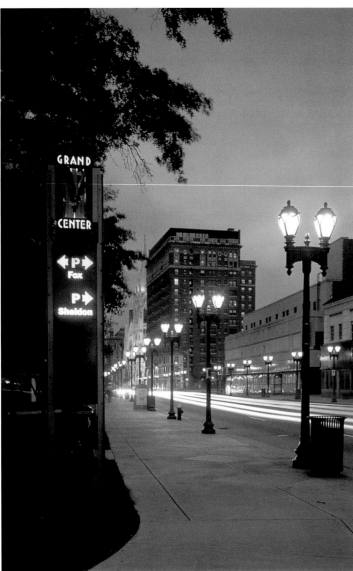

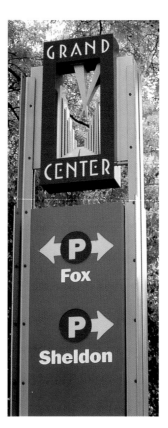

Illuminated directional signs employ routed letters and arrows, backed with acrylic. The three-dimensional Grand Center logos capping the signs are also illuminated.

Design
Kiku Obata & Company. Design Team: Kiku Obata; Heather Testa; John Scheffel; Tim McGinty, AIA; Jane McNeely; Amy Knopf

Consultants
EMG Engineering, St. Louis

Client
Grand Center, Inc.

Approvals from
Grand Center, Inc.; City of St. Louis (Heritage and Urban Design)

Funding
Part of a master plan for the entire 35-block district and paid for with a combination of public and private money, the $350,000 parking sign system was paid for with a federal grant. It will be maintained by Grand Center, Inc., a non-profit organization.

Fabricators
Engraphix, St. Louis; Warren Signs, Fenton, MO; Star Signs: Lawrence, KS; Mon-Clair Signs, Millstadt, IL; Signcrafters, St. Louis (installation)

Photos
Balthazar Korab, Korab Hedrich Blessing Photographers, Clawson, MI

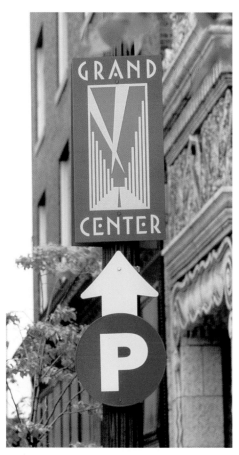

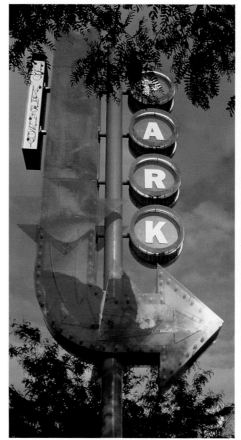

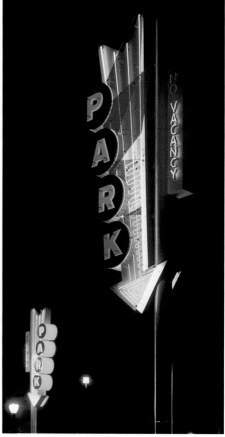

Simple parking signs direct visitors to the neighborhood. They are out of pedestrians' reach, making them both vandal-resistant and more visible to drivers.

Like vintage hotel signs, neon parking signs let drivers know when there's a "vacancy." Unlike vintage signs, these are reinforced with layers of acrylic to make them vandal-resistant. These signs simultaneously solve a familiar urban problem—identifying parking—and become attractions themselves.

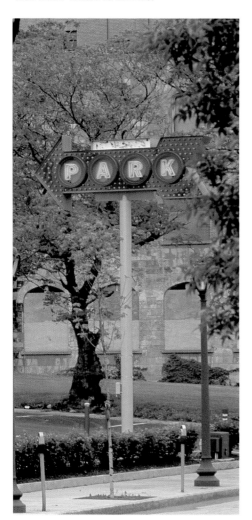

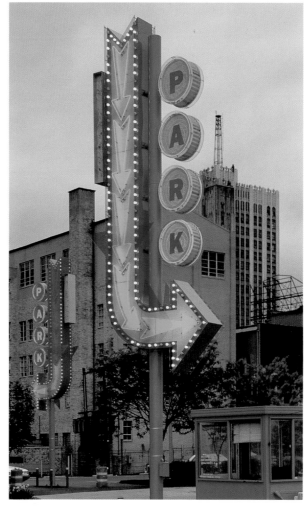

Color-coded to their lots, the giant neon parking signs (some 30-ft. high) feature flashing arrows and chasing tivoli lights. Though St. Louis, like most cities, bans flashing lights with its sign code, the designers convinced planners that such signs can enhance an area's appearance.

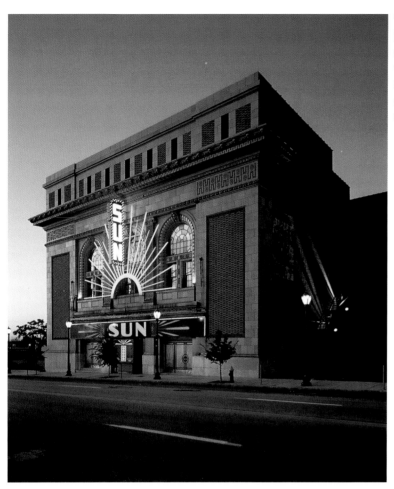

The Sun Theater, long closed and likely to remain so, became an attraction rather than a liability when the designers restored its facade and sign. A trompe l'oeil box office and marquee complement the sunburst sign.

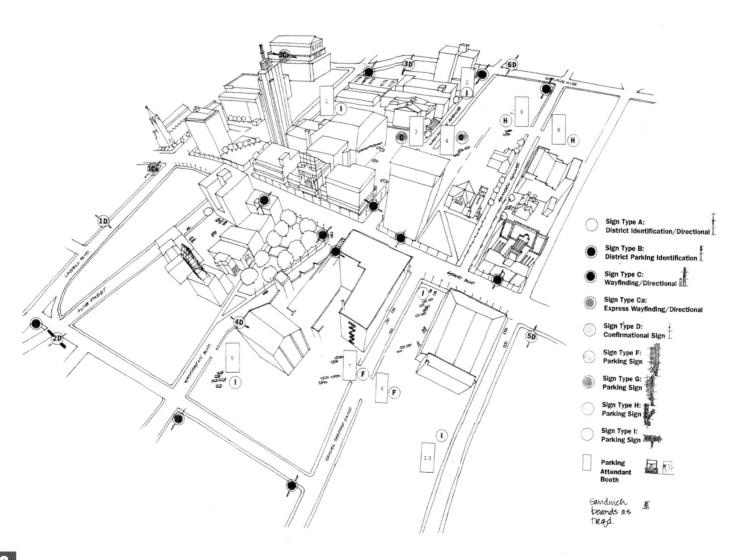

Sign Type A:
District Identification/Directional

Sign Type B:
District Parking Identification

Sign Type C:
Wayfinding/Directional

Sign Type Ca:
Express Wayfinding/Directional

Sign Type D:
Confirmational Sign

Sign Type F:
Parking Sign

Sign Type G:
Parking Sign

Sign Type H:
Parking Sign

Sign Type I:
Parking Sign

Parking Attendant Booth

Sandwich boards as read.

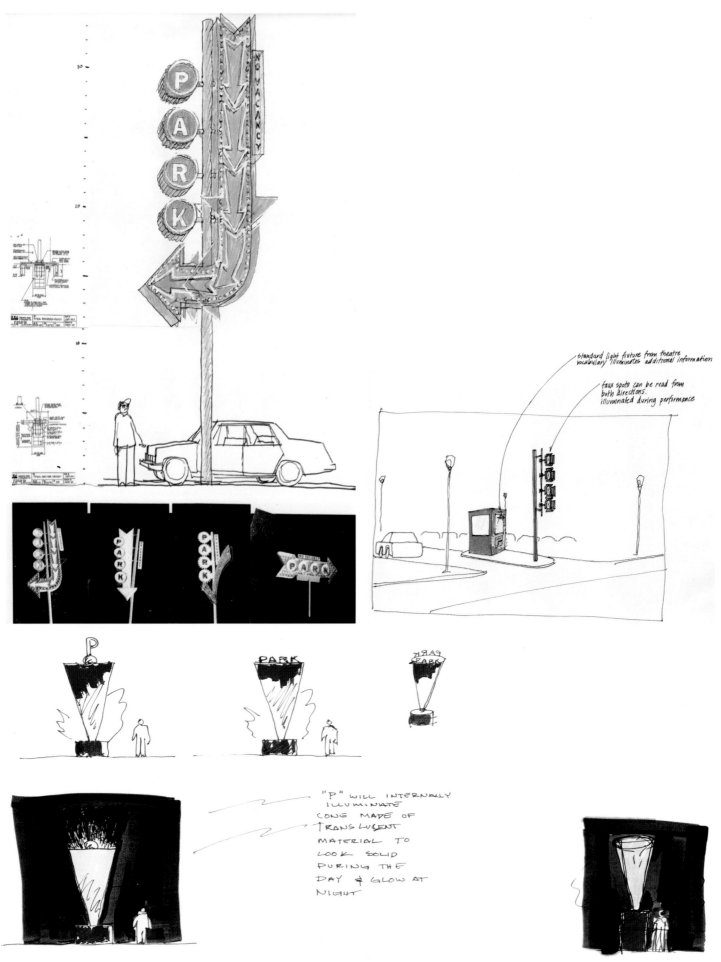

standard light fixture from theatre
vocabulary. illuminates additional information

faux spots can be read from
both directions.
illuminated during performance

"P" WILL INTERNALLY
ILLUMINATE
CONE MADE OF
TRANSLUCENT
MATERIAL TO
LOOK SOLID
DURING THE
DAY & GLOW AT
NIGHT

The designers explored many alternate designs, based on the Grand Center logo or traditional theater lighting.

SANTA BARBARA, CA
REGIONAL BICYCLE ROUTE SIGNS

ROAD MARKERS ELIMINATE SIGNS; CYCLISTS TAKE PART

In a town where cycling is an almost fanatical pursuit, public input was a must for a major bicycle route project. Members of the Santa Barbara Bicycle Coalition helped field test the 150 miles of bike routes, and more than 100 people attended one public meeting to comment on the graphic design proposals and write suggestions on a giant map taped to the floor. Graphics consist of map kiosks and route signs, all sporting the "bicyclist in the sun" logo. On many streets, signs are reduced or eliminated by one-color versions of the logo in thermal applied pavement graphics. Installation began in 1998.

Design
Biesek Design, San Luis Obispo, CA; RRM Architects, San Luis Obispo (planning consultants); Traffic Solutions (roadmap)

Client
Santa Barbara Department of Public Works

Other planners
Santa Barbara Bicycle Coalition

Approvals from
City of Santa Barbara (Architectural Review Board, Sign Commitee)

Funding
Initial funding for the $200,000 project was from a federal Intermodal Surface Transportation Efficiency Act (ISTEA) grant. Additional funding is from the state of California and the city and counties of Santa Barbara. It will be maintained by the city and county of Santa Barbara.

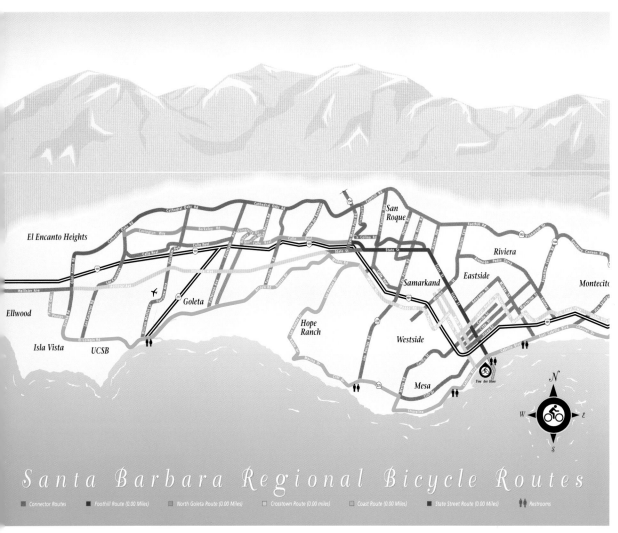

Maps show cyclists the many routes, color-coded by type.

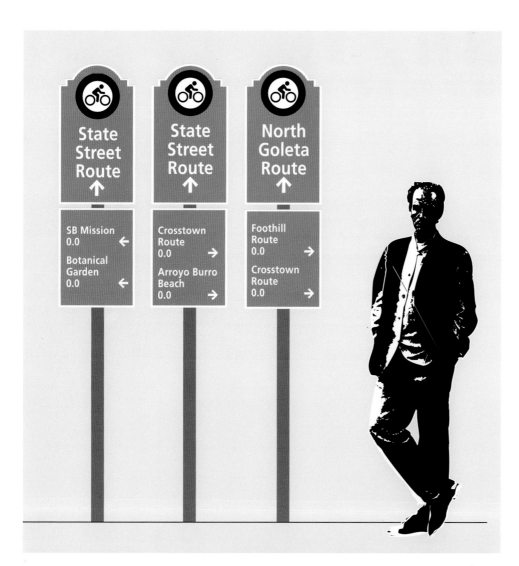

Directional signs are made of simple aluminum panels with reflective vinyl graphics. A shaped top adds distinction. The project typeface, Frutiger Bold, was chosen for its legibility.

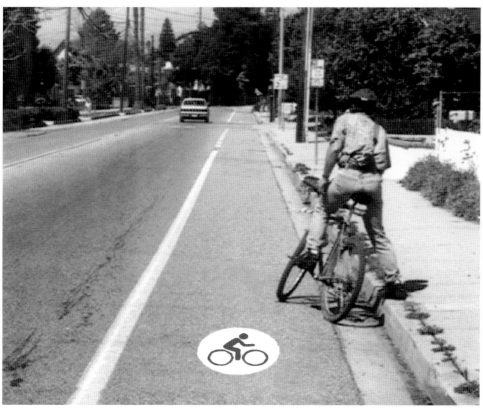

This simplified, one-color version of the route icon was designed for thermal applied pavement materials. It is used to mark trails in residential areas, where signs can cause clutter. On the roadway, these graphics are mainly noticeable to the cyclists who use them.

FRANKLIN, TN
SULLIVAN FARMS SUBDIVISION

UPSCALE DESIGN; COORDINATING LOOK FOR COMPETING CLIENTS

After the design firm was retained for land planning, roadway and infrastructure design, and landscape architecture, the developer added a comprehensive identity program. Designers used local field-stone walls and indigenous animals as their inspiration. After all designs were approved, the designers held a meeting with all eight builders to select which animals and names would go with which neighborhood. They report that the builders, all competitors, were pleased with a design that made all neighborhoods attractive.

Design
Gresham, Smith and Partners, Nashville, TN

Clients
Crowe Property Interests, Inc., and Lumbermen's Investment Corp.

Approvals from
Developer and builders; City of Franklin

Funding
Private; signs will be maintained by home-owners association

Fabricators
Rehorn & Kelly, granite entry signs; Signcraft, neighborhood and regulatory signs; Enameltec, porcelain enamel

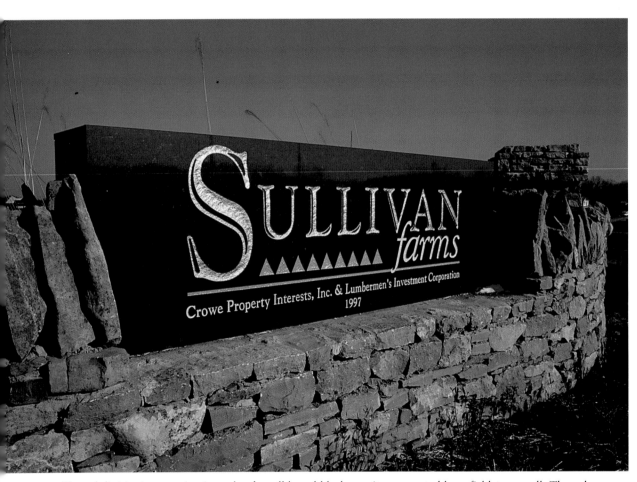

The subdivision's entry sign is made of sandblasted black granite, supported by a fieldstone wall. The color scheme and pattern of triangles is used throughout the project. The primary typeface, Goudy Oldstyle, provides character and personality.

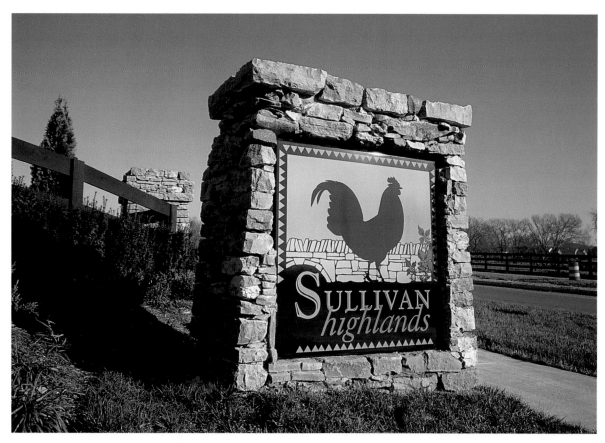

Each neighborhood entry sign consists of a fieldstone "wall" with a porcelain enamel graphic panel. Builders met in the designers' office to choose the animals and names (Sullivan Chase, Sullivan Meadows, etc.) they wanted for their neighborhoods.

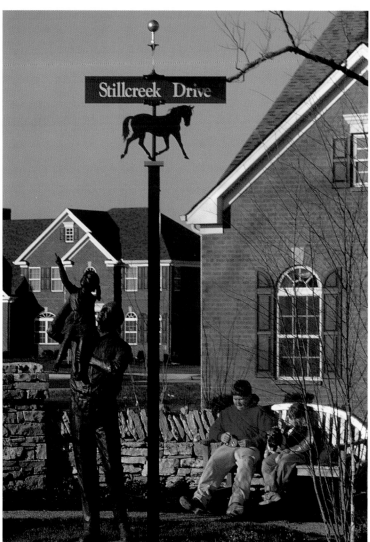

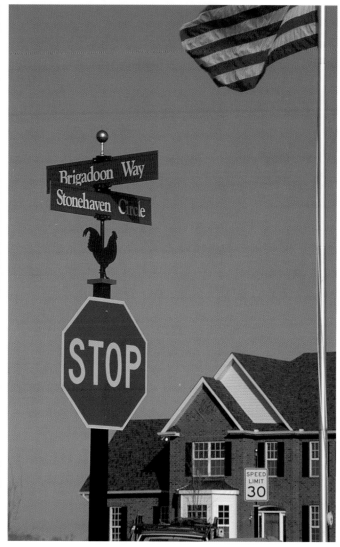

Street signs are mounted on square aluminum tubes and topped with brass finials. Each neighborhood's signs are decorated with its "totem" animal, laser-cut from sheet aluminum. Designers proposed working weathervanes, but the developer thought they might invite vandalism. Designers also proposed black sign blades, but could not get a variance from local codes, which specify DOT green.

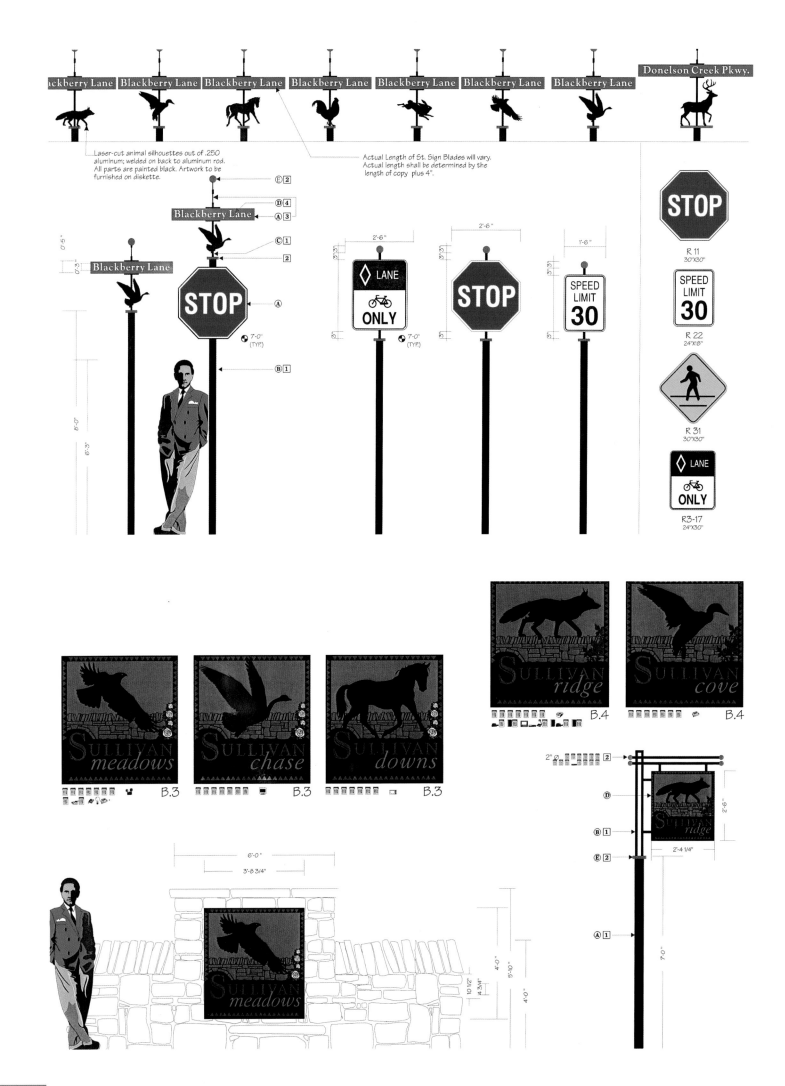

ckberry Lane Blackberry Lane Blackberry Lane Blackberry Lane Blackberry Lane Blackberry Lane Blackberry Lane Donelson Creek Pkwy.

Laser-cut animal silhouettes out of .250
aluminum; welded on back to aluminum rod.
All parts are painted black. Artwork to be
furnished on diskette.

Actual Length of St. Sign Blades will vary.
Actual length shall be determined by the
length of copy plus 4".

E 2
D 4
Blackberry Lane A 3
C 1
Blackberry Lane 2

STOP ← A

Blackberry Lane

7'-0"
(TYP.)

B 1

2'-6" 2'-6" 1'-6"

◇ LANE
ONLY
7'-0"
(TYP.)

STOP

SPEED
LIMIT
30

STOP
R 11
30"X30"

SPEED
LIMIT
30
R 22
24"X18"

R 31
30"X30"

◇ LANE
ONLY
R3-17
24"X30"

SULLIVAN
ridge
B.4

SULLIVAN
cove
B.4

SULLIVAN
meadows
B.3

SULLIVAN
chase
B.3

SULLIVAN
downs
B.3

2"
2

D

B 1

SULLIVAN
ridge

E 2

2'-6"

2'-4 1/4"

A 1

7'-0"

6'-0"
3'-8 3/4"

SULLIVAN
meadows

4'-0"
5'-10"
10 1/2"
4 3/4"
4'-0"

Section A
PHILLIPS

Section C
HORTON

FOUR-COLOR PORCELAIN ENAMEL PLAQUES FOR VILLAGES

1'-6"

1'-6"

Backplate

PLAN VIEW DETAIL
(Enlarged)

1/2" alum. rods
with 1-3/4" sphere
end-caps

Faceplate

6"

4 3/4"

2'-6 1/2"

2'-8 1/2"

3'-9"

7"

3"

3'-0"

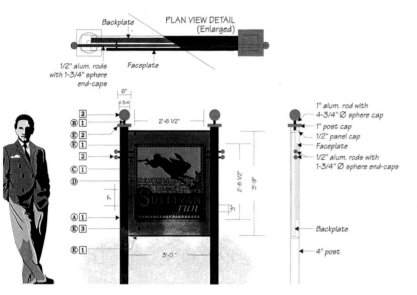

1" alum. rod with
4-3/4" Ø sphere cap

1" post cap

1/2" panel cap

Faceplate

1/2" alum. rods with
1-3/4" Ø sphere end-caps

Backplate

4" post

9"

1'-6"

1'-6"

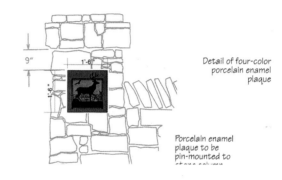

Detail of four-color
porcelain enamel
plaque

Porcelain enamel
plaque to be
pin-mounted to
stone column

10'-0"

1'-0 3/4"

9 1/2"

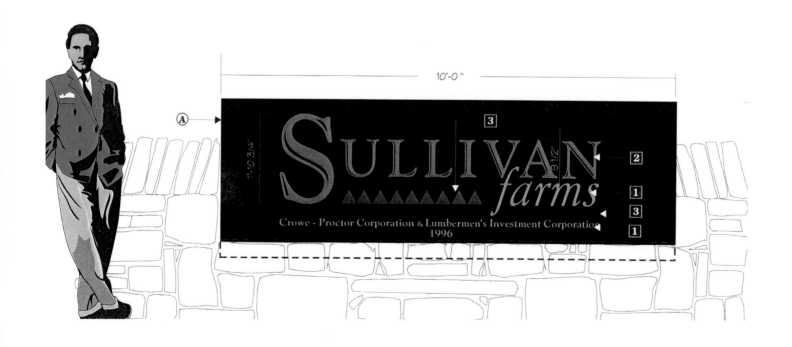

NEW YORK CITY, NY
MTA BUS STOP SIGNS

IN-HOUSE DESIGN; FEDERAL GRANTS; DESIGNED FOR CHANGE

New York City's new bus signs mark a radical change for the transit authority. When designers and planners began looking at the existing signs in 1990, they decided to scuttle the entire system and create a state-of-the-art wayfinding program. The unique "lollipop" shape is instantly recognizable, even in New York's crowded and oversigned streets. The signs incorporate the system's familiar color coding and "Guide-A-Ride" route information system. Modular message sign panels can be changed easily, and include route names as well as numbers. Station stop panels let bus riders find where they are. The result is a clear, readable sign program that reassures users that the bus system is equally modern and usable.

Even in New York's oversigned streets, the new bus signs stand out. The 16-in. diameter logo disk "lollipops" top color-coded, modular message panels. At eye level, "Guide-A-Ride" maps and destination information are easy to read and use.

Design
MTA New York City Transit, Graphics Unit

Consultants
New York City Department of Transportation; Society for Environmental Graphic Design

Approvals from
City of New York Mayor's Office; MTA New York City Transit; New York City Department of Transportation; New York City Council Land Use Committee; New York City Arts Commission

Funding
The system was funded by a combination of two federal Clean Air Mitigation Quality (CAMQ) grants. It will be maintained by NYC Transit, which will inspect the more than 3,400 signs every 25 days.

Fabricator
Amsign Corp., South Hadley, MA

Photos
Customer Services, F. Candelaria

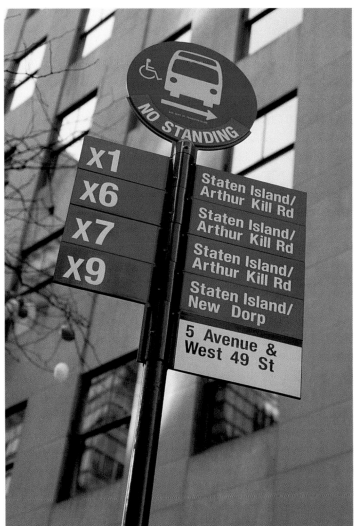

Designers kept the existing color coding system: blue for local lines, green for express, and purple for limited. Modular panels display both bus route numbers and names, and are simple to change. White panels, hung below the others, identify the stop. All sign faces are made of ABS plastic, laminated with a high-impact polymer for greater durability.

Reflective vinyl sheeting allows the sign copy to be read at night.

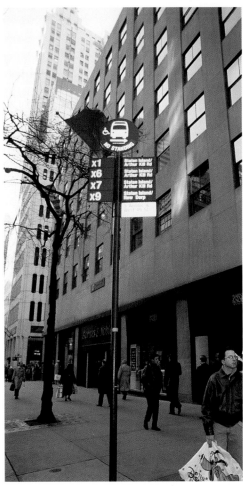

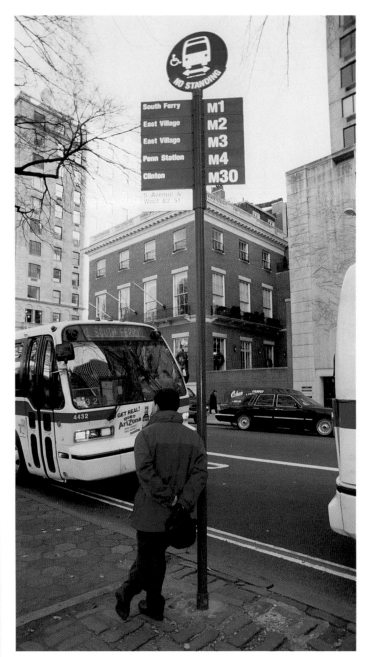

The sign footing is a universal mounting stanchion, which allows posts to be removed or replaced. There are four possible sign heights. None is less than 8 feet from the bottom of the lowest sign panel to the pavement, and all allow the bus logo to be seen above traffic.

Court St & Montague

The bus system's official type-face is Helvetica Neue Bold, Condensed. Though Helvetica is sometimes seen as a sign design cliche, its readability makes it a perennial favorite and this design shows that when used well, it still looks fresh.

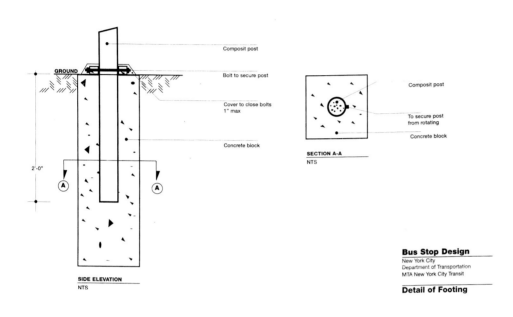

Composit post

GROUND

Bolt to secure post

Cover to close bolts 1" max

Concrete block

2'-0"

SIDE ELEVATION
NTS

Composit post

To secure post from rotating

Concrete block

SECTION A-A
NTS

Bus Stop Design
New York City
Department of Transportation
MTA New York City Transit

Detail of Footing

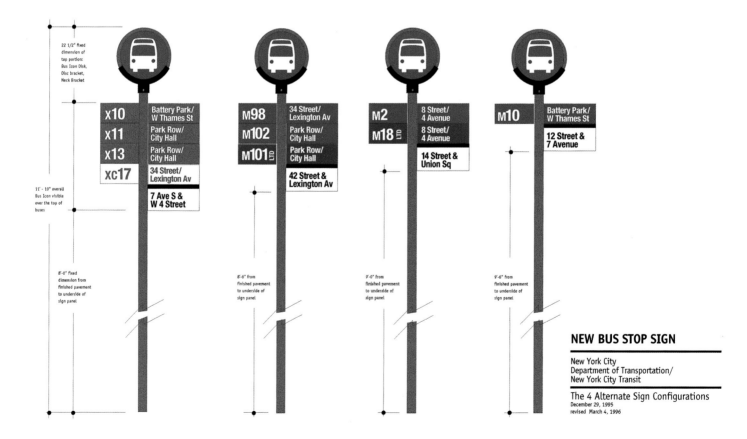

22 1/2" fixed dimension of top portion: Bus Icon Disk, Disc bracket, Neck Bracket

11' - 10" overall Bus Icon visible over the top of buses

8'-0" fixed dimension from finished pavement to underside of sign panel

x10	Battery Park/ W Thames St
x11	Park Row/ City Hall
x13	Park Row/ City Hall
xc17	34 Street/ Lexington Av
	7 Ave S & W 4 Street

8'-6" from finished pavement to underside of sign panel

M98	34 Street/ Lexington Av
M102	Park Row/ City Hall
M101 LTD	Park Row/ City Hall
	42 Street & Lexington Av

9'-0" from finished pavement to underside of sign panel

M2	8 Street/ 4 Avenue
M18 LTD	8 Street/ 4 Avenue
	14 Street & Union Sq

9'-6" from finished pavement to underside of sign panel

| M10 | Battery Park/ W Thames St |
| | 12 Street & 7 Avenue |

NEW BUS STOP SIGN

New York City
Department of Transportation/
New York City Transit

The 4 Alternate Sign Configurations
December 29, 1995
revised March 4, 1996

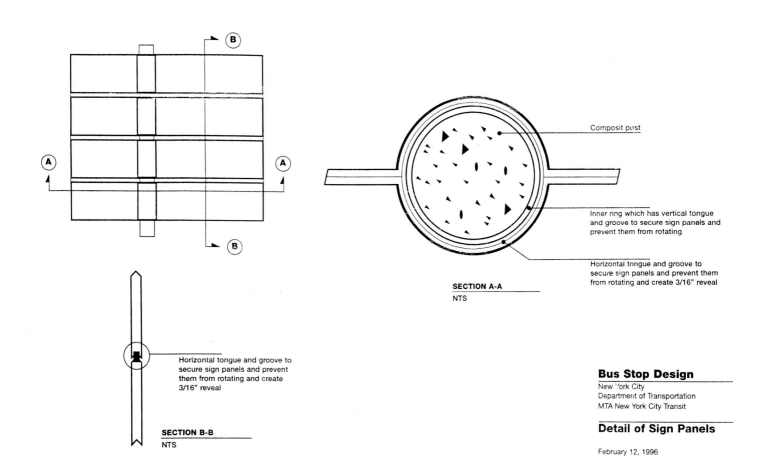

Composit post

Inner ring which has vertical tongue and groove to secure sign panels and prevent them from rotating

Horizontal tongue and groove to secure sign panels and prevent them from rotating and create 3/16" reveal

SECTION A-A
NTS

Horizontal tongue and groove to secure sign panels and prevent them from rotating and create 3/16" reveal

SECTION B-B
NTS

Bus Stop Design
New York City
Department of Transportation
MTA New York City Transit

Detail of Sign Panels

February 12, 1996

WESTLAKE, CA
WESTLAKE CULTURAL FRONT

PUBLIC MONEY; PUBLIC STATEMENT

BJ Krivanek has made a career of giving a voice to the voiceless through art. Only time will tell whether or not his provocative, carefully researched pieces succeed. This piece, installed in 1995, told the story of a neighborhood torn by violence and competing cultures. Moved every two months to a different site at Belmont High School in the Westlake area of Los Angeles, it provided a literal soapbox for the disenfranchised to use to make their voices heard.

Interviews with the high school's students and faculty yielded reams of written text recording their views about many social issues. With the help of the school's associate principal, designers edited the material into a series of provocative phrases in English (traditional statements about the United States) and Spanish (the mostly Latino community's beliefs).

Design
BJ Krivanek Art + Design, Los Angeles; BJ Krivanek, public artist; Sonia Baez-Hernández, urban sociologist; Joel Breux, designer

Client
City of Los Angeles Cultural Affairs Department

Other planners
Students and faculty of Belmont High School

Funding
Money for this one-year installation came from The Los Angeles Endowment for the Arts and the City of Los Angeles Cultural Affairs Department.

Fabricator
Bro Designed Construction

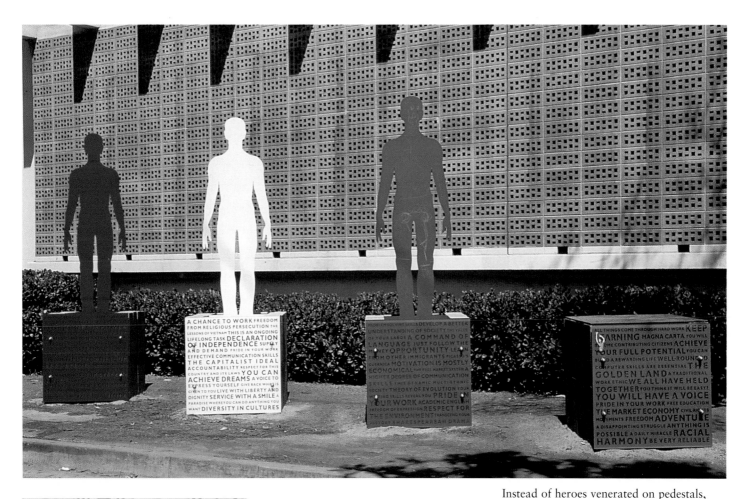

Instead of heroes venerated on pedestals, this installation featured anonymous figures painted red, white and blue. Either perpetrator or victim, or both, the figures stood on platforms that reproduce the collected phrases. Two sides of each were in English, and two in Spanish. A fourth, empty platform stood as a challenge or invitation for viewers to participate in their world rather than watch it.

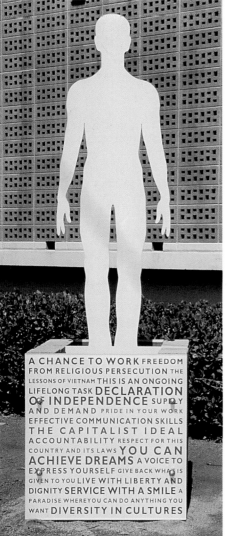

Made of painted aluminum with concrete-reinforced bases and embossed type, the pieces were re-sited on the high school grounds every two months. Movers removed the text panels, lifted the figures and framework with a portable crane, then assembled them at the new site.

MINNEAPOLIS, MI
ST. ANTHONY FALLS HERITAGE TRAIL

PRIVATE AND PUBLIC MONIES; PARK SERVING TWO CITIES

Part of a joint Minneapolis/St. Paul riverfront improvement effort, this park and trail was an immediate success when it opened in 1996, after long delays over funding. A two-mile trail loops along the banks of the Mississippi River, including two historic bridges. Interpretive graphics tell visitors the area's history, which centers around an industrial past and the namesake falls. Tough materials and coatings ensure that the sign system stands up to tough weather. The fabricator invented a porcelain enamel door for message boards, so there is no exposed metal.

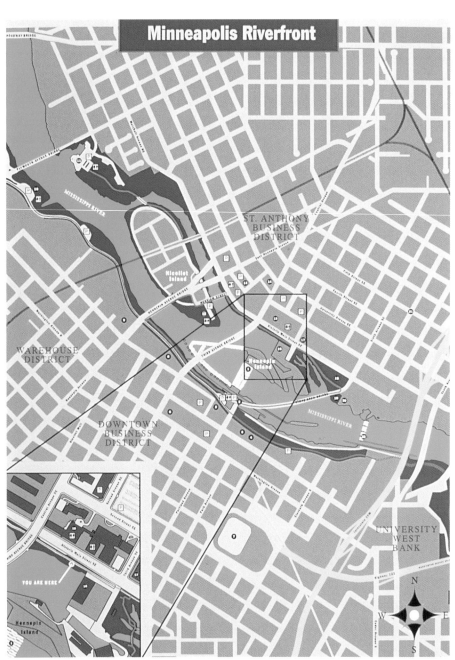

Minneapolis Riverfront

The 1.8-mile trail loops over two historic bridges and winds along both sides of the Mississippi River. Between the bridges are the trail's namesake falls, which provided power for the area's early industrial might.

Design
Signia Design, Minneapolis

Consultants
Bruce Wright, writer; Scott Michel, graphic designer

Clients
St. Anthony Falls Heritage Board; Hennepin County, MN; Minnesota Historical Society; Minneapolis Park & Recreation Board, Minneapolis Community Development Agency

Approvals from
Above

Funding
Signs were paid for with money raised from a variety of private, state and local agencies. The park will be maintained by the Minneapolis Park & Recreation Board. The signs will be maintained by the Minneapolis Historical Society.

Fabricators
Thomas & Sons Construction, Minneapolis, general contractor; Enameltec, Georgetown, Ontario, porcelain enamel; CD Systems, St. Paul, MN, metal fabrication; Artstone, New Ulm, MN, cast and custom molded concrete

A scale model shows the system's main graphic elements and their relative sizes.

All interpretive graphics are printed on steel porcelain enamel panels for durability. All include maps, so that users can decide whether to complete the trail or turn back. Photos are printed in sepia tone, for a "historic" look.

Four kiosks present wayfinding information and hold announcements and other local postings. A limestone cap and concrete base simulating limestone (weather is too harsh for the real thing) add a natural touch. The kiosks are mounted at a 45° angle from the road on giant, embedded bronze compasses, showing how the river influenced the city's construction.

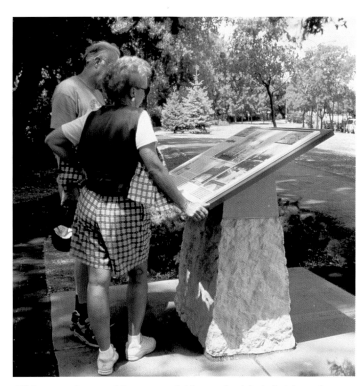

All interpretive graphics are readable at wheelchair height—also convenient for pedestrians.

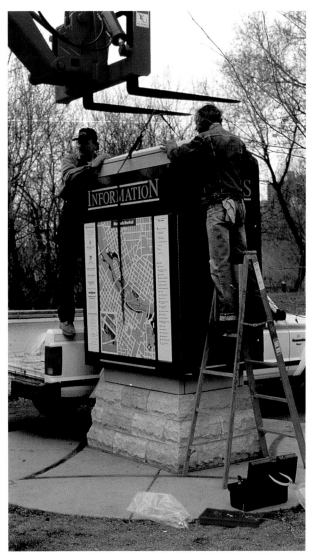

The project's $350,000 price tag included all the site work, making it a job for a general contractor rather than a sign fabricator. Here, workers install the hollow kiosks over their metal frame interiors.

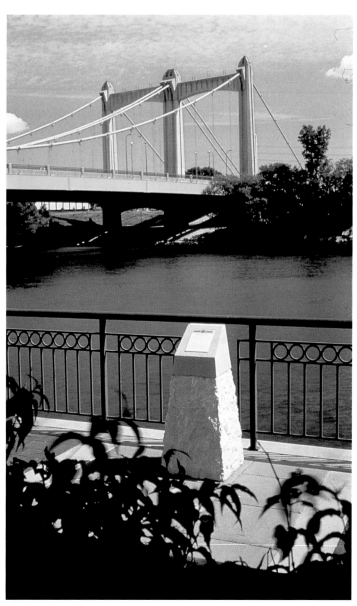

Trailblazer bases, like the rest of the program, are made of cast-concrete with limestone tops. A special coating helps protect the stone from vandalism, but adds to the cost.

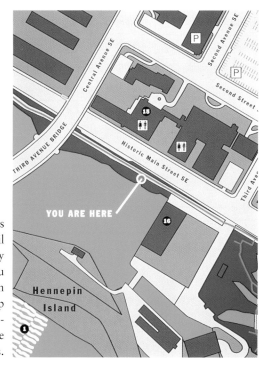

Because visitors can enter the trail from so many points, small "you are here" maps on every sign help them orient themselves and decide their paths.

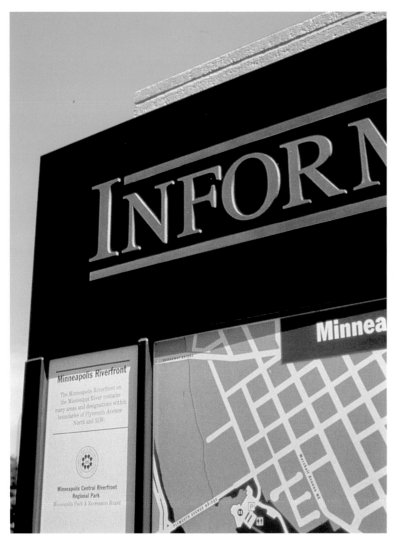

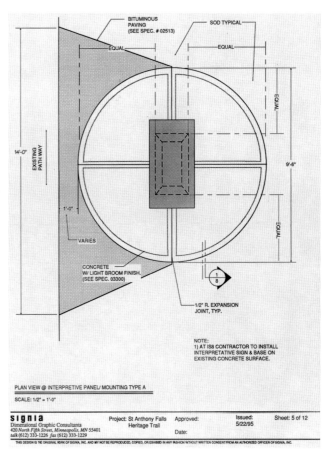

signia
Dimensional Graphic Consultants
420 North Fifth Street, Minneapolis, MN 55401
talk (612) 333-1226 fax (612) 333-1229

Project: St Anthony Falls
Heritage Trail

Approved:

Date:

Issued:
5/22/95

Sheet: 5 of 12

THIS DESIGN IS THE ORIGINAL WORK OF SIGNIA, INC. AND MY NOT BE REPRODUCED, COPIED, OR EXHIBED IN ANY FASHION WITHOUT WRITTEN CONSENT FROM AN AUTHORIZED OFFICER OF SIGNIA, INC.

Anodized aluminum letters and stainless steel lines, attached with epoxy, decorate the porcelain enamel kiosk faces.

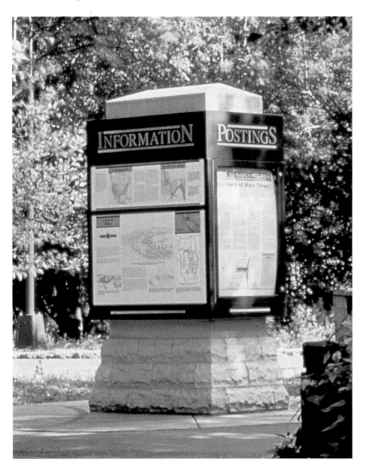

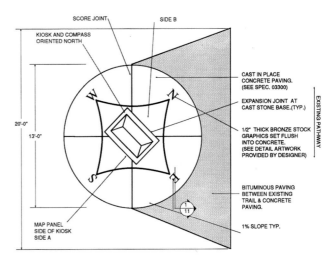

FREMONT, CA
IRVINGTON GATEWAYS

NEIGHBORHOOD SIGNS

These signs for the Irvington neighborhood of Fremont make an arresting statement. Drivers are not likely to miss the boundary—even if they're distracted by the beautiful view.

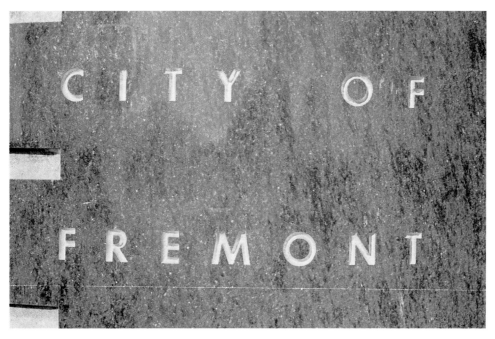

Made of stainless steel with granite bases, the highly polished signs reflect the scenery. Otherwise purely industrial, they seem part of the sky and the far-off mountains.

Design
The Office of Michael Manwaring, San Anselmo, CA

Other planners and consultants
Englund Design; Jay Wood Claiborne; Robert Bruce Anderson

Client
City of Fremont Redevelopment Agency

Fabricators
Arrow Sign Co., Nor-Cal Metal Fabricators

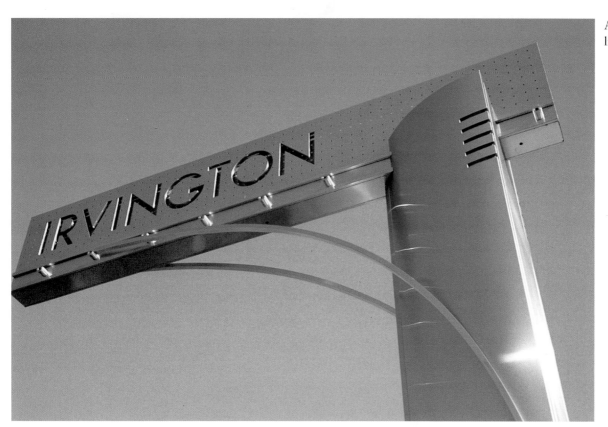

At night, the signs are lit with brilliant neon.

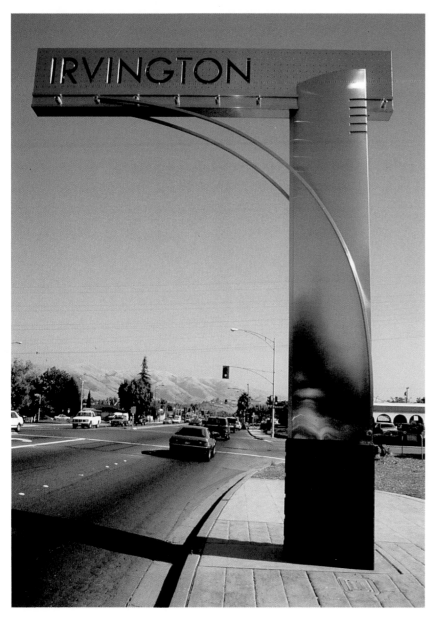

Polished granite bases are incised with the city's name.

FUKUOKA, JAPAN
CANAL CITY, HAKATA

PRIVATE CITY INSIDE A PUBLIC CITY

Designers worked with architects The Jerde Partnership to develop a communications master plan, identity, and merchandise program for this 2 million-sq.-ft. mixed-use complex. Almost a city in itself, it includes hotel, retail, and office space where people can live, work and relax. Here signs do the same work that they do in public spaces. But like Canal City's striking architecture, its signs are markedly different from their urban counterparts. This is partly due to a much bigger budget. But most of all, it's due to the nature of private developments. They are meant to replace outside reality with something cleaner, more efficient, more beautiful.

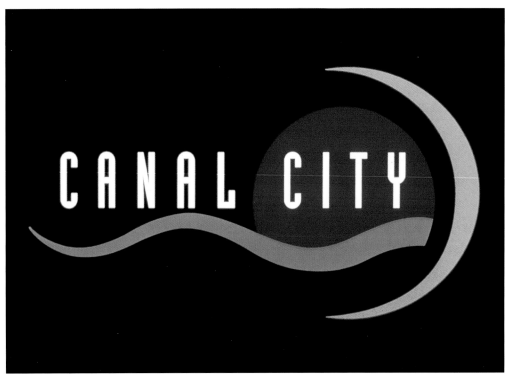

Like any good city logo, Canal City's is bright and crisp. But the abstract design does not allude to a local landmark or historic past. It is a representation of the massive mixed-use center's architecture.

Design
Selbert Perkins Design Collaborative

Consultants
EDAW (landscape architects); Wet Design (water designers); Joe Kaplan Architectural Lighting

Clients
The Jerde Partnership (architecture); Fukuoka Japan Urban Design and Development

Funding
Private

General contractor
Zenetaka

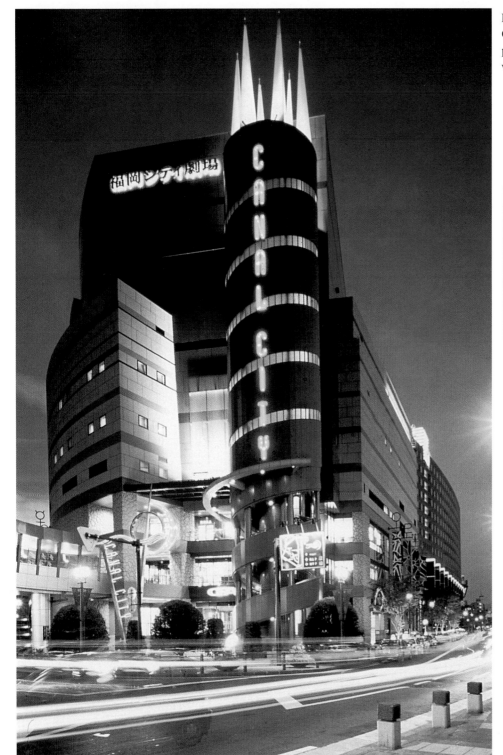

Itself a sign, Canal City announces its presence to the world.

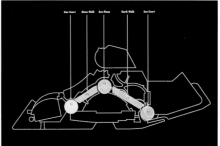

To help plan wayfinding, the 2 million-sq.-ft. area was broken into functional districts. These districts, however, are all within Canal City's undulating walls.

A preliminary sketch shows where giant outdoor signs will be placed. A city within a city, the development reaches out with many open balconies jutting out over the street. Like many Jerde buildings it blurs the line between public and private spaces.

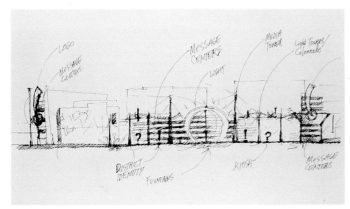

Plans for trailblazer and regulatory signs show their large size and sculptural quality.

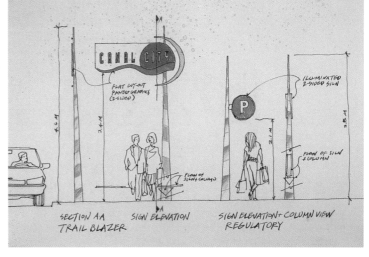

Sculptural "sensory towers" were designed for five courtyards. They represent natural objects such as the sun and the sea, literal interpretations of the project theme, "a walk through the universe." Because they were fabricated in Japan, without the designers' input, the final towers have a different look.

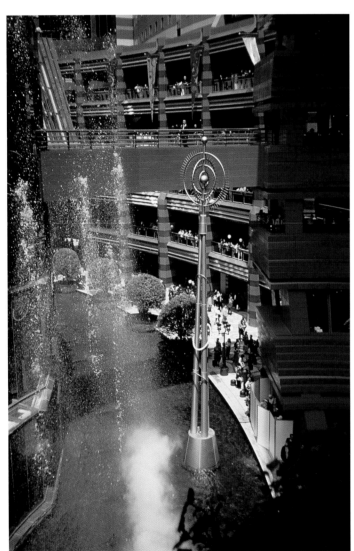

One of the five courtyards features multi-layered overlooks, fountains and other water features, hanging gardens, and integral striped columns.

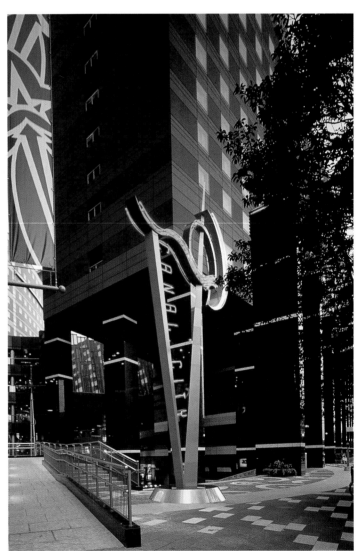

A neon-trimmed exterior sign leads people down to one of five courtyards.

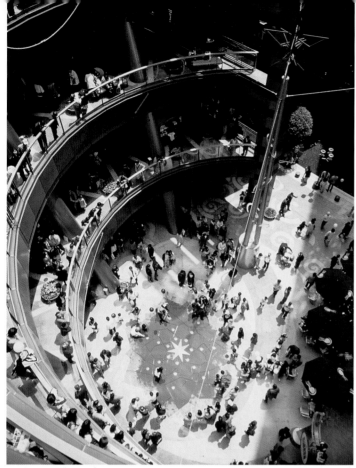

Terraced overlooks, decorative paving, and a massive sculptural tower representing a star mark one courtyard.

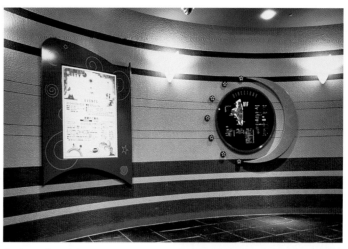

A sign advertising events and a spectacular directory help people find their way to many diverse destinations.

Freestanding directories help visitors navigate the unusual space.

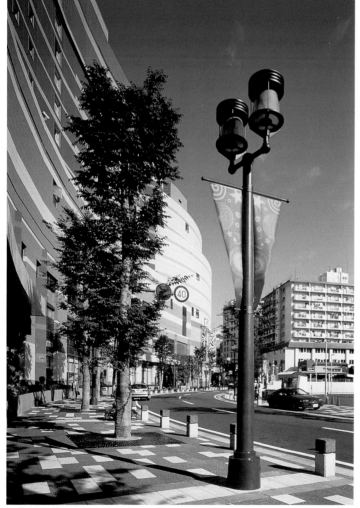

Banners, light poles, regulatory signs, decorative paving, and trees face the public street, just as they do in any urban sign program. But these do not extend past the developer's property.

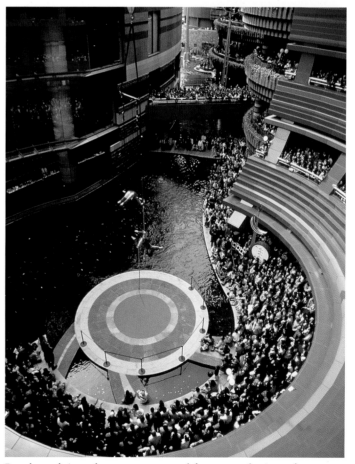

People pack into the water courtyard for an acrobatic performance. Courtyards mimic public parks with plantings, ponds, bridges, banners, lamp poles, and even street vendors.

TEMPE, AZ
TEMPE IN MOTION TRANSIT SYSTEM

NEW SYSTEM; NEW LOOK

Part of a regional transportation system (Valley Metro), the new Tempe transit system launched its first bus in 1998. Designers created a comprehensive graphic identity for the system, called Tempe in Motion (TIM), and its two conventional and one electric bus lines. All bear variations of the TIM logo, featuring a cartoon tornado, and vibrant graphics. The palette of bright desert bloom colors combines Valley Metro colors (teal and fuschia) with gold and bluish purple. Vehicle graphics are marked with a combination of paint and adhesive vinyl, including perforated vinyl used over windows.

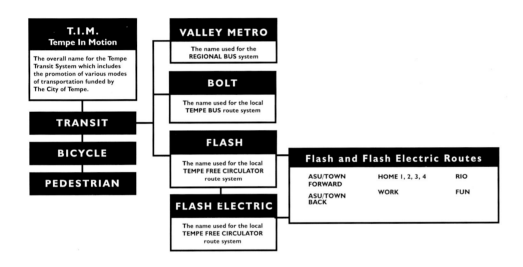

T.I.M. Tempe In Motion		VALLEY METRO
The overall name for the Tempe Transit System which includes the promotion of various modes of transportation funded by The City of Tempe.		The name used for the REGIONAL BUS system

TRANSIT

BICYCLE

PEDESTRIAN

BOLT
The name used for the local TEMPE BUS route system

FLASH
The name used for the local TEMPE FREE CIRCULATOR route system

FLASH ELECTRIC
The name used for the local TEMPE FREE CIRCULATOR route system

Flash and Flash Electric Routes

ASU/TOWN FORWARD	HOME 1, 2, 3, 4	RIO
ASU/TOWN BACK	WORK	FUN

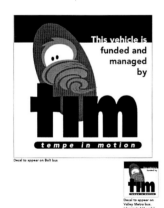

Decal to appear on Bolt bus

Decal to appear on Valley Metro bus. (shown in 1/4 scale)

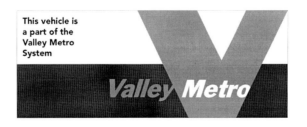

This vehicle is a part of the Valley Metro System

Design
Thinking Caps, Phoenix

Client
City of Tempe Transportation Department and Department of Public Works

Other planners
City of Tempe Department of Public Works; Tempe Transportation Commission

Approvals from
Above and Tempe Transportation Commission Marketing Sub-Committee; Tempe City Council

Funding
Graphics were paid for in part with bond money from a special tax levy raised for the public transportation system, and in part with monies from a federal Intermodal Surface Transportation Efficiency Act (ISTEA) grant.

CURB SIDE

FRONT

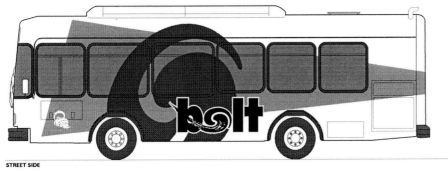

STREET SIDE

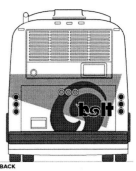

BACK

tim
tempe in motion

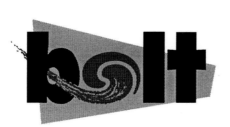

bolt

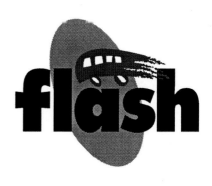

flash

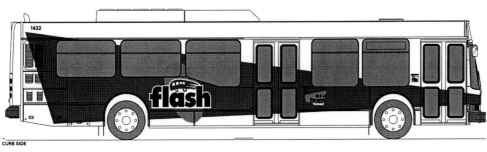

CURB SIDE

FRONT

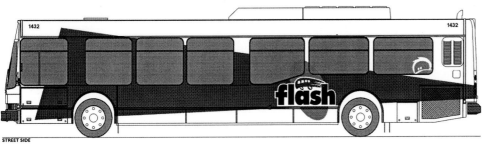

STREET SIDE

BACK

PHOENIX, AZ
VALLEY METRO

PUBLIC STUDIES AT MALLS AND BUS STATIONS; APPROVALS FROM FIVE MAYORS

Begun by one design firm and finished by another, these designs transformed a regional transportation system operating among five Arizona cities. Designers adapted a new identity system to twelve vehicle types. The paint and adhesive vinyl graphics, which can cost up to $1,200 for a bus, include perforated vinyl film over windows.

Design
Thinking Caps, Phoenix (implementation)

Other design
Cornoyer-Hedrick, Phoenix (initial design)

Client
Regional Public Transportation Authority (county-wide agency for Phoenix, Mesa, Tempe, Glendale, and Scottsdale, AZ)

Approvals from
RPTA and mayors of above cities

Fabricator
Phoenix Transit Paint Shop

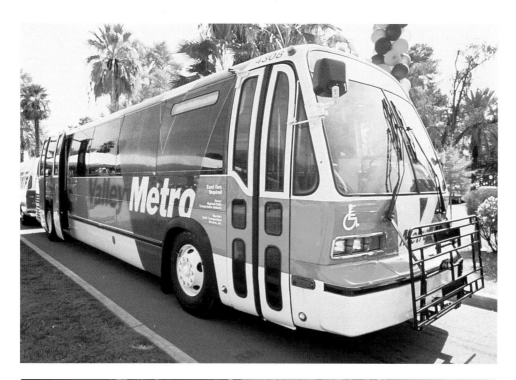

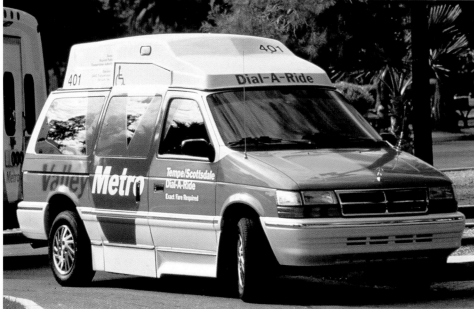

New paint and vinyl graphics in bright Southwestern colors identify a regional transportation system operating in five Arizona cities.

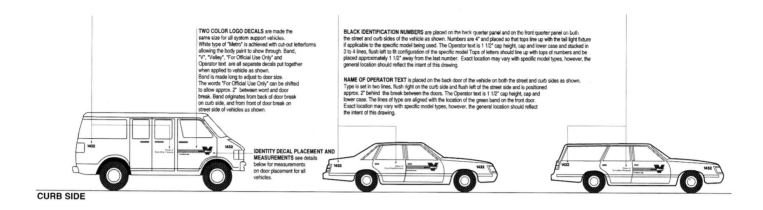

TWO COLOR LOGO DECALS are made the same size for all system support vehicles. White type of "Metro" is achieved with cut-out letterforms allowing the body paint to show through. Band, "V", "Valley", "For Official Use Only" and Operator text are all separate decals put together when applied to vehicle as shown.
Band is made long to adjust to door size.
The words "For Official Use Only" can be shifted to allow approx. 2" between word and door break. Band originates from back of door break on curb side, and from front of door break on street side of vehicles as shown.

BLACK IDENTIFICATION NUMBERS are placed on the back quarter panel and on the front quarter panel on both the street and curb sides of the vehicle as shown. Numbers are 4" and placed so that tops line up with the tail light fixture if applicable to the specific model being used. The Operator text is 1 1/2" cap height, cap and lower case and stacked in 3 to 4 lines, flush left to fit configuration of the specific model. Tops of letters should line up with tops of numbers and be placed approximately 1 1/2" away from the last number. Exact location may vary with specific model types, however, the general location should reflect the intent of this drawing.

NAME OF OPERATOR TEXT is placed on the back door of the vehicle on both the street and curb sides as shown. Type is set in two lines, flush right on the curb side and flush left of the street side and is positioned approx. 2" behind the break between the doors. The Operator text is 1 1/2" cap height, cap and lower case. The lines of type are aligned with the location of the green band on the front door. Exact location may vary with specific model types, however, the general location should reflect the intent of this drawing.

IDENTITY DECAL PLACEMENT AND MEASUREMENTS see details below for measurements on door placement for all vehicles.

CURB SIDE

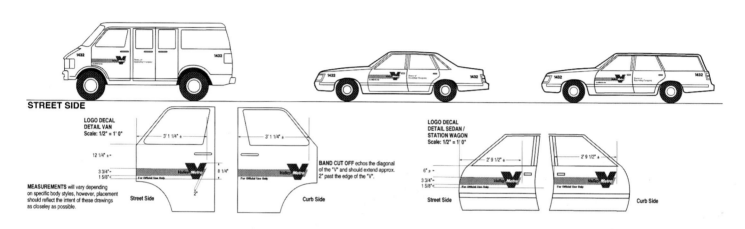

STREET SIDE

LOGO DECAL DETAIL VAN
Scale: 1/2" = 1' 0"

3' 1 1/4" ±

12 1/4" ±

3 3/4" ±
1 5/8" ±

8 1/4"

2"

Street Side

3' 1 1/4" ±

Curb Side

BAND CUT OFF echos the diagonal of the "V" and should extend approx. 2" past the edge of the "V".

MEASUREMENTS will vary depending on specific body styles, however, placement should reflect the intent of these drawings as closeley as possible.

LOGO DECAL DETAIL SEDAN / STATION WAGON
Scale: 1/2" = 1' 0"

2' 9 1/2" ±

6" ±

3 3/4" ±
1 5/8" ±

Street Side

2' 9 1/2" ±

Curb Side

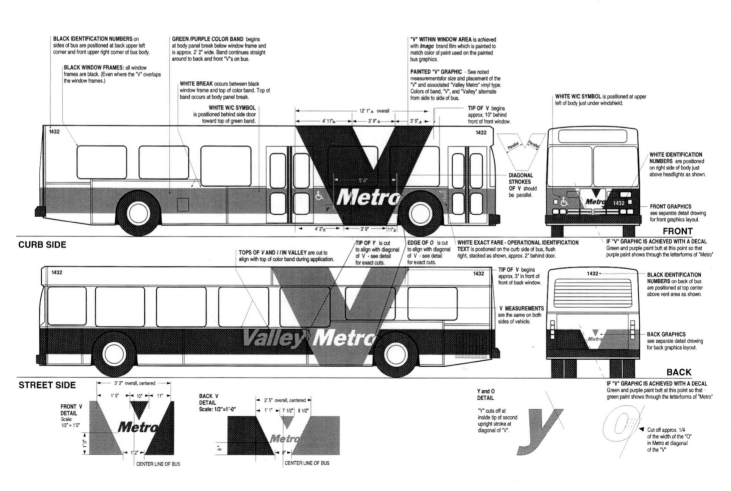

BLACK IDENTIFICATION NUMBERS on sides of bus is positioned at back upper left corner and front upper right corner of bus body.

BLACK WINDOW FRAMES: all window frames are black. (Even where the "V" overlaps the window frames.)

GREEN /PURPLE COLOR BAND begins at body panel break below window frame and is approx. 2' 2" wide. Band continues straight around to back and front "V"s on bus.

WHITE BREAK occurs between black window frame and top of color band. Top of band occurs at body panel break.

WHITE W/C SYMBOL is positioned behind side door toward top of green band.

"V" WITHIN WINDOW AREA is achieved with Imago brand film which is painted to match color of paint used on the painted bus graphics.

PAINTED "V" GRAPHIC - See noted measurements for size and placement of the "V" and associated "Valley Metro" vinyl type. Colors of band, "V", and "Valley" alternate from side to side of bus.

WHITE W/C SYMBOL is positioned at upper left of body just under windshield.

12' 1" ± overall

4' 11" ± 3' 9" 3' 5" ±

5' 6"

TIP OF V begins approx. 10" behind front of front window.

DIAGONAL STROKES OF V should be parallel.

Parallel Parallel

4' 2" ± 3' 9" 11" ±

WHITE IDENTIFICATION NUMBERS are positioned on right side of body just above headlights as shown.

FRONT GRAPHICS see separate detail drawing for front graphics layout.

FRONT

CURB SIDE

TOPS OF V AND I / IN VALLEY are cut to align with top of color band during application.

TIP OF Y is cut to align with diagonal of V - see detail for exact cuts.

EDGE OF O is cut to align with diagonal of V - see detail for exact cuts.

WHITE EXACT FARE - OPERATIONAL IDENTIFICATION TEXT is positioned on the curb side of bus, flush right, stacked as shown, approx. 2" behind door.

IF "V" GRAPHIC IS ACHIEVED WITH A DECAL Green and purple paint butt at this point so that purple paint shows through the letterforms of "Metro"

TIP OF V begins approx. 3" in front of front of back window.

V MEASUREMENTS are the same on both sides of vehicle.

BLACK IDENTIFICATION NUMBERS on back of bus are positioned at top center above vent area as shown.

BACK GRAPHICS see separate detail drawing for back graphics layout.

BACK

STREET SIDE

3' 2" overall, centered
1' 5" 10" 11"

FRONT V DETAIL
Scale: 1/2" = 1'0"

1'-0"

1' 2"

CENTER LINE OF BUS

BACK V DETAIL
Scale: 1/2"=1'-0"

2' 5" overall, centered
1' 1" 7 1/2" 8 1/2"

5' 5"

4"

CENTER LINE OF BUS

Y and O DETAIL

"Y" cuts off at inside tip of second upright stroke at diagonal of "V".

IF "V" GRAPHIC IS ACHIEVED WITH A DECAL Green and purple paint butt at this point so that green paint shows through the letterforms of "Metro"

Cut off approx. 1/4 of the width of the "O" in Metro at diagonal of the "V"

SAULT STE. MARIE, MI
STREETSCAPE REDESIGN

THREE PUBLIC HEARINGS; TAXPAYER-FUNDED

Designed to bring tourists from the city's famous Soo Locks to the adjacent main commercial area, the new sign program emphasizes local shops, restaurants and other attractions with large signs, interpretive panels, and maps. Part of a comprehensive streetscape redesign, the signs were planned after an initial public fact-finding meeting and two other public hearings. Installed in 1993, the program has been so successful that the county, the River of History Museum, and other agencies and attractions are emulating its design.

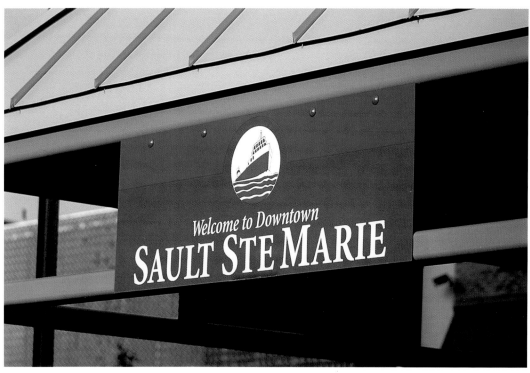

New signs emphasize the city's nautical heritage. The slate blue and burgundy color scheme fits area architecture and showcases the logo, a cargo ship that is the city's symbol.

Design
Corbin Design, Traverse City, MI

Consultants
Jackson Design (urban planning); Deardorff Design Resources (landscape architects)

Approvals from
City of Sault Ste. Marie Department of Planning and Development; Downtown Development Authority

Funding
The $110,000 program was paid for with tax funds generated by the Downtown Development Authority. Maintenance will be done and paid for by the city.

Fabricators
Valley City Signs, Grand Rapids, MI; ASI Sign Systems, Troy, MI

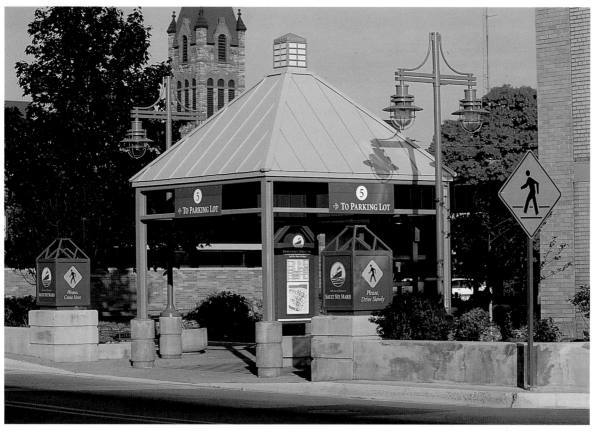

Shaped like buoys, the aluminum signs have a psuedo-industrial look.

Part of a new streetscape system that includes paving and lamp posts, signs are integrated with bus shelters and crosswalks. Updated annually, the detailed city map is printed on adhesive vinyl with a large-format ink-jet printer, then mounted to the sign.

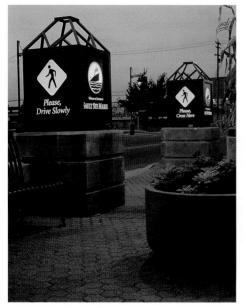

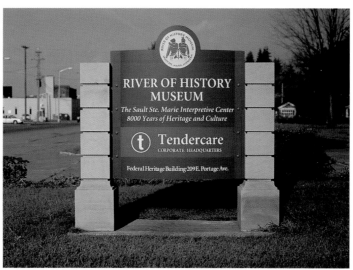

All county buildings and the River of History Museum have adopted similar signs, expanding the look further.

Because dusk comes at 4:00 pm during the long winters, illuminated crosswalk signs are a welcome addition.

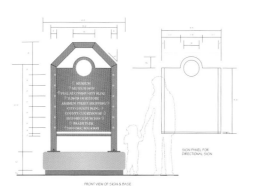

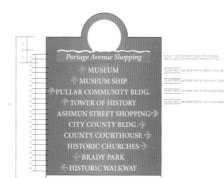

Custom backplates give standard regulatory signs a boost of style.

NEWPORT, KY
RIVERWALK ENHANCEMENT

FEDERAL, CITY AND PRIVATE FUNDS; RICH AREA HISTORY

A half-mile walking trail atop the city's earth floodwall turns a riverfront necessity into a tourist attraction. The park's first phase, completed in 1996 for the city's bicentennial, connected Newport to an existing Riverwalk spanning two states, two sides of the Ohio River, and three other cities. For Newport the designers, who created graphics for the existing Riverwalk, elaborated on their earlier work. Interpretive signs work with sculptural "weathervanes" and other untraditional graphics to explain the area's past. Etched granite plaques provide activities. Phase one was designed in nine months and built and installed in six. Phase two, which adds three new icons and weathervanes, will be complete in 1998.

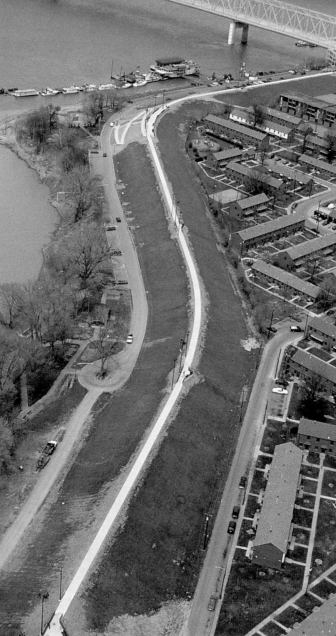

The massive earth floodwall separating the city from the river becomes a tourist attraction with the new walking trail.

Icons celebrate Newport's history: Indian sacred hunting grounds, a Civil War barracks, steamboats, the founding of the Boy Scouts, brewing, river life, turn-of-the-century life, bridge building, steel making.

Design

Firehouse Design Team, Cincinnati: Robert Probst and Heinz Schenker, principals

Consultants

Kolar Design Inc., Cincinnati (environmental graphic design); Myers, Schmalenberger, Meisner (landscape architecture and urban planning); KZF Inc., Cincinnati, (engineering); Applied History Associates (Historical Assessment)

Clients

City of Newport, Department of Economic Development; Commonwealth of Kentucky

Approvals from

City of Newport (Departments of Economic Development, Purchasing, Engineering); Kentucky Department of Transportation; US Army Corps of Engineers

Funding

The system was paid for with a federal Intermodal Surface Transportation Efficiency Act (ISTEA) grant, money from the City of Newport, and private funding from local corporate sponsors. Some of the private money was used to establish a maintenance fund for the project.

Fabricators

Lagenheim (general contractor); ASI Sign Systems/Artisign, (weathervanes); Metalphoto of Cincinnati (interpretive panels); United Signs (directional signs and supergraphics); Rolf Monument (granite plaques); National Flags (pennants); Heath Ceramics (tile markers)

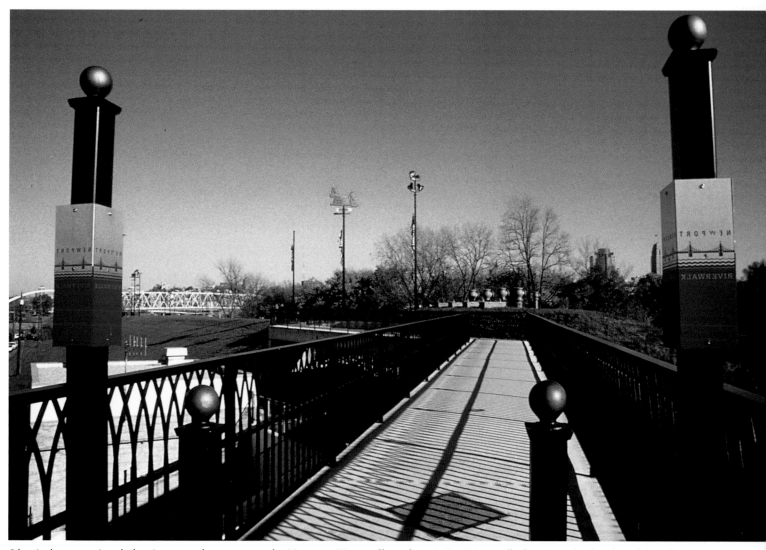

Identical screenprinted aluminum markers connect the Newport Riverwalk to the existing Riverwalk that spans both sides of the Ohio River and three other cities. But Newport's project is far more elaborate.

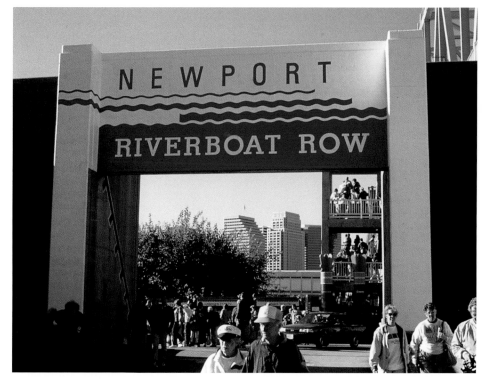

Round tile markers set into the concrete path run throughout the four-city Riverwalk. The signature Riverwalk teal and blue markers assure walkers that they're on the right path.

Supergraphics painted on the concrete floodgate (which allows access to the river) announce the entrance to Riverboat Row, where excursion boats and floating restaurants moor.

Tall poles support the decorative flags and metal weathervane sculptures. Their deep black color and vertical lines contrast with the light-colored bridges beyond them.

Scale models of the weathervanes and flag poles illustrated their varied sizes.

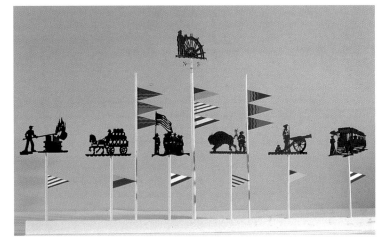

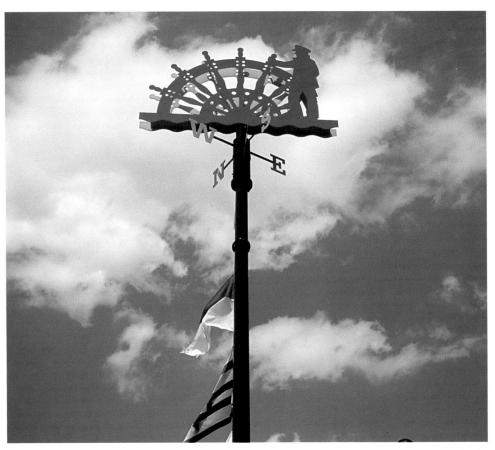

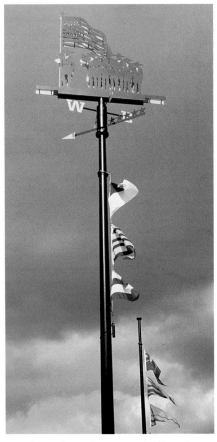

Massive sculptures equipped with weathervanes and flag poles bring color and motion to the linear park. Each marks an overlook and represents an era in the city's history.

Designers and fabricators worked together to realize the sketches.

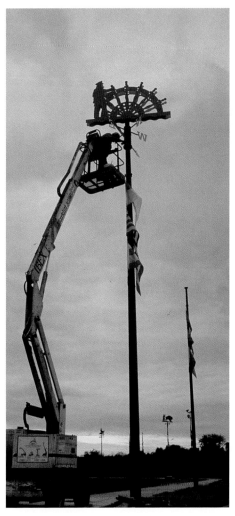

The tallest sculpture is installed on its pole.

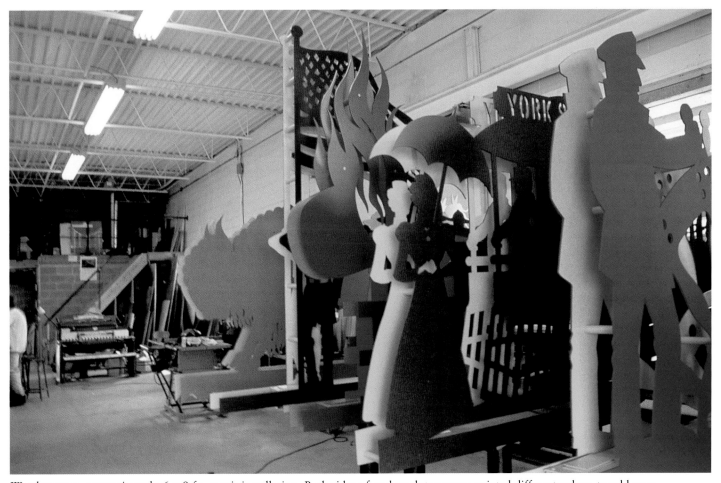

Weathervanes, approximately 6 x 9 ft., await installation. Both sides of each sculpture were painted different colors, to add even more visual interest.

Photo-etched aluminum panels include historical photos. The text, written by local historian Dan Hurley, explains area history.

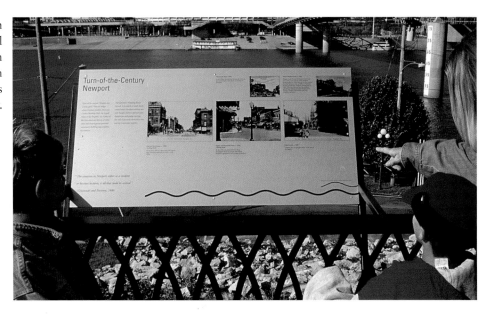

Etched and paint-filled granite markers, set in pedestals or flush to the ground, provide activities such as stone rubbing.

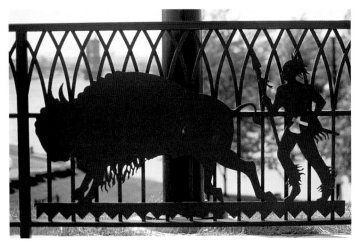

The fencing at each overlook includes cut and painted steel renditions of the appropriate icon.

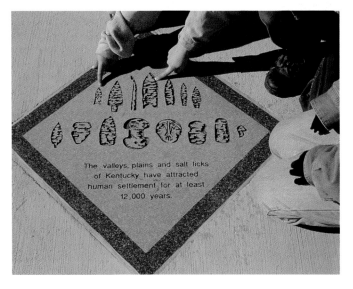

The valleys, plains and salt licks of Kentucky have attracted human settlement for at least 12,000 years.

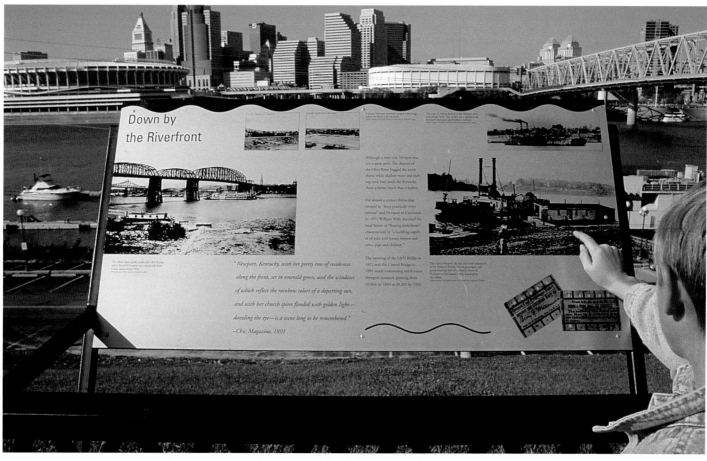

With its Riverwalk, Newport reclaims its spectacular view of Cincinnati, otherwise obscured by the lifesaving floodwall.

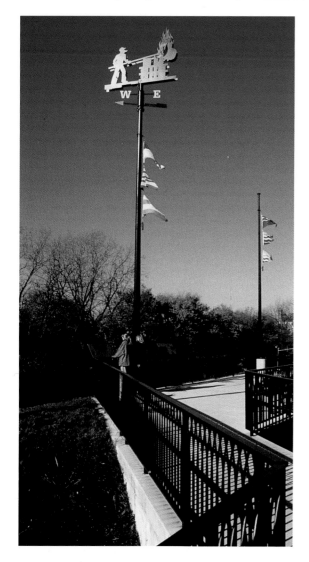

CLEARVIEW
NEW TYPEFACE FOR HIGHWAY SIGNS

UPDATED URBAN SIGN SYSTEMS

Designers have long been unhappy with the "Highway Gothic" typefaces mandated for all highway, freeway and road signs in the United States. Available in five all-cap weights and one mixed weight, the highway faces are neither attractive nor particularly readable, and haven't been updated since their adoption almost 50 years ago. Designers assumed that many other typefaces were equally, if not more, readable. But without studies to prove it, no highway authority felt much like granting an exception that might cost lives.

In 1995, that changed.

Larchmont, NY-based Meeker & Associates worked with the Pennsylvania Transportation Institute (PTI) to develop and test two new typefaces based on the best of the Highway Gothics. The designers created Clearview and Clearview Condensed, both mixed-cased faces, after studying seven common sans serif faces and testing them against the U.S. standards in the field, on paper, and using computer simulations.

The other typefaces studied, all developed for signs, were: British Transit Medium and Bold; DIN Normschrift and Normschrift Condensed; Meta Bold and Heavy; Syntax Bold and Black; Frutiger Bold; Helvetica Bold and Neue Bold; and Gill Sans Bold.

The new typefaces, although originally based on U.S. Standard Highway Series D and E and retaining their proportions, have their own unique character. But what makes them different, in practical rather than aesthetic terms, is considerably more open space. Open space makes them easier to read at night, when the glow of modern reflective materials creates a "halo" of light around each letter. To some, especially older drivers, the result is an unreadable blur.

Driving tests compared the faces on real signs at a Penn State test track. Test drivers were at least 65, and all drove the track in daylight and at night. In the first test, "signs" included three seven-letter place names, each with very different "footprints," stacked on top of each other. Drivers were given a target name, to simulate looking for an unfamiliar destination, and reported its position and when they could read it. A second group of drivers looked at only one of the words used in the first test, without seeing or hearing it first, and reported when they could read it.

Results were striking. Tests showed that, as previous but sometimes ignored tests have indicated, mixed-case fonts were significantly

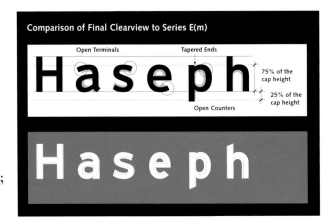

Clearview was originally based on Standard Highway Series D (condensed, all-caps) and E(m) (mixed-case). Unlike the Highway Series faces, which have a consistent stroke-width, Clearview strokes narrow and widen to create larger areas of white space. Other changes, particularly visible in the "e," "a," and "s," keep the letter shape distinct and prevent halation, or fuzzy halos of light, caused by headlights hitting reflective materials.

Design
Meeker & Associates, Larchmont, NY. Donald Meeker, design director; Christopher O'Hara and Harriet Spear, project designers

Consultant
Terminal Design: James Montalbano, final drawing and type engineering

Client
Pennsylvania Transportation Institute, University Park, PA

Research
Pennsylvania Transportation Institute: Martin T. Pietrucha and Philip M. Garvey, principal investigators. The 3M Company: Susan T. Chrysler, human factors consultant

Sponsor
Funded in part by the U.S. Department of Transportation through the Mid-Atlantic Universities Transportation Center

more readable than all-uppercase fonts, at least in word recognition. (The studies replicated previous results that, for reading new words, mixed-case and all-uppercase fonts are equally readable). Clearview was as much as 16 percent more readable at night (14 percent by day) than the existing Highway Gothic fonts in the first study. In the second, Clearview was no more readable by day. But by night, it was up to 22 percent more readable.

What does this mean? By day the new faces perform the same as, or a bit better than, their existing counterparts, and are considerably more attractive. But for night driving, Clearview is clearly superior.

Currently, many states are testing Clearview and Clearview Condensed. Once their test results are in, they too may request approval to use this typeface for highways and road signs. Traffic engineers are getting the hard data they need, and Meeker & Associates has found many willing to accept recommendations for better sign layout, and for presenting messages in both upper- and lower-case letters. The Texas Transportation Institute is testing both faces for freeway signs. And the designers, working with typographer James Montalbano, have created a complete Clearview type family so designers can use it on print materials and smaller signs, as well as road signs.

For designers and planners clamoring for an alternative to U.S. Highway Sign Series B, C, D, E, and E(m), Clearview is a clear winner.

New York Thruway
Fordham Road
Brooklyn Queens
Expressway
Throgsneck Bridge
Grand Central Station

AaBbCcDdEeFfGgHhIiJj
KkLlMmNnOoPpQqRrSs
TtUuVvWwXxYyZz
1234567890

Clearview's regular weight alphabet, displayed here in both cases, reveals its "Highway Gothic" origin. But the new design allows for closer letter spacing than the old Series E(m) face, which also aids in reading.

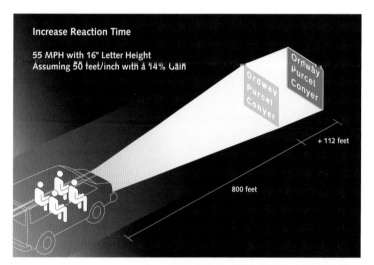

What do study results really mean? When driving in the dark at 55 mph, drivers can read signs in Clearview an average of 112 feet sooner, giving them more time to make decisions. This gain was accomplished without increasing the size of signs, one option transportation engineers are considering to meet the needs of an aging population.

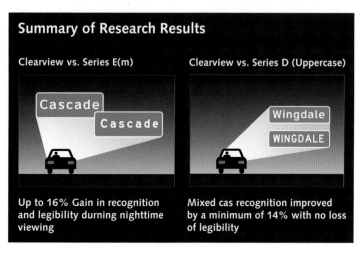

NEW YORK CITY, NY
MID-MANHATTAN GUIDANCE PATHWAY SYSTEM

100 CITY BLOCKS; TWO DISTRICTS; ONE DESIGN-BUILD SIGN SYSTEM

"Just think of us as a really big mall!" says the retailing brochure for two adjacent Manhattan Business Improvement Districts, which work as a team for area businesses. The new Guidance Pathway System created for the 100-city-block area (which includes the Empire State Building, Madison Square Garden, and other famous sites), is another such service. Created as a design-build partnership between two unrelated firms, the new system provides more attractive and comprehensive wayfinding and regulatory information—using 25% fewer signs. It was scheduled for installation in Spring 1998.

Prototypes illustrate the signs' performance on crowded streets. With the redesign the same amount of information, and more, is conveyed with 25% fewer signs.

Design
Gresham, Smith and Partners, Nashville, TN

Client
Grand Central Partnership and 34th St. Partnership

Other planners
New York City Transit, Amsign

Approvals from
New York City Department of Transportation; New York City Metropolitan Transit Authority

Funding
The $1 million sign system was paid for with voluntary taxes generated from the two business improvement districts, which will also pay for the maintenance.

Fabricator
Amsign, South Hadley, MA

Guidance Pathway Sign System

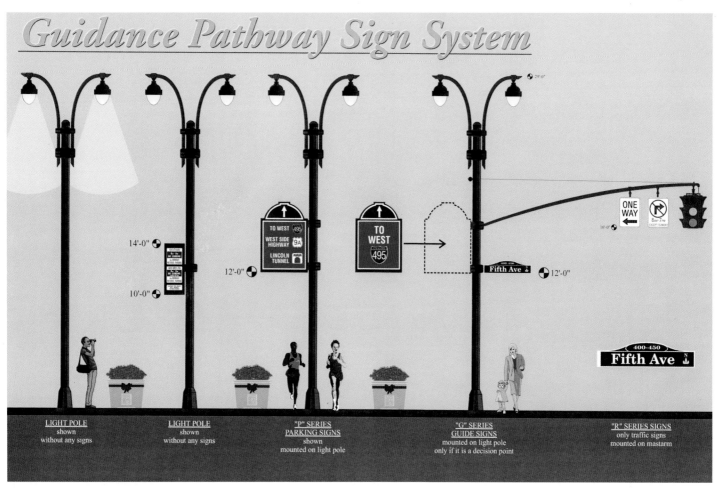

LIGHT POLE	LIGHT POLE	"P" SERIES	"G" SERIES	"R" SERIES SIGNS
shown	shown	PARKING SIGNS	GUIDE SIGNS	only traffic signs
without any signs	without any signs	shown	mounted on light pole	mounted on mastarm
		mounted on light pole	only if it is a decision point	

A number of signs were designed to be hung from new light poles. Distinctive domes top many of the signs, giving them unique and recognizable shapes. Information is consolidated, to take up less space and appear more orderly.

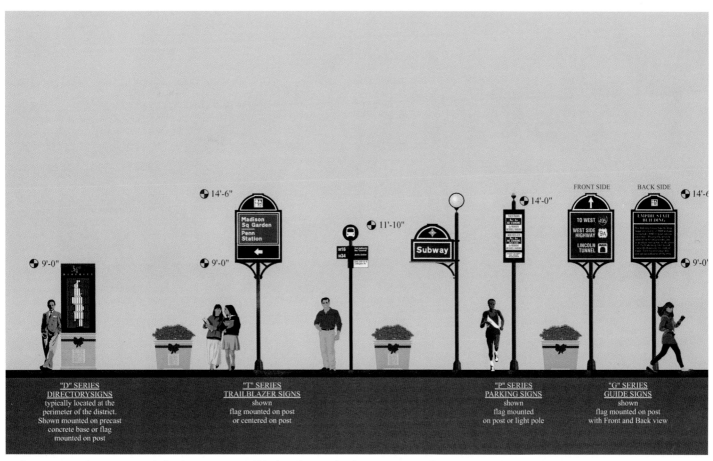

"D" SERIES	"T" SERIES		"P" SERIES	"G" SERIES
DIRECTORY SIGNS	TRAILBLAZER SIGNS		PARKING SIGNS	GUIDE SIGNS
typically located at the	shown		shown	shown
perimeter of the district.	flag mounted on post		flag mounted	flag mounted on post
Shown mounted on precast	or centered on post		on post or light pole	with Front and Back view
concrete base or flag				
mounted on post				

Other signs in the system include directories, trailblazers, bus and subway signs, parking signs, and guide signs. Trailblazers and guide signs share the same shape and same powder-coated steel mounting posts, visually denoting that they give directional and site information.

REGULATORY
CORNER
SECTION

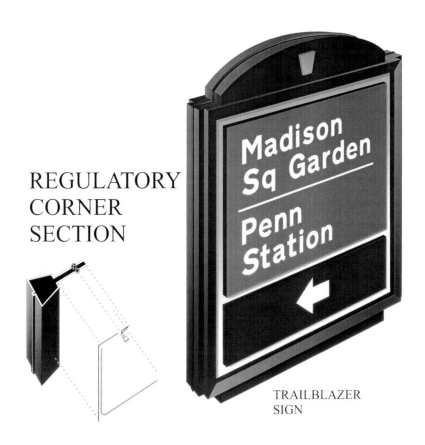

TRAILBLAZER
SIGN

REGULATORY
SIGN

Rather than simple aluminum panels, many guide signs are dimensional. Made of vacuum-formed ABS plastic, the faces are held in frames. Faces are applied reflective vinyl.

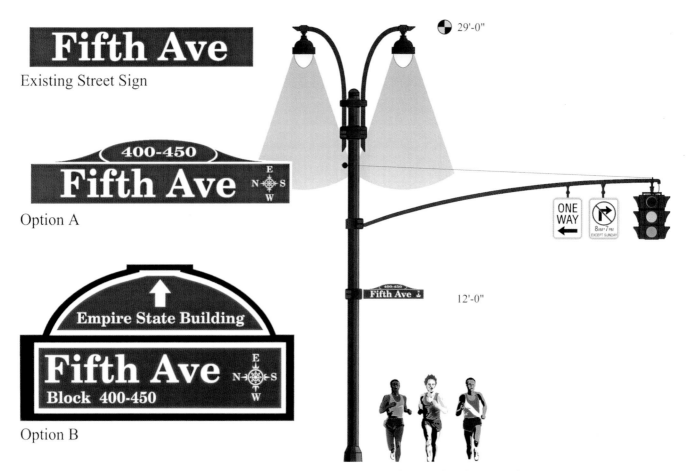

Fifth Ave

Existing Street Sign

400-450
Fifth Ave

Option A

Empire State Building
Fifth Ave
Block 400-450

Option B

29'-0"

12'-0"

Designers created two street sign options, allowing planners to incorporate driver and pedestrian information.

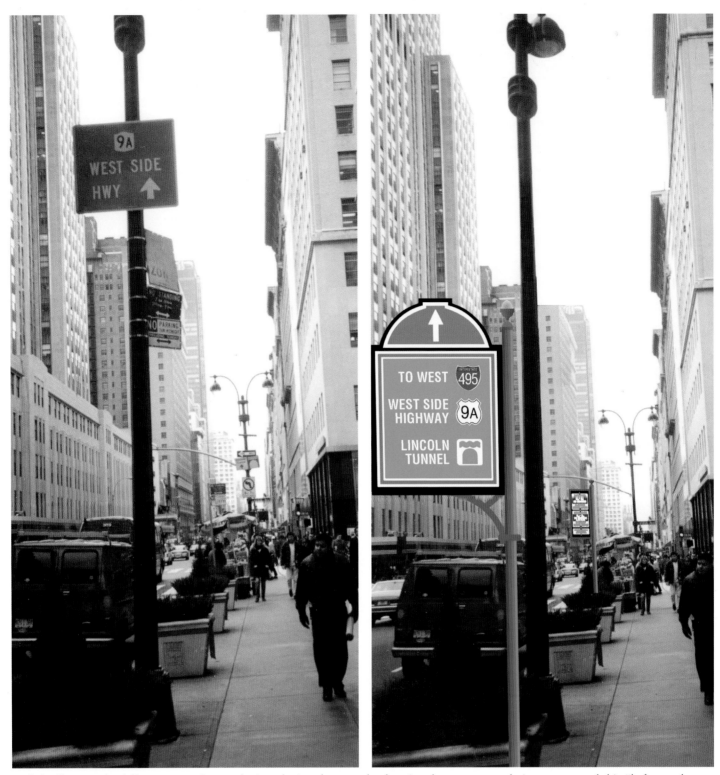

To help illustrate the difference new signs make in reducing clutter and enhancing the streetscape, designers prepared this "before and after" pair—a computer simulation of a (relatively) clutterless vista.

BERKELEY, CA
UNIVERSITY OF CALIFORNIA

CAMPUS SIGN PROGRAM; CLASSIC INSPIRATION; SPURRED CITY PROGRAM

This new sign program combines historic design elements to create a modern look. The $200,000 project encompasses directional and informational signs, as well as graphics guidelines and a new university identity. Designers revived a typeface created by master typographer Frederick Goudy and paired it with the university seal, designed by Tiffany & Co. The resulting identity then drove the design for the rest of the campus-wide system.

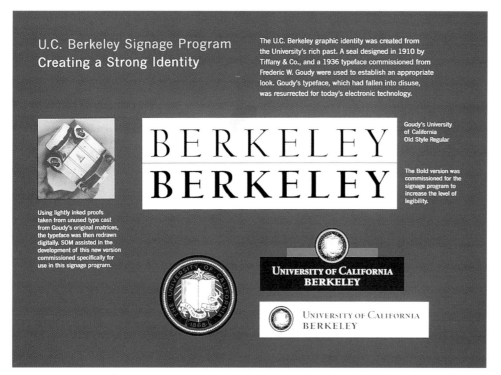

The designers brought back University of California Old Style, a typeface designed by Frederick Goudy in 1936. Pairing it with the university seal, designed by Tiffany & Co. in 1910, they created a modern look firmly rooted in the university's past.

Design
Skidmore, Owings & Merrill LLP, San Francisco; Design team: Lonny Israel, Brad Thomas, Jeremy Regenbogen, John Kriken

Consultants
EDAW; Professor Richard Bender

Clients and co-planners
University of California, Berkeley (Physical and Environmental Planning; Berkeley Publications; Intercollegiate Athletics and Recreational Sports; Transportation and Emergency Planning; Parking and Transportation)

Approvals from
Above and the Campus Design Review Committee

Funding
Each of the above divisions contributed to the sign program guidelines. Parking, Transportation and Emergency Planning also paid for Phase 1 of fabrication and installation. Large maintenance jobs will be contracted out, while the campus sign shop will handle daily maintenance.

Fabricators
LaHue Associates, San Francisco; Von Kohorn & Kitzmiller, Redwood City, CA

Sketches show the wayfinding master plan, including informational and interpretive signs, building and tenant identifications, transportation signs, and maps.

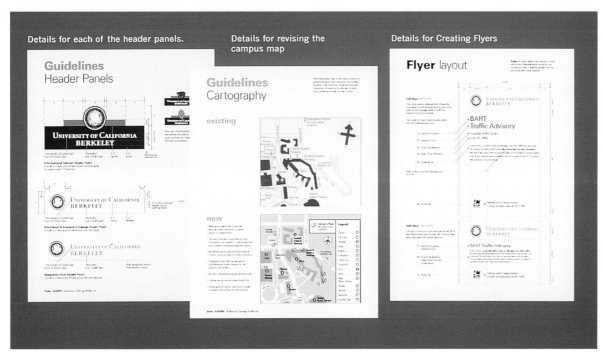

Design guidelines explain how all graphic elements work, providing specifications for signs, maps, and even flyers.

Informational

Sign Type I-5
Used for signing pathways on campus.

Sign Type I-8
Tenant sign or building identification; intended for off-campus facilities which need to be identified with their major tenant and in association with U.C. Berkeley.

Sign Type I-8a
This sign type is to provide additional identification for off-campus properties which already have some signage.

Sign Type I-8b
This sign type is used to identify properties owned by the Regents of the University of California. The intent is to legally identify the property and grant permission to pass.

Sign Type I-10
Used for places of interest and of historical significance to explain the importance of the site.

Sign Type I-5 Sign Type I-5 (alternate)

Sign Type I-8 Sign Type I-8a

The sign hierarchy includes several sign types, shapes, sizes, and colors. Together they form a whole made of many related parts, each with a distinct look.

Sign Type I-8b Sign Type I-10

This sign type identifies off-campus buildings, identifying the major tenant and its affiliation with the university. The blue porcelain enamel signs are ornamented in gold and lettered in white vinyl.

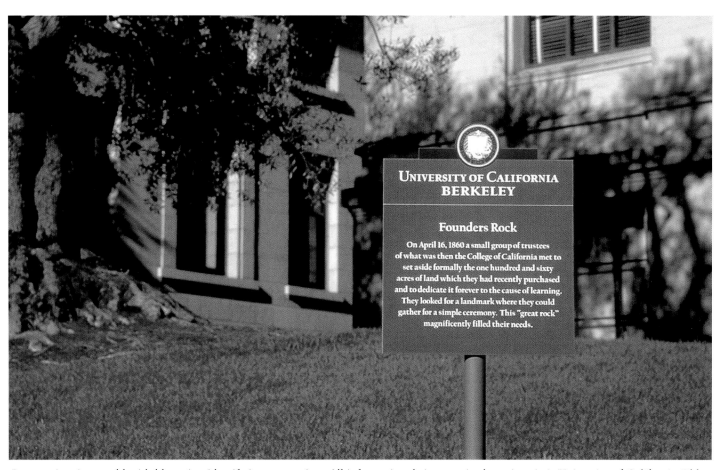

Interpretive signs, gold with blue trim, identify important sites. All informational signs are in the university's University of California Old Style Regular (Goudy's original design) and Bold (created by the designers).

Directional and regulatory signs are simple squares and rectangles, lettered in Univers 55 and 65. Designers used the Goudy face only as an accent, relying on the Univers faces for an "official" look.

BERKELEY, CA
CITY IDENTITY PROGRAM

INSPIRED BY UC BERKELEY; ARTS AND CRAFTS LOOK; THREE PUBLIC MEETINGS

Simplicity was the key to this sign program, which will be maintained by the city's sign shop. The design harmonizes with the new campus sign system for the University of California at Berkeley, particularly in shape and color, and has its own style. The arts and crafts look matches the area's architecture and its primarily residential character. Installation is scheduled for 1998.

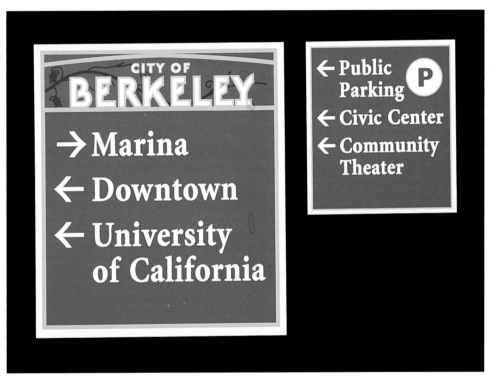

Designers created the letters used in the city's new identity. Other sign text is in Minion, a readable but neutral face that allows the identity's design to dominate. Like the UC Berkeley identification signs, these are blue squares trimmed in a tawny gold.

Design
Skidmore, Owings & Merrill LLP; Design team: Lonny Israel, Steve Townsend, Brad Thomas, John Kriken

Clients
City of Berkeley (Office of the City Manager, Department of Public Works, Department of City Planning)

Other planners
City of Berkeley (Office of the City Manager; Department of Public Works; Department of City Planning; Office of Special Community Services); University of California, Berkeley

Funding
Maintainance and expansions will be handled by the city; initial fabrication and installation will be done by an outside fabricator.

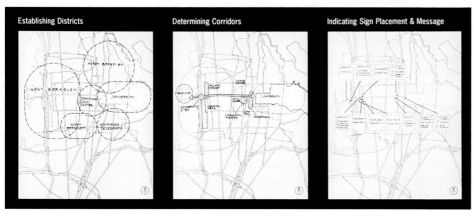

Establishing Districts | **Determining Corridors** | **Indicating Sign Placement & Message**

Designers mapped thearea thoroughly to determine districts, plan traffic corridors, and analyze where signs were needed most.

A. City Gateway /
 Major District Directional Clarify and enhance the sense of entry to the community
B. City Limit from the major arterials and city limits.

C. Major District Directional Initiate ideal routes to specific destinations within the city.

D. Specific Location Directional Encourage a divergence of traffic around areas which are
 burdened with traffic congestion.

E. Parking Directional Encourage a simple pattern of searching for parking in
 the downtown and campus areas.

F. Location Marker (small scale) Enhance the sense of arrival at certain key points of interest.
G. Location Marker (large scale)

H. Regulatory Inform the public of regulations such as crime watch,
 park rules, and drug free zones.

I. Temporary Mark construction/project sites with signs that are part
 of an overall sign family.

Designers created a family of nine sign types, each subtly (or not so subtly) different. All signs are to be made of painted aluminum panels, so that the city's sign shop can make repairs easily.

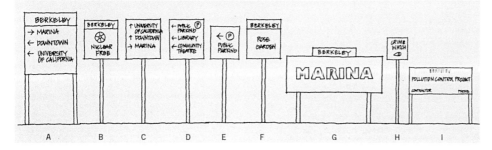

A B C D E F G H I

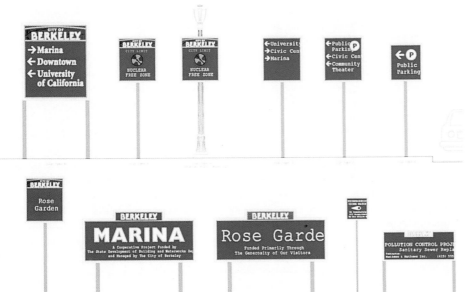

Simple sketches show the types of signs needed for a comprehensive program.

Wayfinding Masterplan

Shown are the conceptual sketches for informational signage—the arriving visitor's first major introduction to the campus. It includes identification information such as street and path names, building identification, and campus maps, to help the visitor whether by car, bus, BART or foot. Incorporated into the informational signage components are safety/protection tips, listing of facility hours, emergency phone numbers, and current events.

Informational

I-1 West Gatehouse
I-2 Bus Shelters
I-3 BART Station,
 Welcome to the Campus
I-4 Campus Maps
I-5 Pathway Names
I-6 Building Names
I-7 On-Campus Building
 Identification
I-8 Primary Off Campus
 Building Identification
I-9 Primary Tenant Name
 Identification
I-10 Interpretative

A standards manual will contain all specifications and design guidelines, so that the city can repair and expand the sign program on its own.

DELAWARE & LEHIGH VALLEY, PA
NATIONAL HERITAGE CORRIDOR

PRIVATE, STATE AND FEDERAL GRANTS; TOWN BY TOWN IMPLEMENTATION

The 150-mile Delaware & Lehigh Valley National Heritage Corridor in Pennsylvania includes historic canals, scenic lakes, the Pocano mountains, museums, cultural centers, and parks. To encourage better signs throughout the area, the Delaware and Lehigh Navigation Canal National Heritage Corridor Commission eliminated the difficult planning step. Together with representatives from federal, state, and local agencies, it worked with designers to create standard directional, interpretive, and identification signs. Municipalities can choose the elements that fit their needs and use the standard specifications to order signs from any vendor. Easton, home of the Crayola Crayon factory, was the first town to adopt the signs.

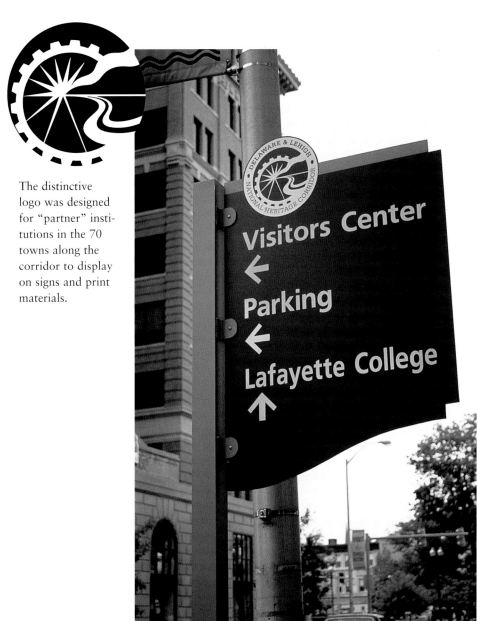

The distinctive logo was designed for "partner" institutions in the 70 towns along the corridor to display on signs and print materials.

Easton, PA, home of the Crayola Crayon factory, was the first town on the Corridor to implement the signs.

Design
Cloud + Gehshan Associates, Inc., Philadelphia

Client
The Delaware and Lehigh Navigation Canal National Heritage Corridor, Bethlehem, PA

Other planners
The Pennsylvania Department of Transportation; Historic Fallsington, Inc.; Carbon County Department of Parks and Recreation; National Park Service; Pocono Mountains Vacation Bureau; Pennsylvania Bureau of State Parks; Pennsylvania Anthracite Museum Complex; South Bethlehem Historical Society; Pennsylvania Department of Community Affairs; Friends of the Delaware Canal; Carter Van Dyke Associates; Lehigh County Historical Society

Approvals from
Above

Funding
Design was paid for with grants from the National Endowment for the Arts; the Pennsylvania Heritage Parks Program; Friends of the Delaware Canal; and the Delaware and Lehigh Navigation Canal National Heritage Corridor Commission. Signs will be purchased and maintained by each town.

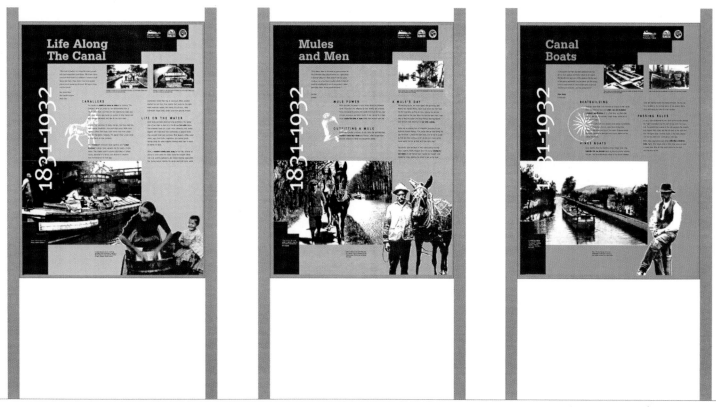

"High profile" interpretive panels present large amounts of information or graphics. Standards include type and coatings specifications.

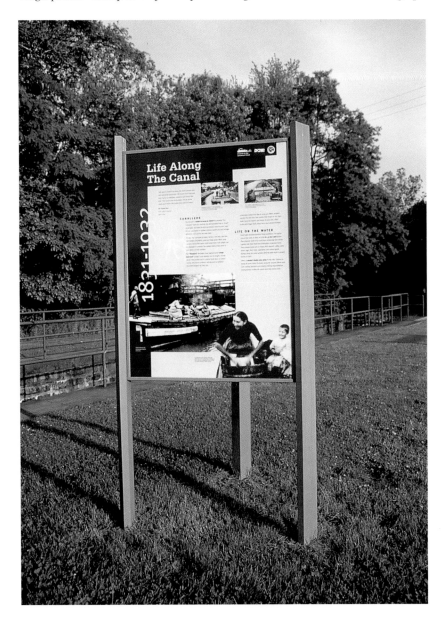

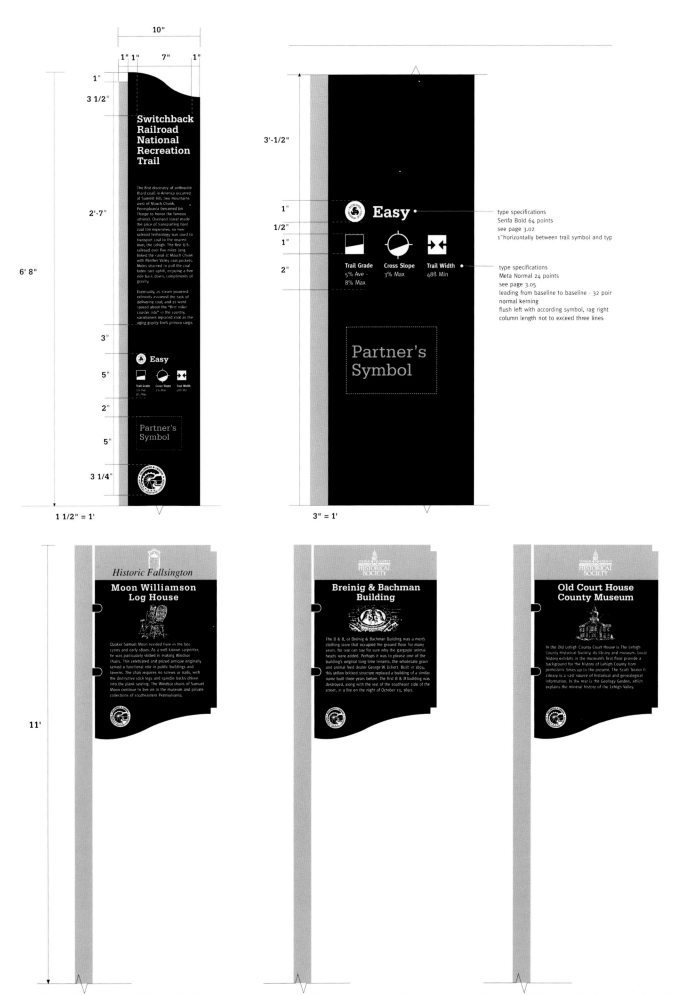

A complete system of directional signs allows towns and institutions to choose the ones they need. The standards manual explains when and how each sign type is to be used. Two complementary type families, Serifa and Meta, are specified throughout the system.

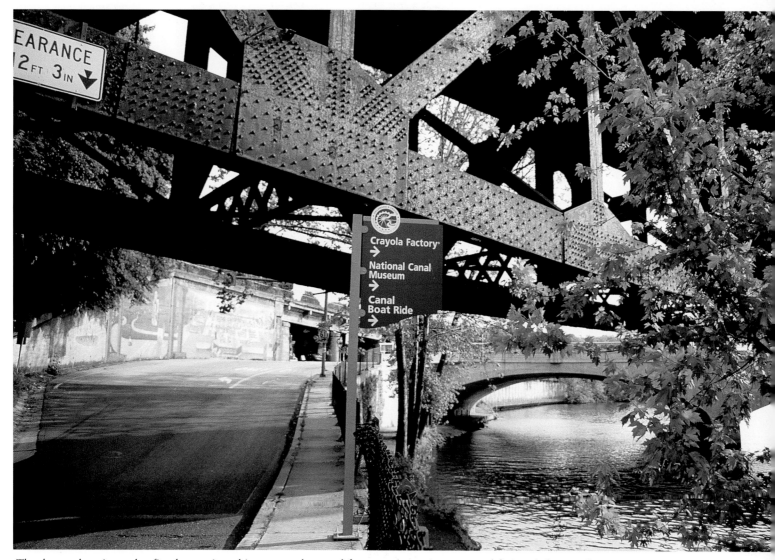

The deep red project color fits the area's architecture and natural features. Attractive posts and fittings help give the program a contemporary, neat look.

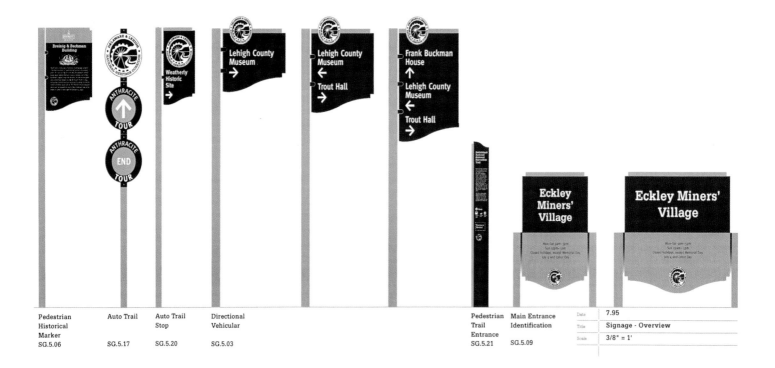

Pedestrian Historical Marker SG.5.06	Auto Trail SG.5.17	Auto Trail Stop SG.5.20	Directional Vehicular SG.5.03		Pedestrian Trail Entrance SG.5.21	Main Entrance Identification SG.5.09	

Date	7.95
Title	Signage - Overview
Scale	3/8" = 1'

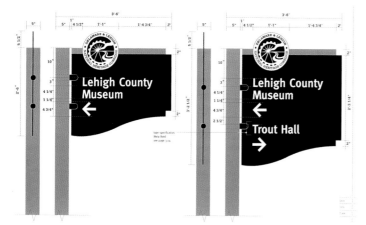

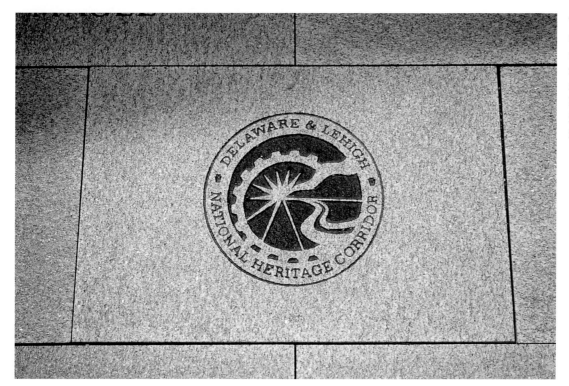

The National Heritage Corridor must approve all uses of the logo. This gives towns and institutions room to innovate—as Easton did when etching it in stone—while still retaining some control.

Easton used both types of interpretive graphics. The smaller, "low-profile" signs were created for use at historical sites, where large signs would be distracting.

CINCINNATI, OH
PARKING PROGRAMS

ADVERTISING PARKING; EMPHASIZING PRICE

Parking is a persistant problem for cities. Cincinnati has adopted a variety of strategies to combat the widespread belief that the city has no available parking. Programs such as a "$1 first three hours" plan at public garages and ten minutes of free parking at meters have been heavily promoted with advertising, free leaflets, and colorful signs. Graphic programs are now extending to various city neighborhoods, with signs being modified to fit their architecture.

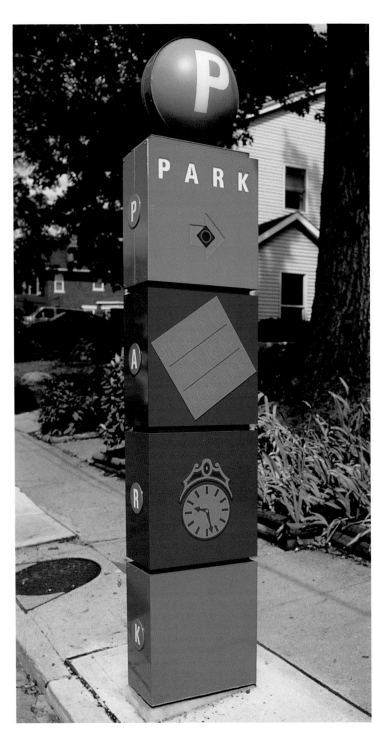

Parking signs are now being adopted outside the central business district. This sign for an upscale neighborhood expands on the basic design.

Design
City of Cincinnati Office of Architecture and Urban Design, Graphic Design Team. Marcia Shortt, design director; Laura Martin, Lucy Cossentino, Laura Curran, designers

Consultant
City of Cincinnati Engineering Division

Client
City of Cincinnati

Other planners
City of Cincinnati (Departments of Public Works, Economic Development, Parking Facilities, City Planning, Traffic Engineering, Highways)

Approvals from
Above

Funding
Design and fabrication funds came from a city capital improvement program. Signs were free to city garages, which agreed to maintain them.

Fabricators
United Sign Co.; Meyer Sign Co.; Signs & Blanks

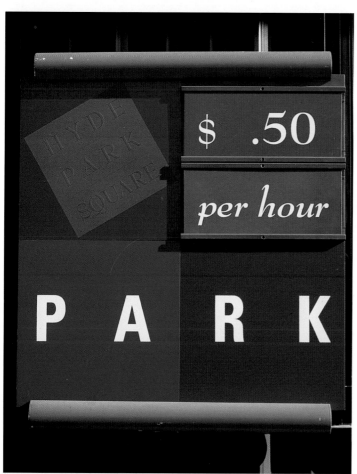

This rate sign matches the parking pylon in color and detail, but doesn't depart from the downtown sign look.

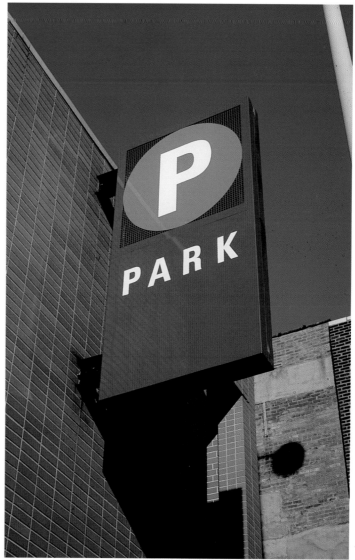

New, non-illuminated signs give public garages a fresh look at a small price.

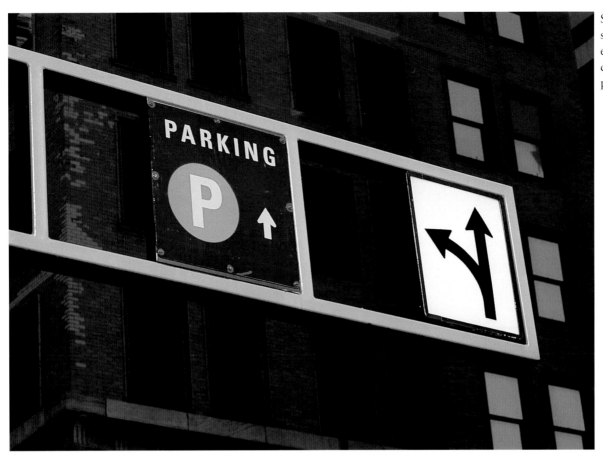

Simple parking signs added to existing systems direct drivers to public garages.

Stickers on meters explain how to park free for 10 minutes, a program designed to help motorists with quick errands.

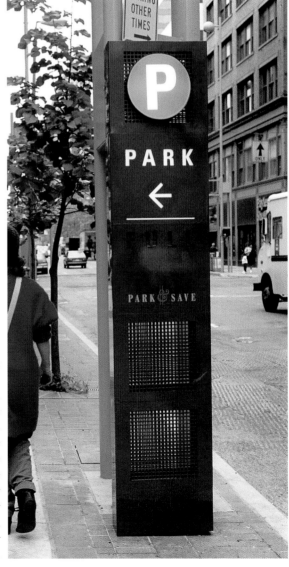

Private garages received parking pylons at no charge, in exchange for agreeing to maintain them. A $3,200 value ($2,600 without the light-up "full" message), the signs coordinate with pylons for the city's elevated skywalk, and are mounted on sidewalks. Signs were designed with room for other graphics such as this sticker for Park & Save program, a coupon program in which retailers offer rebates for certain garages.

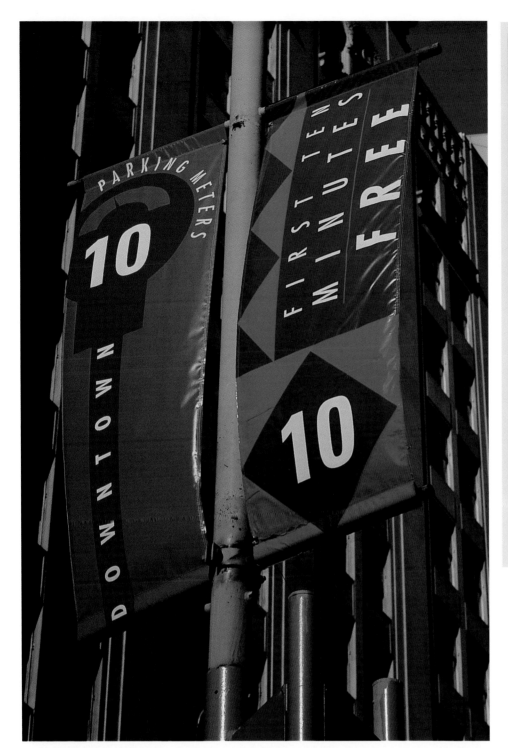

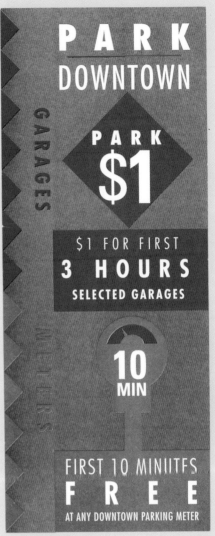

PARK FIRST 3 HOURS FOR $1 IN THESE GARAGES:

1 **Lazarus Garage**
Seventh and Elm Streets

2 **The Gramercy Garage**
Seventh Street near Lazarus and Petersen's

3 **The Garfield Garage**
Ninth Street near the Main Library

4 **The Parkade Garage**
Sixth and Race Streets

5 **Fountain Square North**
Under Fountain Square

6 **Fountain Square South**
South of the Westin Hotel Garage

These six garages also offer a special rate of $2 or less after 5 p.m. You can also ask your favorite retailer for "Park & Save" coupons redeemable for $1 at most downtown parking areas. The coupons give you free parking for up to 3 hours at these six facilities. **Plus, park free for 10 minutes at any downtown parking meter; just turn the handle!** And please remember to lock your car and put valuables out of sight.

Decorative banners and sign toppers advertise a $1 for three hours program at the city's six public garages. Advertisements and leaflets promote discount parking plans developed to bring shoppers downtown.

CINCINNATI, OH
QUEEN CITY TOUR

A LABOR OF LOVE; DESIGNERS PAINT BOLTS

Citizen Caroline Taylor began the self-directed Queen City Tour in 1968, and it was redesigned in 1978. Now in her 70s, Taylor convened the first planning meeting for the second redesign and attended every meeting for the next two years. About a dozen planners from area cities and institutions helped plan the tour, which promotes the area's history and neighborhoods. Tourists buy spiral-bound guidebooks and choose their routes. Simple aluminum signs bearing the Queen City Tour logo mark the streets. Several additional tours are being planned; they will have the same logo but different project colors.

The entire Queen City Tour takes drivers through three cities in two states. Tourists can also choose smaller mini-tours of particular areas or neighborhoods.

Design
City of Cincinnati Office of Architecture and Urban Design, Graphic Design Team. Marcia Shortt, design director; Laura Martin, designer

Consultant
Judson Engels, cartography

Original Queen City Tour
Caroline TaylorJ

Clients
City of Cincinnati; City of Covington, KY; City of Newport, KY; Greater Cincinnati Convention and Visitors Bureau; Northern Kentucky Convention and Visitors Bureau; Cincinnati Preservation Association; Cincinnati Museum Center/Cincinnati Historical Society

Other planners
The Queen City Tour Committee (representatives of all agencies listed above)

Approvals from
All agencies above

Funding
The redesign and new signs were paid for in part by the three cities involved, and in part by donations from The Greater Cincinnati Foundation, The Northern Kentucky Convention and Visitors Bureau, and Dan Pinger Public Relations. Maintenance will be paid for by sales of the tourbook.

Fabricator
City of Cincinnati

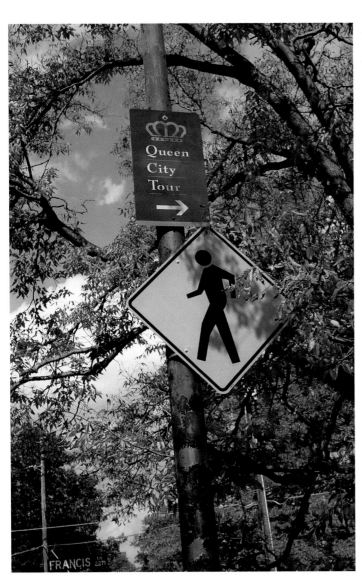

Many of the tour's signs, last updated in 1978, were missing. Those left were often too faded to read. New signs are bright, readable, and inexpensive. Made of aluminum with vinyl film and durable screen-printing inks, the 165 signs cost less than $5,000 to make and install.

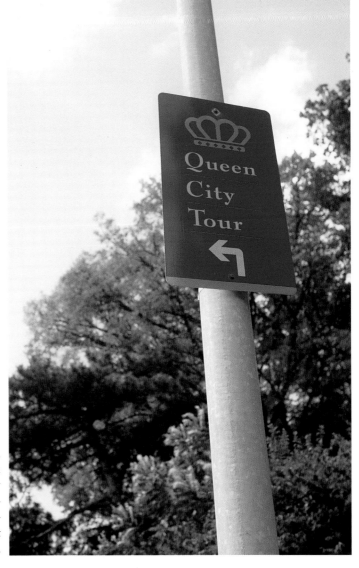

Designers insisted that the signs be bolted, and that the top bolt be threaded through the crown's diamond. The highway department agreed but wanted to use silver bolts, so the designers asked for mustard jars full of the purple and gold paint and painted the bolts themselves.

Made to fit into map-stands, the narrow spiral-bound book is easy to refer to while driving or navigating. The cover features the project logo, a golden crown on a purple ground, re-drawn for the update.

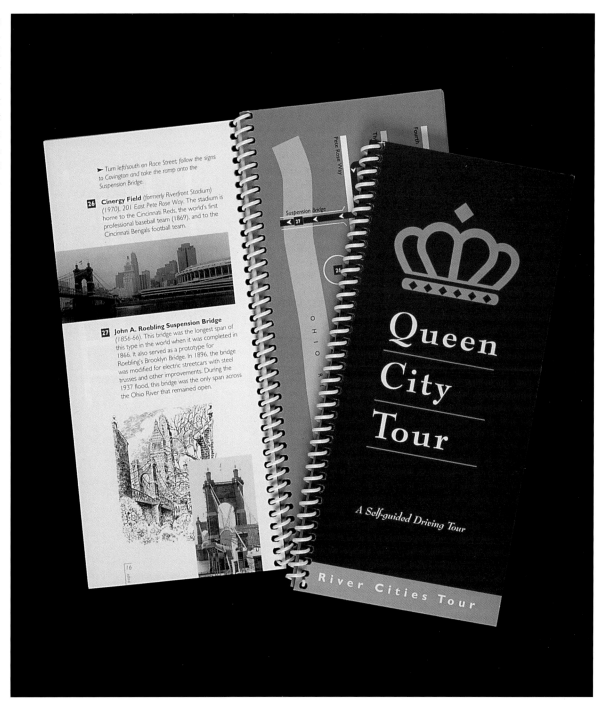

The original Queen City Tour logo, designed in 1968, featured a white crown on a purple background.

54 **York Street Historic District,** *York Street between Seventh and Tenth Streets.* This area was a fashionable residential area in the mid-19th century for prominent local businessmen and public officials. The district includes a former Masonic hall, several churches and stately residences, many of which have been converted to business or cultural uses.

Worth-a-Stop

➤ *Turn left on Ninth Street and continue for seven blocks to Overton. (Do **not** turn on Monmouth Street.)*

55 **Monmouth Street Historic District,** *Monmouth Street between Third and Tenth Streets.* The Monmouth Street business district has historically been Newport's commercial center. In its prime, the district was one of the largest and most popular shopping districts in Greater Cincinnati known for its wide array of stores including clothing, jewelry and furniture establishments.

➤ *Turn left onto Overton Street through the East Row Historic District.*

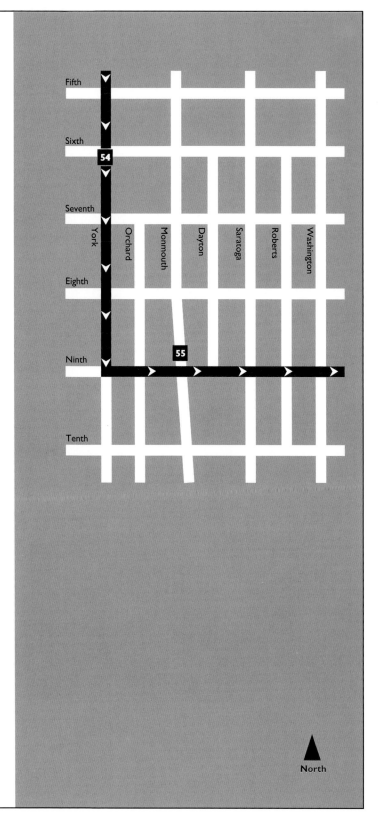

North

LEON SPRINGS, TX
THE DOMINION

PRIVATE DEVELOPMENT; "PUBLIC" SIGNS

E legant hand-carved stone, glazed tile, and photo-etched bronze signs fit the Renaissance-style architecture of this private residential community. The exclusive 3,000-acre development includes private tennis courts, a swim club, an aerobics center, and a country club with a golf course. Rather than using aluminum pole signs for regulatory information, developers commissioned signs that try hard to be pieces of art. Each system was commissioned and designed separately. A matching system of interior etched and paint-filled bronze plaques completes the project.

Design
Geoffrey Scott and Associates, Santa Monica, CA

Clients
The Dominion Development; The Dominion Country Club

Funding
Design and fabrication were funded by the developer. Maintenance will be performed by The Dominion Maintainance and Grounds Department, with funds from The Dominion Homeowners Associations.

Fabricator
Intex

Photos
Hugo Rojas Photography, Los Angeles

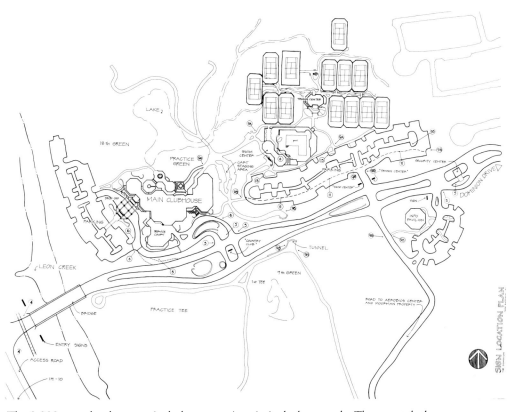

The 3,000-acre development includes many signs in its lush grounds. These match the Renaissance Revival architectural style established by the "public" architecture (country club, swim center, etc.) as well as the aesthetic expectations of the homeowners.

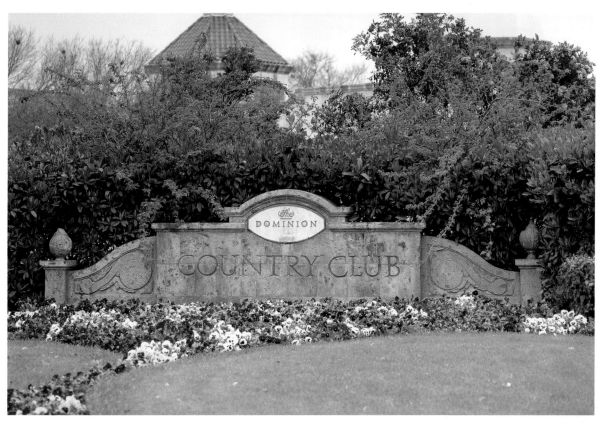

Large monument signs at the development's entry, country club, swim center and visitor's pavilion are made of hand-carved canterra stone. Renaissance motifs and shapes were chosen to match the architecture.

Designers created a custom system of icons for interior plaques and exterior signs.

Cast bronze identification plaques are faux-finished for an elegant, weathered look.

Regulatory sign faces, made of ceramic tile, were screenprinted before glazing. This creates an elegant look and creates indelible messages. Cast-metal bases complete the look.

Secondary identification signs retain the monumental look while eschewing ornamental detail. The project typeface, Augustae, has the look of ancient Roman script.

ST. LOUIS, MO
METROLINK

RELATED PROJECTS; MULTIPLE CLIENTS

Designers originally created the logo, graphic identity, and signs for St. Louis's new light rail system, which began operating in 1993. In a related project, they also created an innovative donor wall. When the system began rapid expansion only five years later, it needed better, clearer graphics. The designers were called back to create improved wayfinding, route and mapping graphics, a comprehensive sign system, decorative metal "banners," and vehicle graphics. All will be used on new signs, and will gradually be retrofit to existing signs.

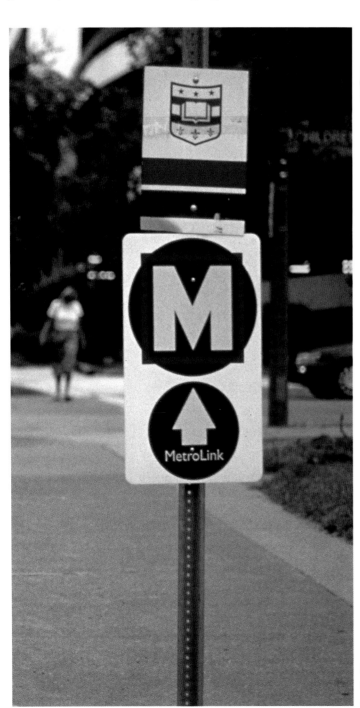

Simple transit signs blend into the existing St. Louis streetscape.

Design
Kiku Obata & Co., St. Louis

SIGNS

Clients
The Bi-State Development Agency; Arts in Transit

Other planners
MetroLink Engineering and Design; Paratransit (ADA committee); Customer Service; Facilities Maintenance

Approvals from
Bi-State Development Agency; St. Clair County Transit District; City of St. Louis Heritage and Urban Design

Funding
Signs were paid for with Federal Transportation Authority funds, and will be maintained by the Bi-State Development Agency's Facilities Management Department.

Fabricator
Engraphix

METROLINK BANNER SYSTEM

Clients
Bi-State Development Agency; Art in Transit

Other planners
MetroLink (Engineering and Design, Customer Service) Bi-State Development Agency Facilities Maintainance Department; Paratransit (ADA committee)

Approvals from
Bi-State Development Agency; St. Clair County Transit District; City of St. Louis Heritage and Urban Design

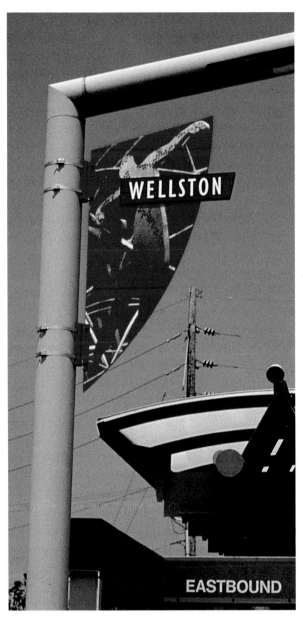

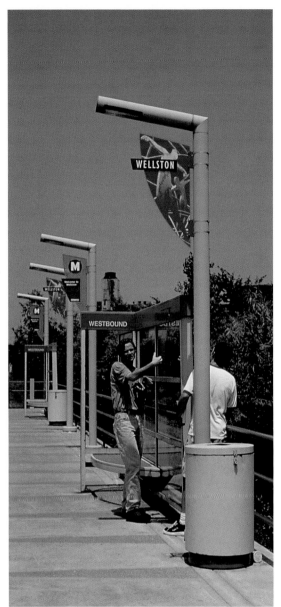

Banners are made of painted, perforated aluminum. Changeable plastic panels are used for custom, temporary messages.

Designed to beautify station stops, the MetroLink "banners" look equally attractive on platforms or among landscaping. They were first installed at this station, located in a depressed area, as part of a redevelopment effort. They will be included in all new stations.

Funding
Banners were paid for with funds from the Federal Transportation Administration, and will be maintained by the Bi-State Development Agency.

Fabricator
Star Signs, Lawrence, KS

WALL-OF-FAME
Design
Kiku Obata & Co.: Pam Bliss and Amy Knopf, designers

Client
Citizens for Modern Transit

Other planners
Citizens for Modern Transit; Bi-State Development Agency; Downtown St. Louis Inc.

Approvals from
Citizens for Modern Transit

Funding
Sponsors paid for the wall with their contributions to a marketing campaign designed to sell the new light rail system to potential riders.

Fabricators
Pioneer Porcelain Enamel, Seattle; Engraphix, St. Louis (installation)

Photos
Cheryl Ungar, Denver

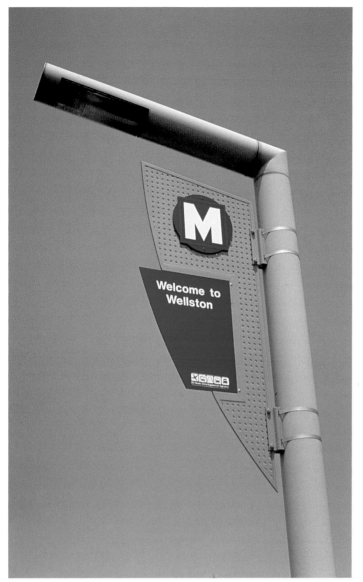

Designed to look like trolley and subway tokens, round porcelain enamel disks are printed with donor names. Three sizes of tokens donate three gift levels for both corporate and individual gifts. Donors also received tickets to a kickoff gala and seats on the first car to run on the MetroLink line.

Station signs are made of screenprinted aluminum.

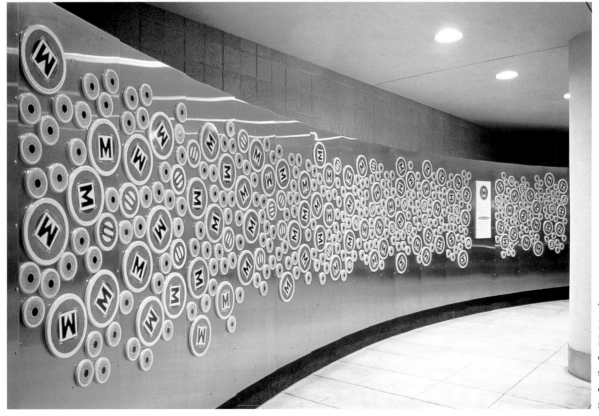

The curving MetroLink Wall of Fame, prominently displayed in a tunnel stop, commemorates donors to the system's marketing campaign.

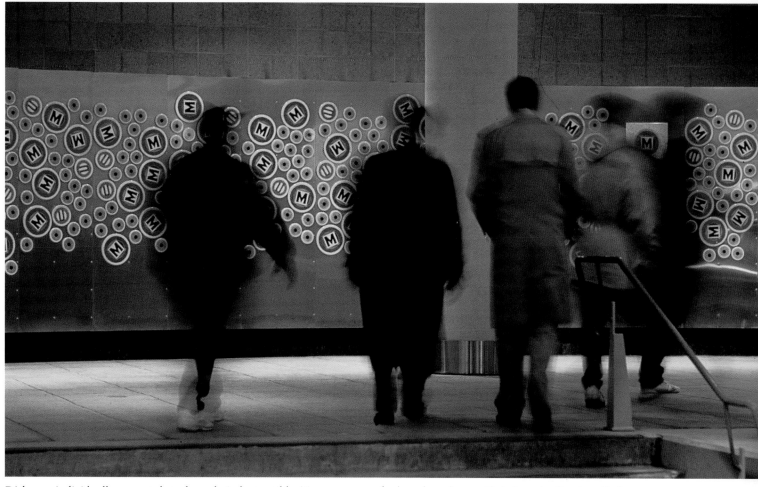

Disks are individually mounted, and nearly indestructible. Two new sets of tokens have been added since the first installation.

Existing kiosks will be retrofitted with new, more attractive and functional faces. These will include Braille panels, a redesigned map, and blue bands crowning and underlining the structures.

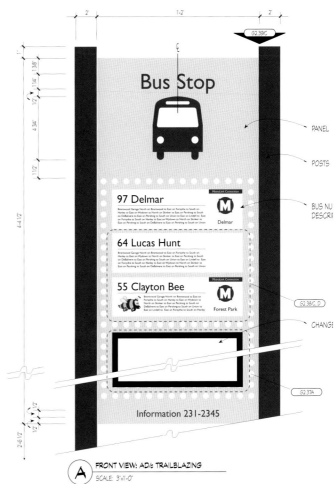

Station wayfinding signs combine directional arrows with standard transportation line-maps. Station icons, used when MetroLink opened, were abandoned because there would be far too many as the system expanded. To improve legibility, designers replaced Palatino, used for station identification, with Palatino Bold, and changed messages from all-caps to mixed-case. They also standardized Gill Sans, the official MetroLink type, to Book weight, and adopted Meta, which had been introduced on ticket vending machines, for all information messages.

Pedestrian trailblazers will be simple aluminum post and panel signs painted to look like perforated metal. Their complex messages will be displayed in attractive and functional units.

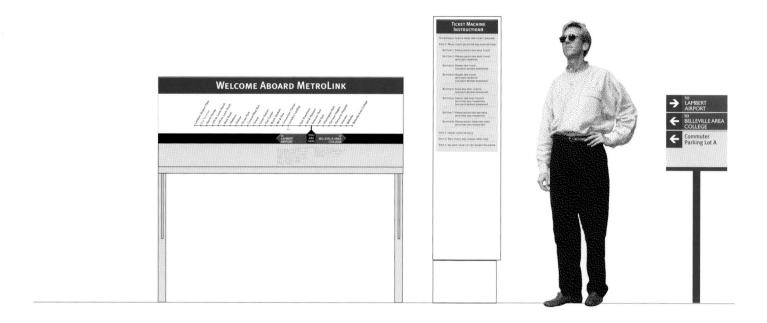

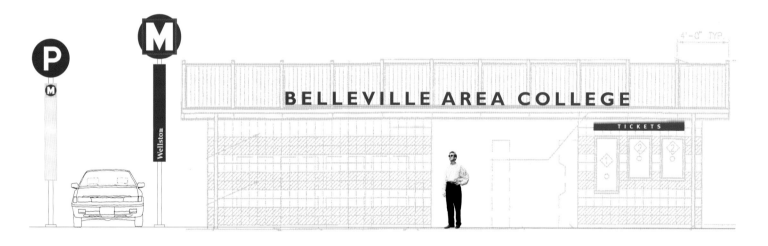

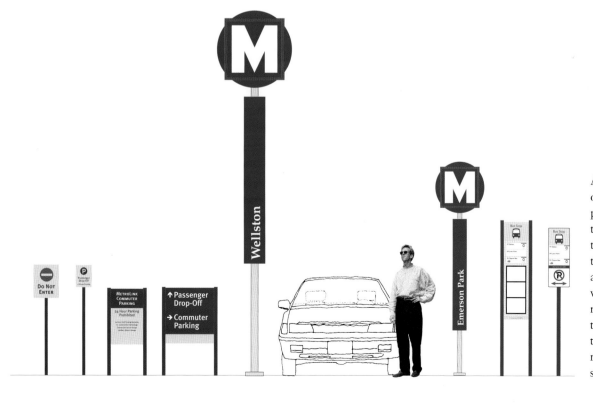

A complete hierarchy of signs will direct people every step of their journey from their cars to their destinations. Simple, bold and colorful, the signs will be gradually retrofitted to existing transit signs, making the system easier for riders to use without starting from scratch.

CULVER CITY, CA
EAST WASHINGTON BOULEVARD STREETSCAPE

FIVE YEARS; SEVEN HEARINGS AND WORKSHOPS

The graphics alone for this streetscape enhancement project for the Culver City's major street cost nearly $6 million to design and build. Installed in 1998, the graphics make massive contributions to the landscape with their sheer bulk, as well as their confident colors. The new streetscape makes the bold statement that Culver City, once considered in decline, is back and has big plans for the future.

This preliminary rendering shows the "Sky Gallery," a system of permanent metal skeletons designed to hold printed art banners paid for by sponsoring corporations. It will be built in Phase II.

Design
Sussman/Prejza & Co. Inc., Culver City, CA

Other design
Parsons Transportation Group (civil engineering); Campbell & Campbell (landscape architects); Ove Arup & Partners (structural engineering and lighting)

Consultants
CBM Consulting Inc (project management); CMI (construction management)

Clients
Parsons Transportation Group (Barton-Aschman Associates Inc.); Culver City Redevelopment Agency

Additional planners
Culver City community; Culver City Redevelopment Agency

Approvals from
Culver City Redevelopment Agency, Los Angeles County Department of Public Works; Los Angeles Metropolitan Transportation Authority; U.S. Army Corps of Engineers; Culver City Council

Funding
The project was paid for with funds from the Culver City Redevelopment Agency and sewer department, and from Los Angeles County. It will be maintained by the city.

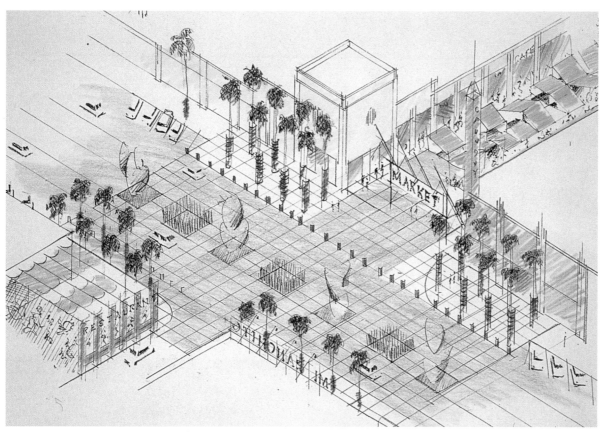

An aerial-view rendering of major intersections shows many streetscape improvements, including plantings and tree cages.

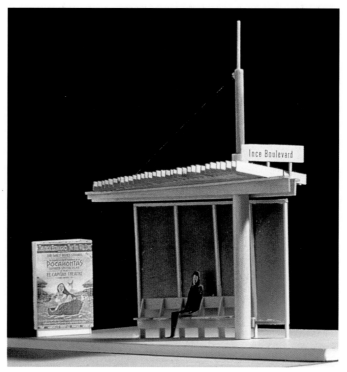

A scale model of a distinctive bus shelter demonstrates its scale and dimensions.

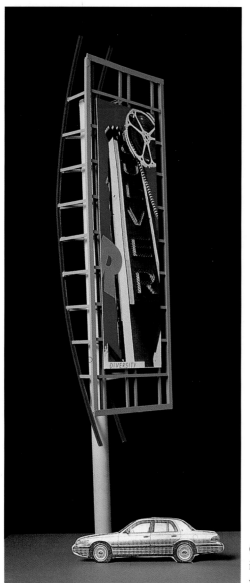

Computer renderings add color as well as scale.

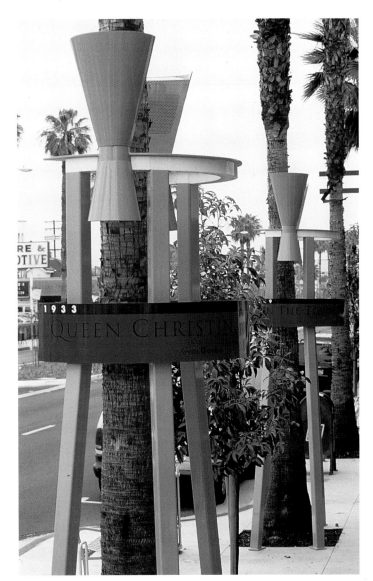

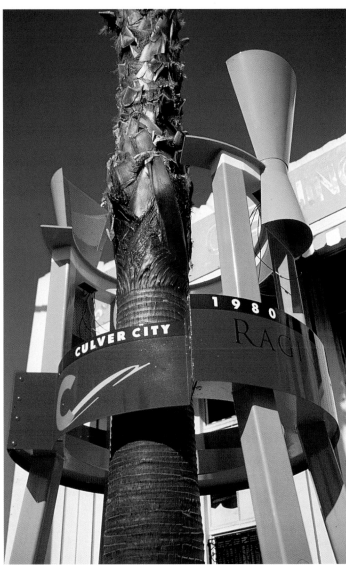

Finished tree surrounds are fat, tall, and bright yellow. Red and black rings name classic films made in Culver City, and identify their stars, directors, and the years they were made. At night, the sconces shine down as well as up, creating warm pillars of light.

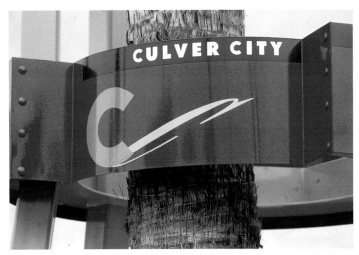

The new city identity appears, recessed in a break in each ring. The identity uses Futura Bold and Extra Bold, while the film information is presented in Futura (most text), Trajan (film titles) and Snell Roundhand (first names).

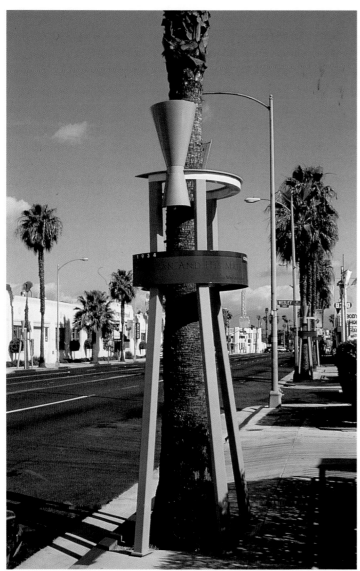

The Culver City logo is meant to suggest both movie lights and car headlights, two California staples.

While each tree surround towers far above pedestrians, on the broad avenue and beneath the immense trees they appear small and neat.

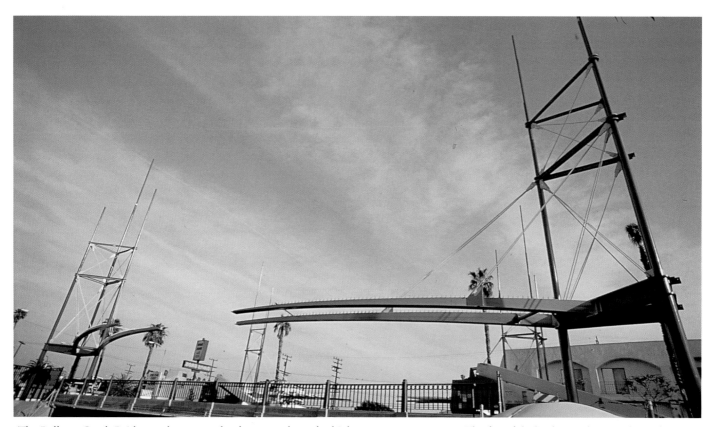

The Ballona Creek Bridge sculpture marks the spot where the highway crosses a stream. The fanciful "bridge" is lit at night with tivoli lights.

SAN JOSE, CA
GUADALUPE RIVER WALK & GARDENS

LINEAR PARK; NO BOUNDARIES; LACK OF DIRECTION

The three-mile Guadalupe River Walk & Gardens, a linear park, lacked clear boundaries. It was easy for users who left the streets for its landscaped trail to lose track of where they were. Designers solved these problems elegantly with mosaic compasses and cast bronze directional plaques, both embedded in the concrete, and with metal letters added to the numerous bridge crossings that lead to and from the park. A second phase of the project, currently on hold until funds are available, will include interpretive graphics explaining the area's history and wildlife.

GUADALUPE
RIVER PARK
& GARDENS

The project typeface, Mantinia, was chosen for its organic forms and small-cap combinations, which complement the park's classic design.

Design
Landor Associates, San Francisco. Scott Drummond, creative director; Jean Loo, senior designer; David Rockwell and David Garcia, designers

Client
The Redevelopment Agency of San Jose

Approvals from
The Redevelopment Agency of San Jose; Guadalupe River Park & Gardens Technical Committee and Task Force

Funding
The project was paid for with funds from the Redevelopment Agency's capital improvements budget, which come from tax money. It will be maintained by the city's Department of Conventions, Arts & Entertainment.

Fabricators
Marinelli Environmental Graphics, San Francisco; Archetile, San Francisco; Princeton Welding, Half Moon Bay, CA; All American Tile and Terrazzo, Richmond, CA; La Haye Bronze, Corona, CA; Artworks Foundry, Berkeley, CA

Photos
Mark Johann Photography, San Francisco

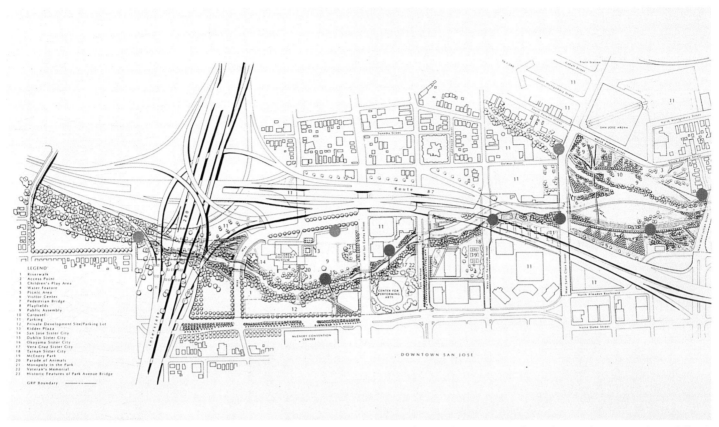

The linear park runs through downtown San Jose. Its careful landscaping provides a welcome respite from the city, but can make it difficult for users to tell where they are.

Cast bronze letters mounted to bridge railings announce the park entry to drivers. As they age, the letters' patina will make them stand out further from their surroundings.

Compasses of mosaic tile and cast-bronze letters, set into marble terrazzo, will last for many years. Placed by entrances, they direct visitors into the park.

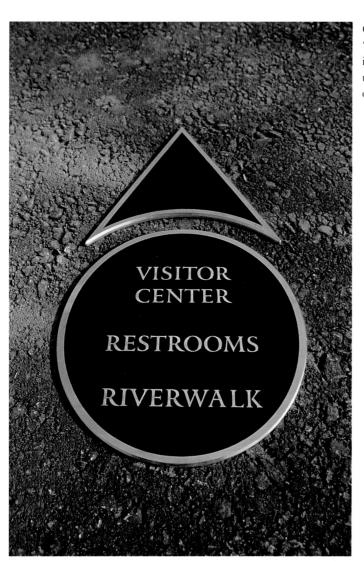

Cast bronze directional "medallions" embedded in the pavement help users find their way without obstructing views.

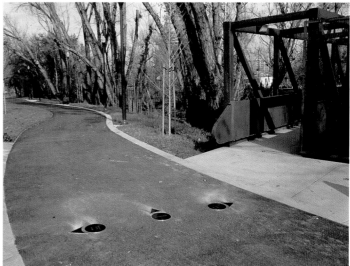

Freestanding trellises, made of waterjet-cut aluminum, identify park destinations. Disguised as park furniture, they do not register as signs.

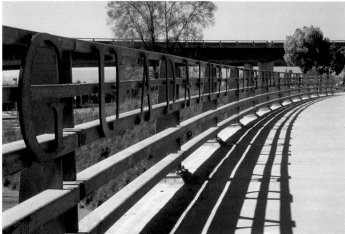

Two large round compasses, made of the same materials used for the smaller square ones, are located near the river. Major destinations are set into their marble terrazzo boarders with cast bronze letters.

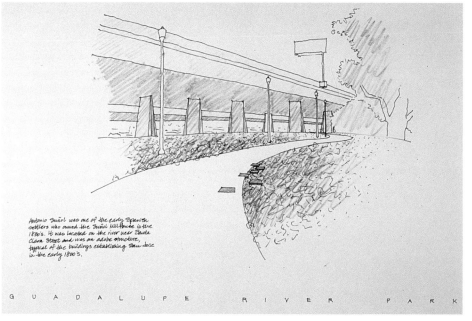

Antonio Suñol was one of the early Spanish settlers who owned the Suñol Millhouse in the 1830's. It was located on the river near Santa Clara Street and was an adobe structure, typical of the buildings establishing San Jose in the early 1800's.

GUADALUPE RIVER PARK

Interpretive graphics and displays planned for the project's second phase include a topographical relief map of the river, which visitors can walk or play on, and inlaid stones marking the sites of vanished roads or buildings.

SANTA MONICA, CA
IDENTITY PROGRAM

EXTENSIVE RESEARCH; MANY PUBLIC MEETINGS

The new identity, commissioned in 1994, represents Santa Monica both literally and figuratively. It's based on the area's natural features, as well as its reputation as an upscale, progressive, and artistic city. Designers created many applications, especially in directional signs and fleet graphics, then created a related look for the city's bus system.

The city's new symbol was based on its existing seal, which the designers distilled into three elements: sun, sea and shore. A bright color palette and a combination of classic typefaces (Bodoni and Frutiger) complete the look.

Design
Sussman/Prejza & Co., Inc.

Client
City of Santa Monica

Additional planning
City of Santa Monica, City of Santa Monica Big Blue Bus

Approvals from
City of Santa Monica

Funding
The ongoing project is funded and maintained by the City of Santa Monica.

Fabricators
Zumar Industries Inc., Los Angeles (street signs); Trendmark, La Mirada, CA (bus graphics)

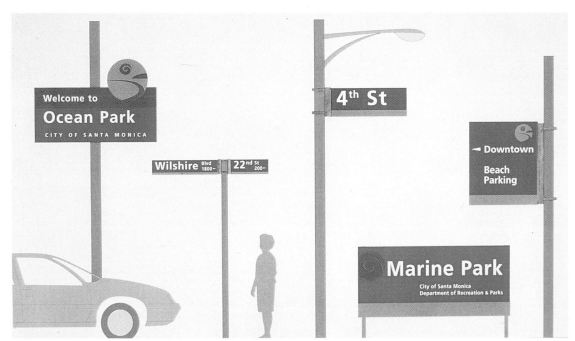

For the new sign system, designers modified the colors used for print graphics, deepening some to provide higher contrast so they'd be legible from greater distances and at driving speeds. Directional signs are blue, underlined with bright yellow bands.

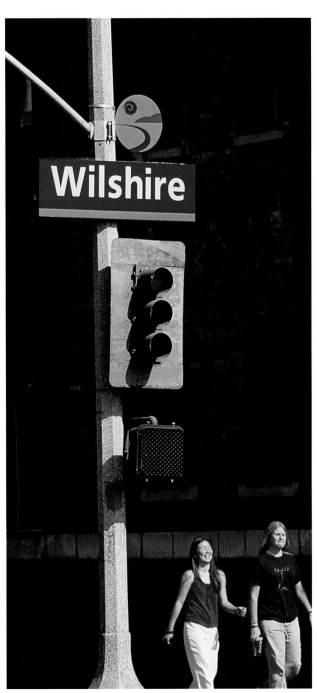

Some applications need alternate colors. On these two city vehicles, the seal has a blue background.

Street signs at major intersections are center-mounted. Circular panels depicting the city logo are mounted separately above them.

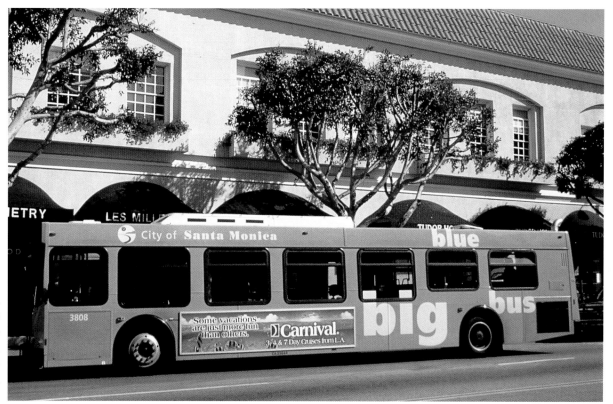

Designers created a new look for the city's "Big Blue Bus" system. Here, the city's logo appears with a white background.

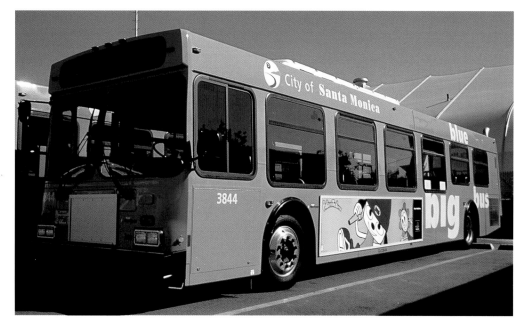

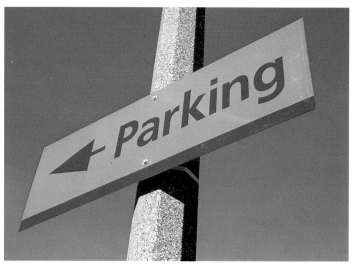

Blue and white signs with ornamental gold bands are attractive by day and, thanks to retro-reflective vinyl, more visible by night. Parking signs reverse the color scheme.

The standards manual helps city employees use the identity—a major investment—correctly.

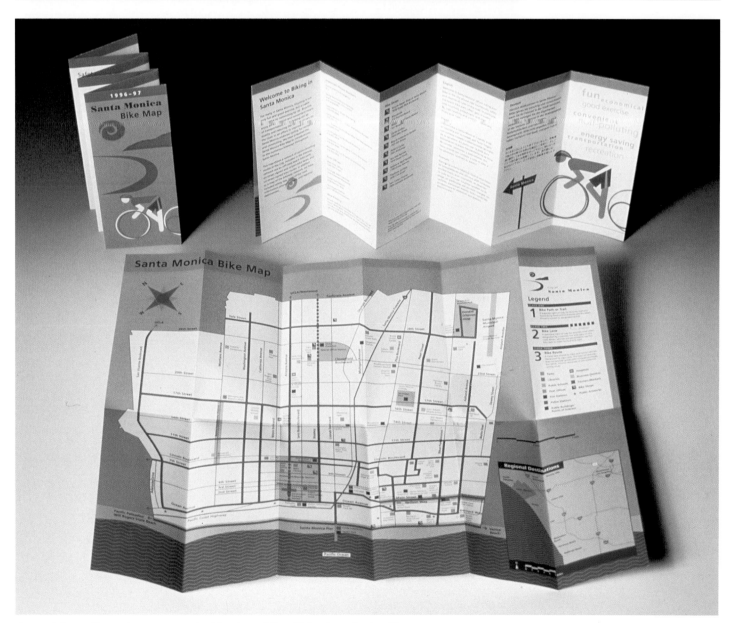

A new bike trail map incorporates the identity, while still having a look of its own.

SYDNEY, AUSTRALIA
PARRAMATTA STADIUM DIRECTIONAL SIGNS

PRIVATE SITE; PUBLIC PROBLEMS

This stadium for Rugby League football games has four main pedestrian entrances and two distinct viewing areas: terraced grandstands and grassy hills. All four have entrances and ticket booths. The comprehensive wayfinding system, installed in two phases, leads visitors from the streets to their seats. Directional signs include other local destinations as well as stadium sites.

Design
Anne Gordon Design
Pty. Ltd., Sydney

Client
Parramatta Stadium Trust

Funding
Private

The site map shows the stadium's size, its entrances, and its proximity to public and private destinations including a swimming pool, municipal parking, and offices.

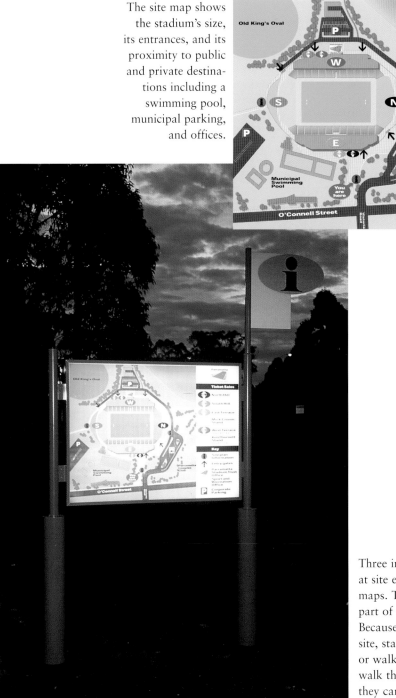

Three information signs, located at site entrances, show detailed maps. The orange sign frame is part of the system's color coding. Because there is no parking at the site, stadium-goers come by bus or walk. Once on site, they must walk the right way to their gate—they cannot walk through the stadium to get to the opposite side.

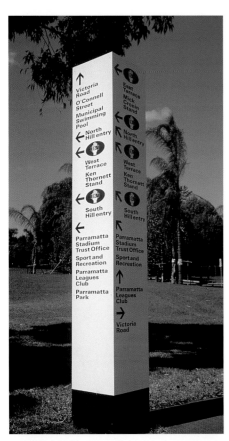

One four-sided directional sign is located at the last decision point on the main stadium entry route. It includes public destinations and landmarks, to help people orient themselves. Instead of more usual circles or squares, icons appear in stylish ovals.

Each of the four entries has its own color: black for north, green for south, orange for east, and blue for west. Colors were chosen partly for their availability in reflective vinyl, non-reflective vinyl, and paint. This west bay (blue graphics) entry includes orange arrows as accents.

Sign poles are painted with stripes for a unified look. The project typeface, Univers, was chosen for its contemporary, "non-fussy" appearance. Sign copy is black for readability and to coordinate with color-coded icons.

The stadium's logo, which is used on stationery and print graphics as well as uniforms, incorporates the Parramatta Football Club's blue and yellow-gold team colors.

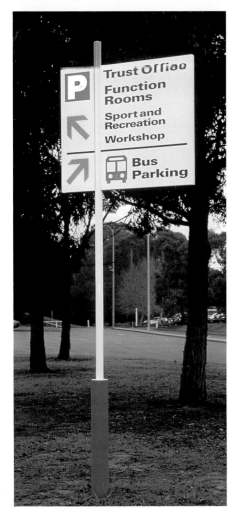

Made of aluminum with letters and graphics in reflective, adhesive vinyl, the signs were also given a clear polyurethane coating to make them resistant to vandalism. Orange stripes are for color coding.

Bay and seat numbers are color-coordinated to their location.

CULVER CITY, CA
STREET IMPROVEMENT PROGRAM

DISCIPLINED REVIEW PROCESS; FOUR PUBLIC MEETINGS

Meant to recall the Beverly Hills "BH" logo, Culver City's twin Cs top every sign in this elegant program. Part of on an ongoing street improvement program, the color-coded aluminum signs feature the "CC" mark in three-dimension.

Design
Hunt Design Associates, Pasadena, CA (wayfinding); working with Spurlock Perrier (street improvements, landscaping)

Client
Culver City Planning Department

Approvals from
Culver City (Planning Commission, City Council, Arts Committee)

Funding
Signs were paid for and will be maintained out of the city's budget.

Fabricator
AmericaWest

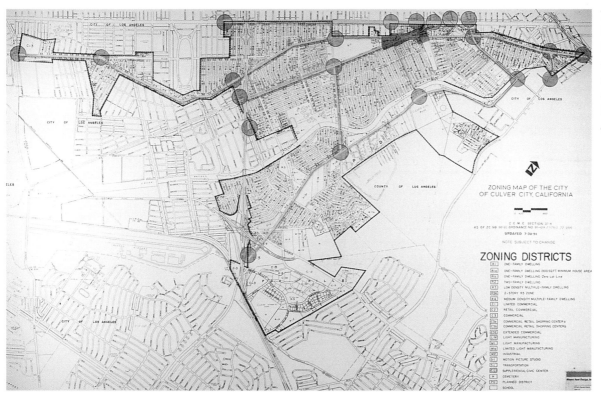

The map shows Culver City's sprawling, irregular shape—one of the reasons it needs signs to show drivers when they have entered or left city limits.

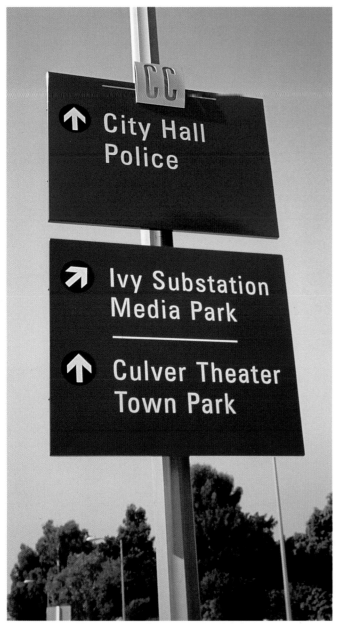

An early design featured attached arrows and a design combining the city's seal with a movie reel, a symbol of the film industry that built the city.

In the final design, signs feature smooth porcelain enamel faces with no graphics other than their simple Futura letters. Understated pizzazz comes from the fabricated aluminum ornament. The letters "CC" are cut from a piece of curved aluminum, backed by a straight aluminum sheet painted yellow.

Signs fit their surroundings, visible but not ostentatious. Subdued colors signal different destinations: red for cultural attractions, blue for civic and downtown sites, green for parking.

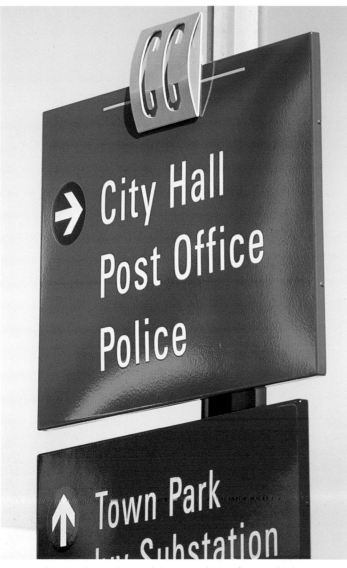

Rather than traditional porcelain enamel sign faces, which are screenprinted and baked to an indelible finish, these signs are simple colored panels. To insure that it can be read at night, copy is cut from retro-reflective, adhesive vinyl and applied.

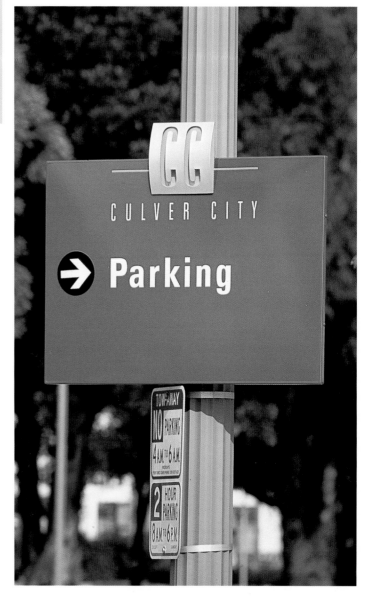

HOLLAND, MI
NEW SIGN SYSTEM

MANY CLIENTS; MANY APPROVALS; FEW DOLLARS

Holland's recent streetscape improvement project redesigned everthing but signs. With a small budget—only $60,000 for fabrication—the designers created a crisp sign program that makes a big impact without using unusual materials or fabrication methods. Installed in 1998, the system includes many large signs as well as small trailblazers that mark circuitous routes into the city. Designers also specified simple but attractive temporary signs for the city's annual Tulip Time Festival.

Design
Corbin Design, Traverse City, MI

Clients
MainStreet/DDA;
City of Holland Office of Planning and Development

Other planners
MainStreet: Downtown Development authority; City of Holland (Planning & Development, City Managers's Office); Community Services and Development; Holland Chamber of Commerce; Tulip Time Committee; Shops of Downtown Holland; Hope College; Holland Historical Trust

Approvals from
All parties above and the Holland City Council

Funding
The $85,000 project was paid for by funds from the Downtown Development Authority, generated from taxes. It will be maintained by the City of Holland using general fund monies.

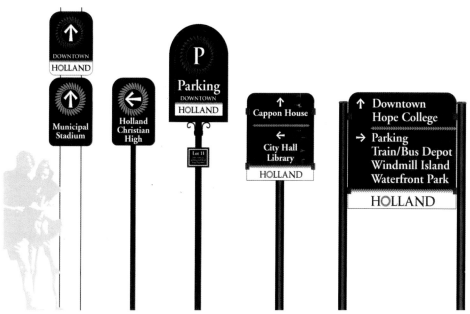

Signs are blue, Holland's official color, to reflect the city's Dutch heritage and nautical character. Signs are lettered in Garamond for readability, and are made of sheet aluminum with a baked enamel finish and copper highlights. The floral design of the "o" in the city's new logo repeats as a design element on many of the small directional signs.

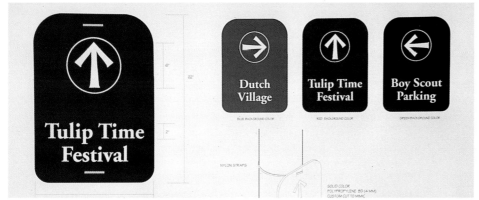

The annual Tulip Time Festival is one of Holland's greatest assets. To give it graphics that looked as attractive and professional as the new sign system, designers created this system of temporary signs. They are to be made of colored plastic, lettered in white adhesive vinyl, and attached to poles with plastic straps.

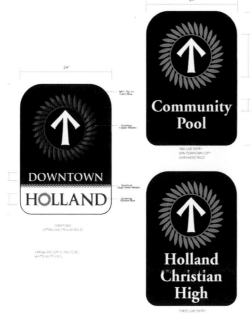

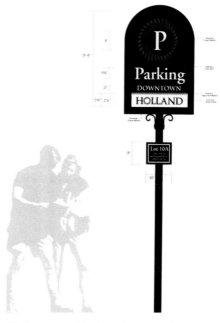

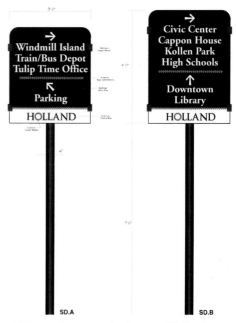

Small trailblazer signs help visitors find their way along circuitous routes to many destinations. Panels are made of painted aluminum, with white vinyl letters and arrows.

Holland's parking lot signs are the most ornate in the system, denoting their importance to the user. All graphics and letters are vinyl film on a painted aluminum surface.

All large signs contain the new Holland logo, as well as a pattern reminiscent of greenery. The logo typeface, Trajan, is different enough from the Garamond project face to be distinguishable, but not enough to clash.

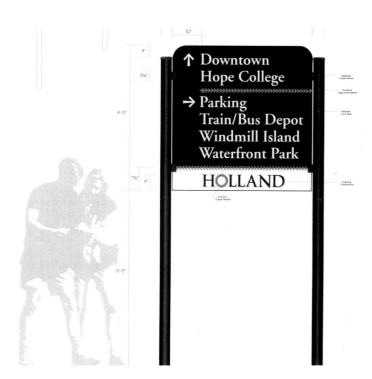

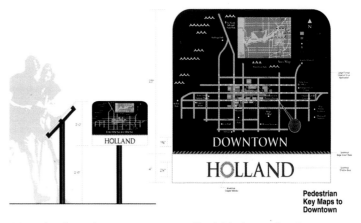

To make the pedestrian map signs affordable for Holland to produce, designers specified them as large format inkjet prints on adhesive vinyl film. They will be updated annually.

BRONX, NY
NEW YORK BOTANICAL GARDENS

TEMPORARY TO PERMANENT; BOTANICAL INSPIRATION

Originally planned as a temporary festive program to celebrate the illustrious garden's renovation, the environmental graphics are simple and made of inexpensive materials. But their spectacular impact made them permanent additions. Strong colors, painted lattice, and botanical illustrations adapted from the garden's archives make a contribution to the landscape that is matched only by the flowers in bloom. Exhibits, a restaurant, and a tram complete the renovation.

THE NEW YORK BOTANICAL GARDEN

The project typeface, Bodoni, was chosen because it combines a historic look with contemporary style, and because it works well with the garden's logo.

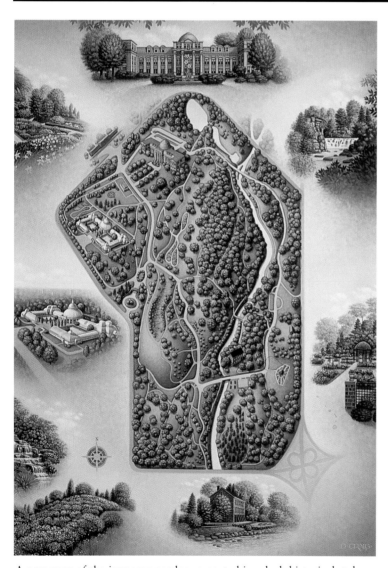

A new map of the immense garden, executed in a lush historical style, stresses the institution's history without sacrificing wayfinding.

Design
Selbert Perkins Design Collaborative, Cambridge, MA (environmental graphics); Hardy Holzman Pfieffer (architecture); New York Botanical Garden

Consultants
Paul Ritscher, Daniel Craig and Melanie Lowe (illustrations)

Client
New York Botanical Garden

Funding
The $1 million renovation was paid for privately, through a development campaign and private contributions. It will be maintained by the New York Botanical Garden.

Fabricator
Design Communications, Boston

Artists adapted botanical prints from the garden's archives into a menu of floral illustrations used throughout the project.

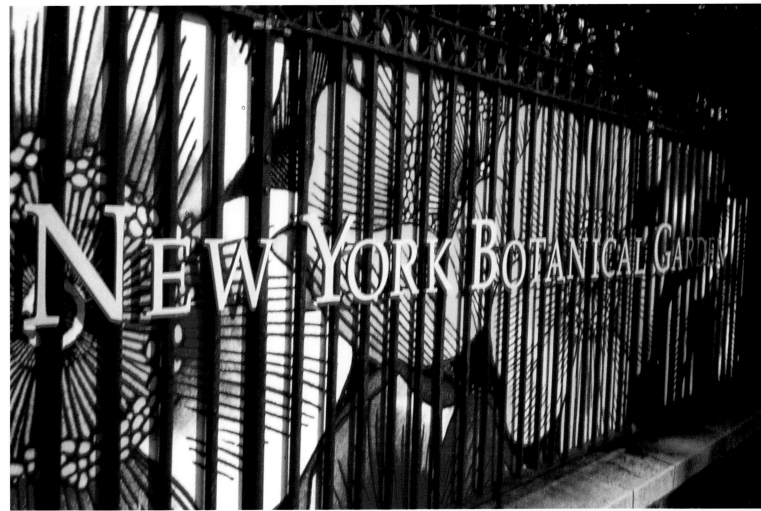

The new illustrations work well at any scale, from tiny print graphics to huge banners.

Freestanding kiosks made of wood lattice are both decorative and useful. They hold blow-ups of the botanical prints, adding color to the landscape, and also let visitors consult garden maps. Whimsical pointed roofs and silver gilt balls complete the garden furniture look.

Simple banners add color to a historic building, and let visitors know what goes on inside.

Structures are painted mint green—at the suggestion of a major contributor—to stand out without detracting from the historic surroundings.

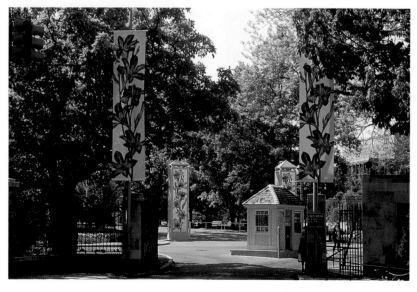

SEATTLE, WA
GRAND PLAZA & CULTURAL CENTER

SPECIAL TAX DISTRIC; REGIONAL LANDMARK

The redesign of Seattle Center, a grand plaza and cultural center on the site of the 1962 World's Fair, featured new graphics and refurbishment of the famous International Fountain. Phase I of the graphics installation sign program features custom light fixtures that double as poles for whimsical blade signs, illuminated directories, and colorful art. Phase II, now being fabricated, will expand the program to pedestrian shelters and parking signs. Phase III will add entry gateways.

The design inspiration for the new graphics is explained in "Dance of Diversity," a gift book given to project supporters. Illustrations from the book are laser-cut into the directory signs' steel bases.

Design
TRA Architects and Maestri Design Inc., Seattle (environment and wayfinding); Nakano Dennis Landscape Architects (fountain)

TRA Architects:
Jerry Ernst, principal-in-charge; Jon Bentz, project director; Jeff Benesi, master planning and artist

Maestri Design Inc.:
Paula Rees, project director; Linda Soukup: senior designer

Nakano Dennis Landscape Architects:
Kenechi Nakano, principal-in-charge

Consultants
Greg Stadler (illustrator); Gloria Bornstein (public artist); Tim Siciliano (public artist); Wet Design (water design)

Clients and planners
Seattle Center; City of Seattle

Approvals from
City of Seattle (Mayor's office, City Council, design review board); Seattle Center Advisory Board; Seattle Arts Commission)

Funding
The $4.7 million project was paid for and will be maintained with funds from a special tax district.

Fabricator
SignTech, Seattle

Photos
©1996, Steve Keating

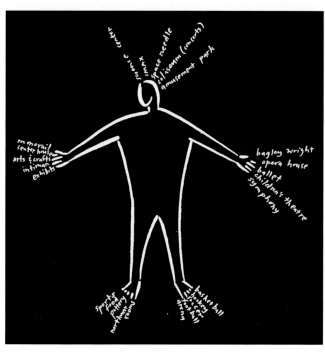

A mythic figure illustrates the site's five major areas and diverse attractions including professional basketball, the symphony, arts and crafts exhibits, the monorail, and an amusement park.

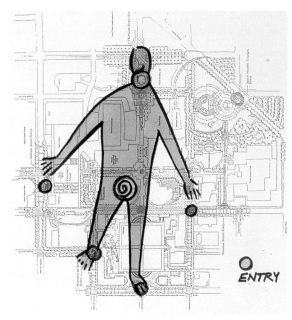

Superimposed on the site map, the figure becomes the Center's totem.

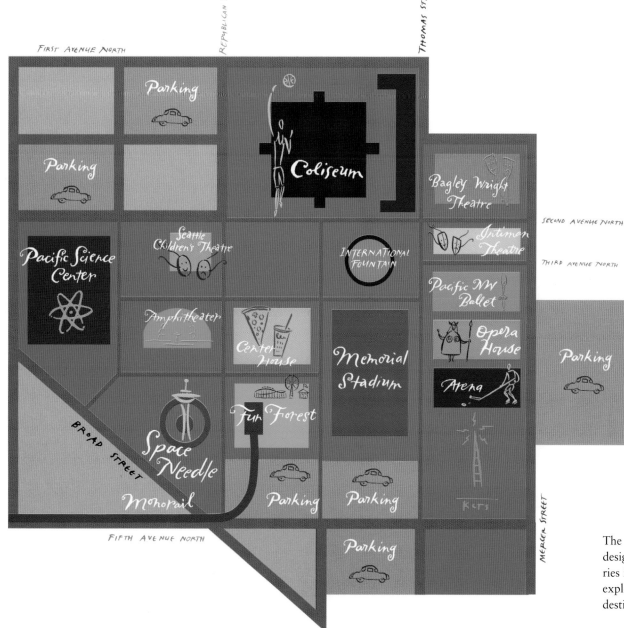

The friendly site map designed for directories invites visitors to explore beyond their destinations.

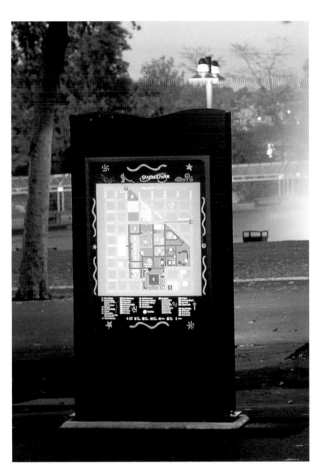

New illuminated directory signs are visible night and day, and are readable in rainy weather. Made of steel with plastic faces, the signs are durable but cost-efficient, and can be replaced or moved easily.

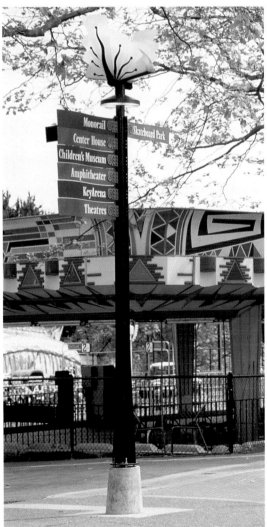

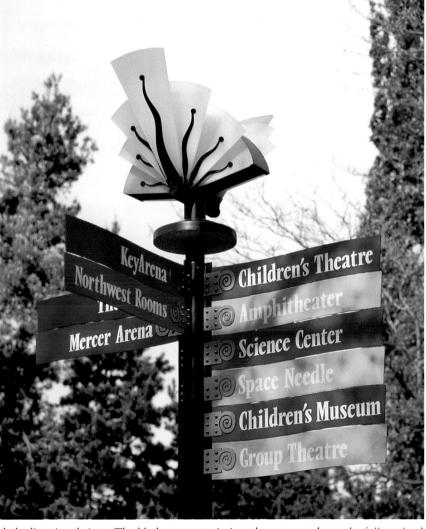

Custom glass and steel lamp posts hold the aluminum blade directional signs. The blades curve to imitate banners, and are playfully striped in four color palettes, to reflect the four seasons and the four directions. The project typeface, Vendome, continues the whimsical look.

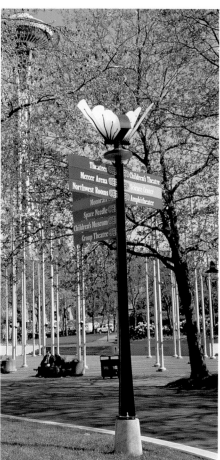

Like the Space Needle, the International Fountain is one of Seattle Center's biggest attractions. Now refurbished, the fountain has also been given new decorative paving for public spaces and walkways, public art, and underground utilities to support special events.

New artwork, including colored concrete "carpets" and acrobat sculptures at the fountain, created by artist Tim Siciliano, ornament the International Fountain and its grounds. More acrobat sculptures, also by Siciliano, ornament a building's facade.

A mural facing a parking lot reproduces an illustration from the project book, adding color and movement to an otherwise blank wall.

A preliminary sketch for the project shows its enduring elements: bright colors, a playful style, whimsical organic shapes, and fluid lines.

Mama

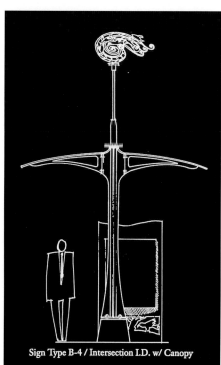

Sign Type B-4 / Intersection I.D. w/ Canopy

The final design for pedestrian shelters, now being fabricated, is loosely based on both the fan-shaped glass lamps and the Space Needle's familiar shape.

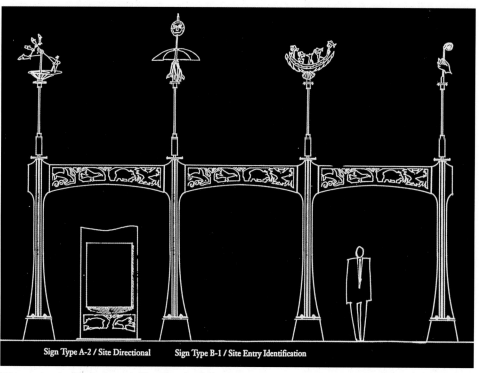

Sign Type A-2 / Site Directional Sign Type B-1 / Site Entry Identification

The project's third phase will add colorful gateways.

PORTLAND, OR
INTERNATIONAL PICTOGRAM STANDARDS

PRO-BONO STUDY CREATES NEW SYMBOLS FOR A CITY

In 1974 the American Institute of Graphic Arts, hired and paid by the U.S. government, launched a pictogram study. It resulted in a system of transportation symbols that are still the world standard. In 1994 the City of Portland and Portland-based Design Pacifica International launched an equally ambitious project: developing a pictogram standard for public and private use throughout the city, one that applied to far more than transportation.

Deciding that adding another set of custom pictograms to the hundreds already existing would not help anyone, the designers volunteered their services to identify the most effective of existing pictograms. They worked with the city's director of international relations to evaluate dozens of pictogram sets from around the world. Then, over two months, representatives from more than 60 city agencies and organizations scored them for readability, design, and how well people of other cultures could understand them.

Design Pacifica then redrew the 160 "winning" pictograms, giving them consistent proportions. Portland City Council adopted the set in 1995. Mayor Vera Katz unveiled the pictograms in a public ceremony, introducing them as Portland's latest effort toward becoming an "international city," communicating and doing business with people around the world. City Council pledged to use the symbols in all new and replacement signs, and to vigorously promote its use among local designers and businesses.

Design Pacifica continues to evaluate pictograms, with a web site (http://www.pictograms.com) and "scoring forms" provided with the pictogram system. It is available as a book of large-format, scan-nable designs, and as an interactive CD-ROM. Every 30 months, Design Pacifica plans to publish an updated version of the symbols—once again scored by Portland's public officials, as well as the agencies and designers who have used this system around the world.

Design
Design Pacifica, Portland, OR; Todd Pierce, Jason West, Barbara Pierce, Phil Davis, R.D. Aikins

Clients
City of Portland (Office of International Relations); Portland Oregon Visitors Association

Other planners
Sixty city bureaus, agencies, organizations and private businesses

Funding
Pro bono

	Average Semantic Score	Average Syntactic Score	Average Pragmatic Score	To include in Standard			Average Semantic Score	Average Syntactic Score	Average Pragmatic Score	To include in Standard
Check-in Registration	4.0	3.8	3.9	65%	Ice		3.8	3.3	3.6	85%
Conference Room	4.0	4.0	3.7	71%	Keys		4.5	4.2	4.4	74%
Drinking Water	3.3	3.2	3.4	63%	Light Switch		3.3	3.1	3.2	59%
Electrical Outlet	4.1	4.0	3.7	78%	Quiet		3.9	3.5	3.6	65%
Hotel	3.5	3.7	3.6	60%	Room Key Return		3.5	3.2	3.5	63%
Hotel Information	3.5	3.3	3.5	62%	Room Service		4.0	3.8	3.9	75%
Housekeeping	3.8	3.7	3.8	60%	Shower		4.5	4.3	4.5	80%
Elevator	4.3	4.4	4.0	82%	Stairs (Down)		4.1	4.2	4.2	85%
Entry	2.1	2.4	2.6	53%	Stairs (Up)		4.1	4.2	4.2	86%

"Judges" from private businesses and nearly 60 departments at the City of Portland, OR, evaluated symbols from many pictogram sets, using a modified version of the three-part system the AIGA developed in 1974.

HOUSTON, TX
BUSINESS DISTRICT GRAPHIC FACELIFT

SPECIAL TAX DISTRICT; BIG IMAGINATION AND NO FEAR

People expect big things to come out of Texas. And at Uptown Houston—the 13th largest business district in the United States— something did. While other cities struggle with costs and design, commissioners at the special tax district voted to raise their taxes, hired a designer known for bold works, and ordered a streetscape extravaganza featuring giant illuminated signs, median plantings, and pocket parks featuring vibrant art. Home of the city's glamorous hotels, stores, and entertainment centers, Uptown Houston has been a special tax district since 1975. The streetscape improvements are directed at drivers, while the arches and parks also make it inviting to pedestrians, who formerly had no place to walk or sit.

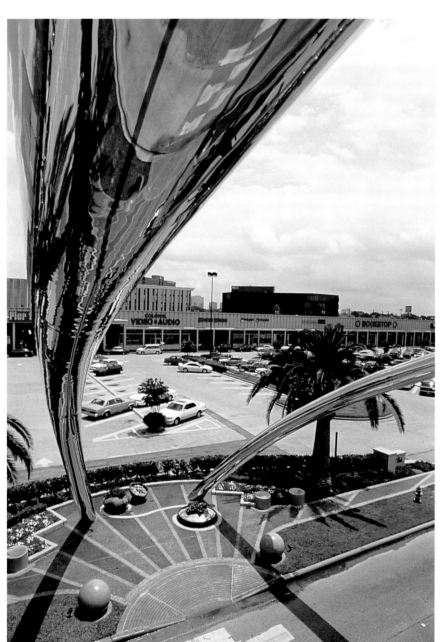

The project's focus was a 1.5-mile stretch of Post Oak Blvd. and the primary "gateway" intersections leading to it. To make the area more attractive to pedestrians (who typically avoided it), designers created six "pocket parks" and marked their locations with giant stainless steel arcs.

Design
Communication Arts, Boulder, CO: Henry Beer, design principal; Leonard Thomas, project manager; Mike Doyle, designer, Bryan Gough, designer, John Ward, project director

Additional design
Sikes, Jennings, Kelly & Brewer, Houston (architects of record); Slaney Santana Group, Houston (landscape architects)

Consultant
Walter P. Moore & Associates Inc., Houston (engineering)

Client
Harris County Improvement District #1

Other planners
Houston Lighting & Power Co., Metropolitan Transit Authority of Harris County, City of Houston, Texas Department of Transportation

Approvals from
Above

Funding
Signs were part of an $11 million graphic and streetscape facelift paid for with a special tax voted in by the improvement district.

Fabricators
Offenhauser Co., Houston, and Milestone Metals Inc., Houston (arches); Intex United Inc., Houston (signs); Neon Electric Corp., Houston (gateway sign rings); Union Metal Corp., Canton, OH, and Offenhauser Co. (street light poles and arms); Century Development Corp., Houston (construction manager)

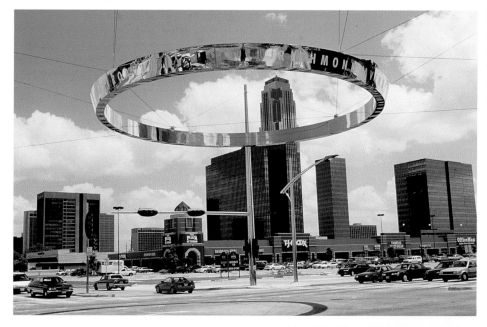

Intersections are marked by giant glowing rings suspended above the traffic by steel cables. An engineering feat, the stainless steel rings are 40 ft. in diameter.

Maintenance-free stainless reflects light, looking different throughout the day, at night, and in different weather conditions.

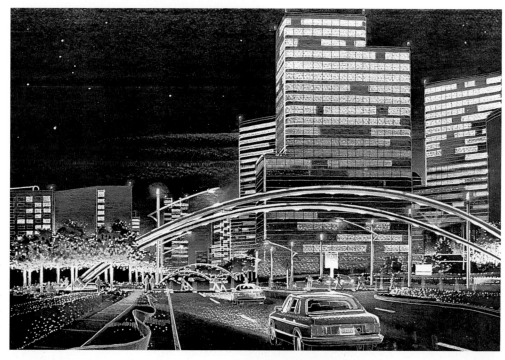

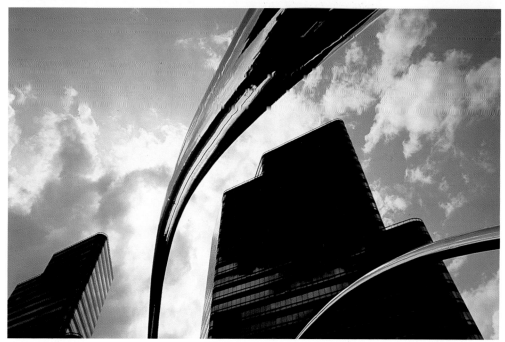

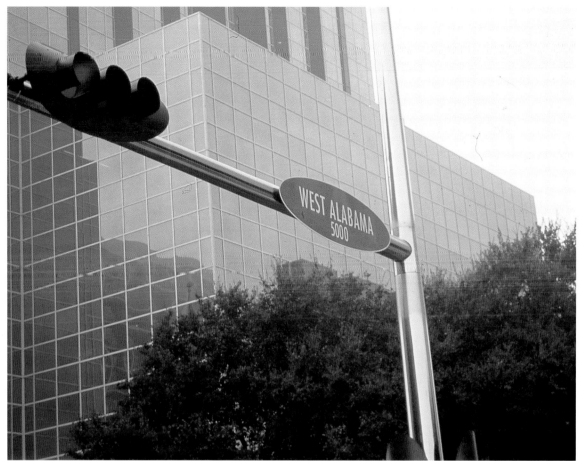

Custom light and traffic poles replaced standard-issue street furniture. There are almost 200 of these stainless steel light poles, based on the shape of a "bobbing grasshopper" oil pump.

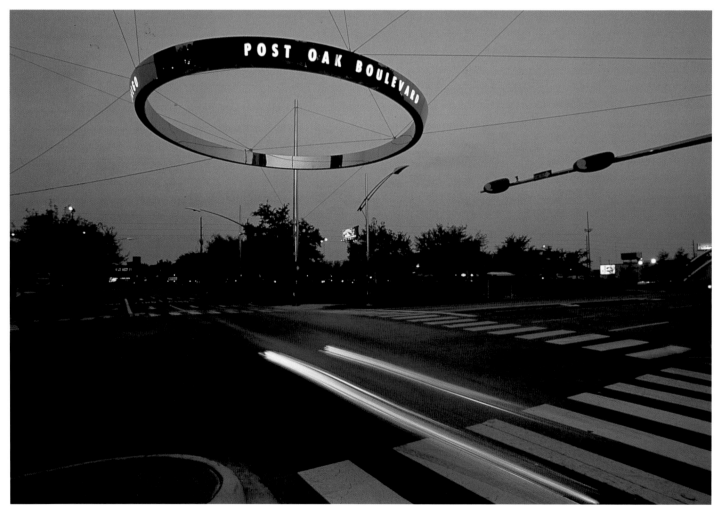

Controversial when first installed in 1994, the gleaming arches became old news when the "flying saucer" intersection signs appeared two years later. Symbolizing oil, the wealth that comes from the ground and returns to it, they are built to the scale of the highrise buildings that surround them.

Nestled at the feet of the giant arches are small, human-scaled parks for people who work in the area to use for resting, chatting, and eating. Colorful plantings and pavings make them inviting places to visit.

Pigmented, decorative paving gives the tiny parks much of their character. Together, paving and plantings create a powerful look in a small space.

Each park also houses artwork by regional artists, such as this mosaic divan by Nevada artist Jeannie Linam.

Before the new streetscape program, drivers on the 6-lane boulevard often missed their turns. Now surfboard-sized, oval street signs help them see intersections in plenty of time.

Custom traffic light poles share the same design sensibility as the streetlights and signs.

LOS ANGELES, CA
UCLA CAMPUS SIGNAGE

UNIVERSAL DESIGN; ADA AND LOCAL CODES; MULTIPLE MEETINGS

Since 1993, designers have been reworking all signs on UCLA's sprawling campus. Signs address the students, faculty, and visitors who venture to one of the more than 50 campus buildings every day. Each project is designed separately, refining and adding to the new standards. Designers created a UCLA typeface, a basic color scheme (supplemented with colors that match particular buildings), and a general "look." They make it a point to meet frequently with UCLA staff throughout the design process. Because UCLA planners and architects can work with any designers they choose, the designers' strategy is to win them over with quality and service, and sell the idea that a consistent identity is good for each department as well as for the university as a whole.

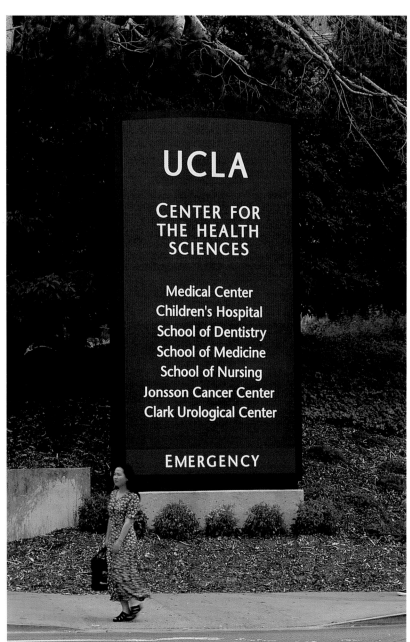

UCLA's hospitals and medical centers are heavily used by the public, as well as by students and staff, so signs must address a wide audience. Designers created a project typeface by modifying Stone Sans. "UCLA Gothic" has been adopted by several departments for other uses. The university purchases the licensed version each time.

Design
Biesek Design, San Luis Obispo, CA

Other designers
Robert Venturi, AIA; Barton Phelps, AIA; Gere Kavanaugh Design

Client
University of California at Los Angeles

Approvals from
Project architects; UCLA (Capital Programs Planning Team; Campus Project Managers; facility managers; fire department; ADA Compliance Office)

Funding
This ongoing, more than $1 million project is paid for in part by UCLA capital funds, raised both from state taxes and private donations, and by funds from the Federal Emergency Management Agency (FEMA) for repairing earthquake damage from the 1980s. Maintenance will be done by the UCLA Sign Shop or outside vendors, and will be paid for with university operating funds.

Fabricators
Karman Ltd., AHR Ampersand; Apco; TFN Architectural Signage

Photos
© Barry Goyette

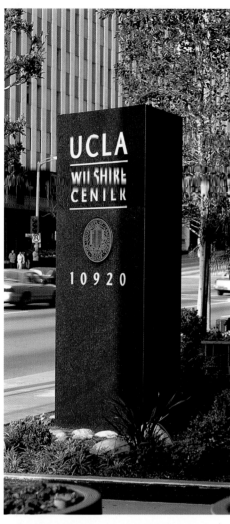

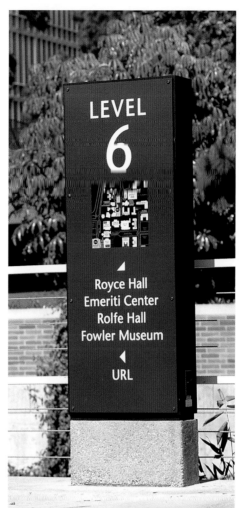

The vast number of sign types, inside and out, make it difficult to design a comprehensive sign manual. Instead, designers work project by project, refining and adding to standards as they go. Eventually, UCLA hopes, the entire campus will have one identity.

Each site gets its own variation on the UCLA "look," designed to match its particular architecture. Older buildings generally receive bronze details while newer ones, like Wilshire Center, get stainless steel letters and graphics.

ST X5.00 ST X6.00 ST X17.00

ST X20.00 ST X26.00 ST X19.00

ST X24.00

Many UCLA signs are made of bronze, a reference to the school's many sculpture gardens. Although there is no rigid color scheme, bronze and bronze-like colors appear throughout the program, further tying it together.

Accessibility signs at the classic Royce Hall building have beveled edges to give them a more architectural appearance.

137

OXNARD, CA
SIGNS & BANNERS

BRIGHT NEW LOOK; IMPLEMENTED IN STAGES

This small city's first move was to install bright fabric banners to give the streets a new visual punch while its new directional signs were being made. Both signs and banners feature a pattern of radiating lines, a subtle reference to the city's agricultural heritage and location in a major produce center.

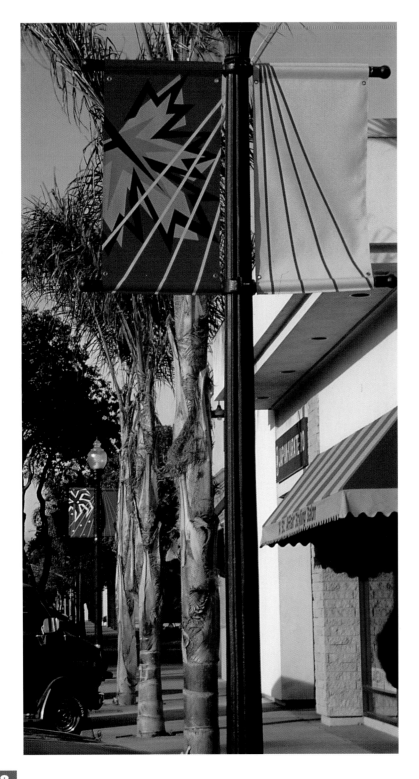

Design
Hunt Design Associates, Pasadena, CA

Client
Oxnard Wayfinding Committee

Approvals from
Oxnard City Council

Funding
The project was funded and will be maintained by the city.

Fabricator
AAA Flag & Banner

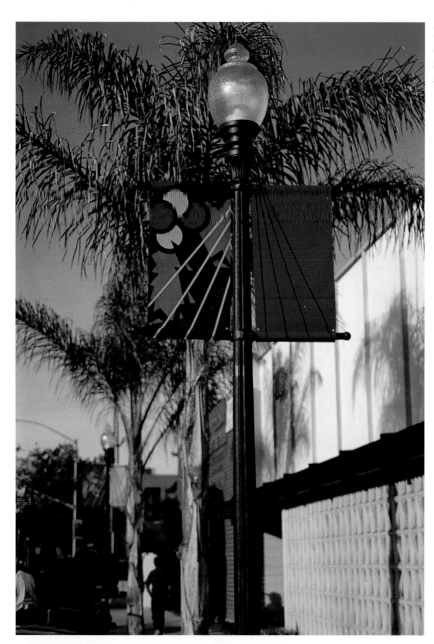

Final designs feature bold colors and folksy images. Highly visible and decorative, they are changed every four months to add variety.

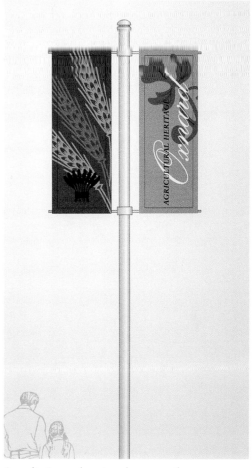

A preliminary drawing shows a softer, more ornate look.

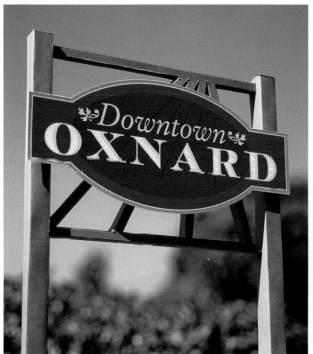

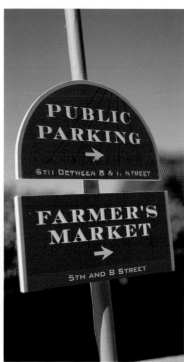

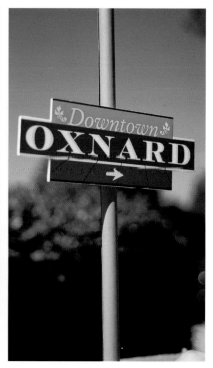

Models of the directional sign program, currently being fabricated, show bright colors, old-style type, and the same design of radiating lines featured on banners.

BLACKSTONE RIVER VALLEY
NATIONAL HERITAGE CORRIDOR, MA & RI

FOR 25 TOWNS IN TWO STATES; NUMEROUS PLANNERS; INNUMERABLE APPROVALS

This distinctive program for towns in two states includes an area logo, a complete system of interpretive and wayfinding signs, and a distinctive look and color scheme. The design was inspired by the region's history, particularly during the industrial revolution. Colors match area architecture and coordinate with the Natural Park Service's signature brown.

BLACKSTONE RIVER VALLEY
National Heritage Corridor Commission

A new logo and seal connect all towns and sites with the National Heritage Corridor. Two typefaces convey distinct messages: sans serif Eagle Bold (shown) stresses the program's contemporary importance, while familiar Century (used on signs) emphasizes tradition, friendliness, and legibility.

Design
Selbert Perkins Design Collaborative, Cambridge, MA

Consultants
Brian Callahan and Polly Becker (illustrators); Stona Fitch (writer); Gregory Wostrel (photographer)

Clients
Blackstone River Valley National Heritage Corridor Commission; National Park Service

Other planners
Blackstone River Valley National Heritage Corridor Commission; National Park Service; various state and federal agencies; various local governments; various interest groups; various businesses; public and citizens groups from 25 towns

Approvals from
Blackstone River Valley National Heritage Corridor Commission; National Park Service; 25 towns in two states; state and federal highway authorities

Funded by
Design and fabrication was paid for with federal grants and matching contributions from state and private funds. Systems will be maintained by local governments, state agencies, and non-profit corporations.

Fabricator
Design Communications, Boston

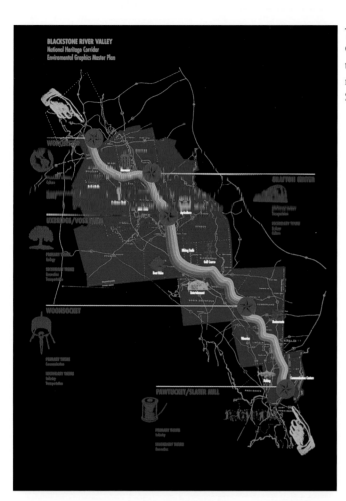

The National Heritage Corridor stretches through two states, 25 towns, and numerous National Park Service historic sites.

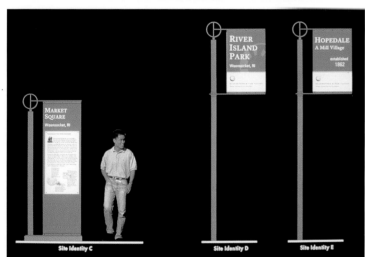

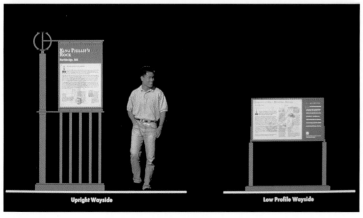

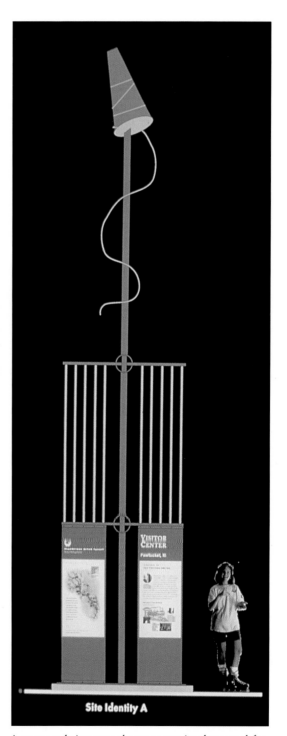

Site Identity A

Preliminary sign designs show an emphasis on steel and aluminum construction. Designers then chose a palette of earth colors, emphasizing rust and green, to recall the industrial revolution.

A proposed sign type that was not implemented featured giant depictions of tools, such as the spool of thread shown here, important to each town's past.

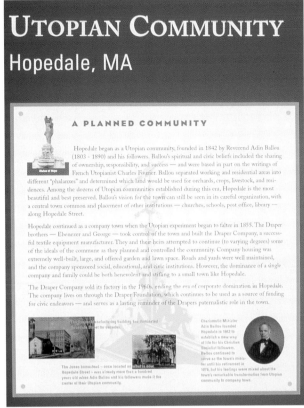

UTOPIAN COMMUNITY
Hopedale, MA

A PLANNED COMMUNITY

Hopedale began as a Utopian community, founded in 1842 by Reverend Adin Ballou (1803 - 1890) and his followers. Ballou's spiritual and civic beliefs included the sharing of ownership, responsibility, and success — and were based in part on the writings of French Utopianist Charles Fourier. Ballou separated working and residential areas into different "phalanxes" and determined which land would be used for orchards, crops, livestock, and residences. Among the dozens of Utopian communities established during this era, Hopedale is the most beautiful and best preserved. Ballou's vision for the town can still be seen in its careful organization, with a central town common and placement of other institutions — churches, schools, post office, library — along Hopedale Street.

Hopedale continued as a company town when the Utopian experiment began to falter in 1855. The Draper brothers — Ebenezer and George — took control of the town and built the Draper Company, a successful textile equipment manufacturer. They and their heirs attempted to continue (to varying degrees) some of the ideals of the commune as they planned and controlled the community. Company housing was extremely well-built, large, and offered garden and lawn space. Roads and yards were well maintained, and the company sponsored social, educational, and civic institutions. However, the dominance of a single company and family could be both benevolent and stifling to a small town like Hopedale.

The Draper Company sold its factory in the 1960s, ending the era of corporate domination in Hopedale. The company lives on through the Draper Foundation, which continues to be used as a source of funding for civic endeavors — and serves as a lasting reminder of the Drapers paternalistic role in the town.

Interpretive panels such as this one are used to introduce historic sites and highlight historic periods or events.

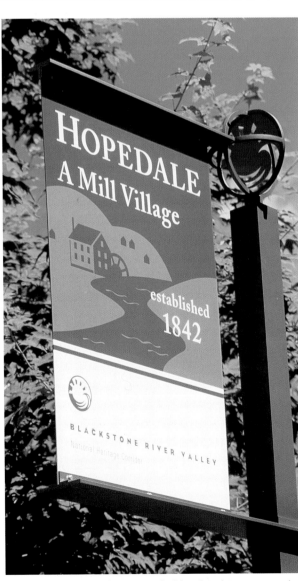

The bottom third of site signs hold only white space and the project logo, tying each site into the whole.

The design complements the often picturesque New England architecture.

Round signs repeat the shape of the round National Heritage Corridor seal.

A simple directional sign for a Rhode Island clock museum.

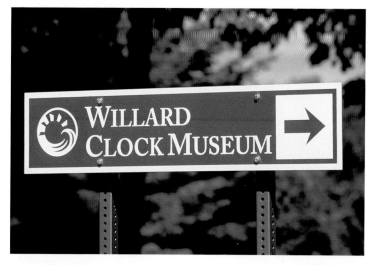

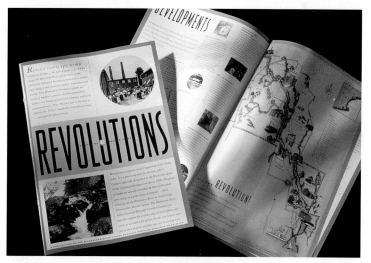

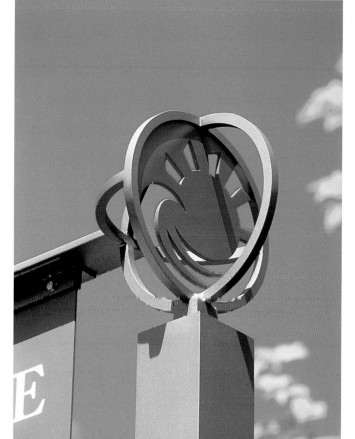

An elegant, three-dimensional detail, this corner decoration features a cut metal version of the seal.

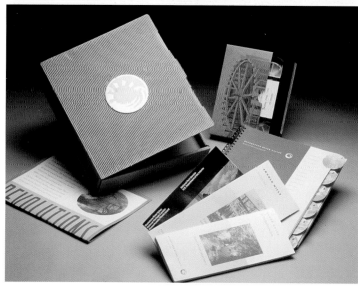

Designers created a marketing brochure and a newsletter for the towns on the corridor, to help them feel a part of something beyond their individual borders.

COSTA MESA, CA
SOUTH COAST PLAZA SHUTTLE

PRIVATE PROGRAM; PUBLIC TRANSPORTATION STYLE

Like the public transportation system signs they emulate, the graphics for this free shuttle carry maps, site and destination markers, safety messages, and vital information such as hours of operation. But the private funding, the system's purpose (primarily entertainment) and limited size (it connects three related shopping areas) gave designers far more leeway than traditional systems. The result is a striking, yet whimsical, sign system that shows what can be accomplished with a little imagination—and adequate funding.

Design
Sussman/Prejza & Co., Culver City, CA

Client
South Coast Plaza

Funding
Private

Fabricator
Carlson & Co., San Fernando, CA

Photos
Annette del Zoppo Photography

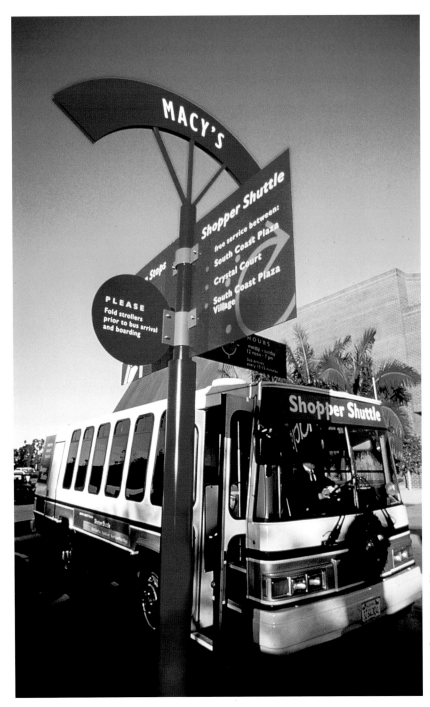

Shuttle stop signs are unmistakable, their innovative forms and bright red color catching the eye. Shuttle buses and vans are marked with matching graphics.

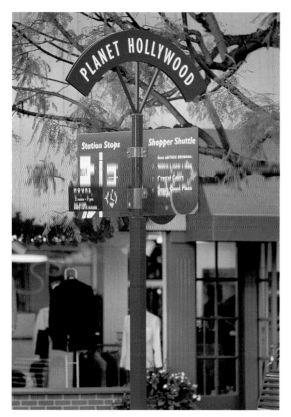

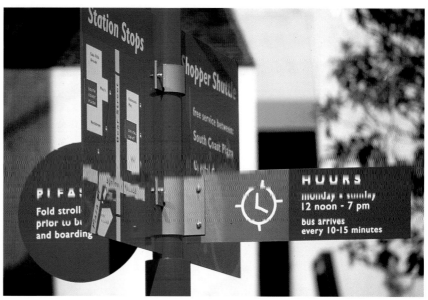

Two vertical rectangular panels are identical in size and shape. They identify the shuttle's purpose and the buildings it connects. A horizontal panel gives the shuttle's hours, while a circular panel asks users to fold their strollers. The different shapes and sizes add to the visual interest.

Shuttle stop names are placed on curved sheets of cut aluminum. The sign poles and caps are painted red, with copy in white. Small but bold punches of cream, orange, purple and green accent the main color and give the signs much of their visual impact. The color scheme stands out from the surrounding buildings, but complements them.

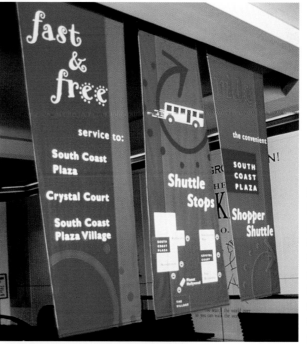

Screenprinted vinyl banners inside shopping areas advertise and explain the shuttle. Bolder use of color and a new typeface, Remedy Double, adds whimsy to this two-dimensional version of the graphics.

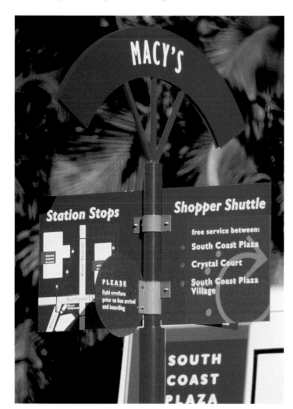

Unpainted bolts and caps become design elements. Fabrication detail is important in this system, which is meant to be seen close up.

Like weathervanes, the shuttle stop signs contain information on four panels set at right angles to each other. This arrangement separates each message from the other, giving them more importance. Text is set in Gill Sans Regular and Bold Italic for readability.

BEVERLY HILLS, CA
HOLIDAY DECORATIONS

PLANNED AS TEMPORARY; NOW PERMANENT

With an annual budget of $200,000 (including design), Beverly Hills expects a bit more from its holiday decorations than a few lights and wreaths. Since 1994, the same design firm has headed the program. The first year gave the city vibrant swaths of color from banners carefully designed in six shades each of red and green. Then came 50-ft. "ribbons" of glittering stars strung above the streets, new street banner designs, a giant park banner, and holiday parking banners.

Design
Sussman/Prejza & Co., Inc., Culver City, CA

Client
City of Beverly Hills

Approvals from
Beverly Hills City Council

Fabricators
Dekra-lite, Santa Ana, CA, overhead decorations and banner lighting; Gold Graphics, Pacoima, CA, banners; West Coast Lighting, Inglewood, CA, electricalCitizens for Modern Transit

Photos
Annette del Zoppo Photography

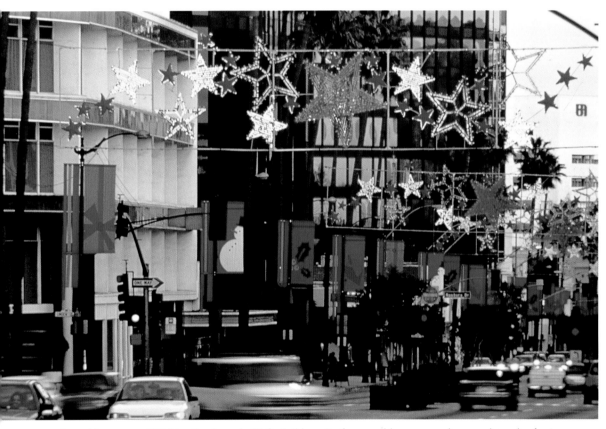

Stretching across Wilshire Boulevard, 50-ft. "ribbons" of stars add a spectacular punch to the festive decorations. Only the white lights are actually illuminated. The blow-molded plastic stars are studded with reflectors that shine in car headlights at night.

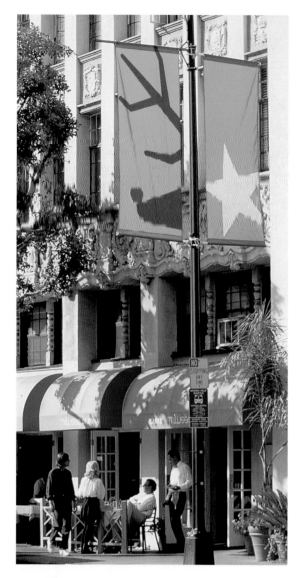

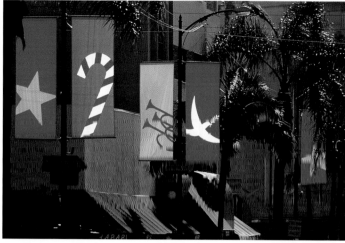

Six different reds, chosen from the Nylon suppliers' offerings, are used in the banners for all north/sound streets. The bold designs are appliqued, rather than screenprinted, to keep the colors vibrant when backlit at night, as well as in California's bright sunlight.

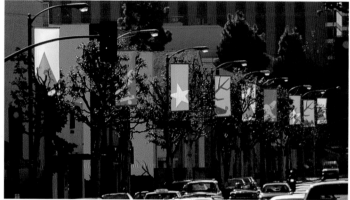

Six different shades of green are used for all banners on east/west streets. Designs show traditional Christmas motifs—without any references to snow.

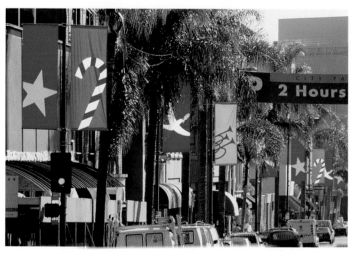

Parking banners help shoppers find a place to put their cars, a perennial problem in most cities, especially at holidays. Several weights of Futura are used for the copy.

This giant banner at a city park incorporates all design elements: the two color palettes, the simple icons, and the stars. Designers chose the typeface, Univers 59, because its condensed letterforms fit the program's style and are eminently readable.

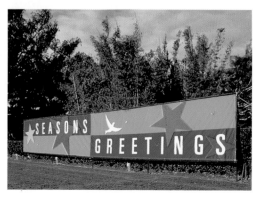

Looking down a street gives the viewer a vista of either warm or cool colors. At intersections, both color palettes are visible.

BERKELEY, CA
UNIVERSITY OF CALIFORNIA STUDENT HOUSING

FUN AND YOUNG; VANDAL-RESISTANT

Chosen to match the buildings' architectural style and the lifestyle of university students, these bright, fun graphics are also made of durable, vandal-resistant materials. Primarily designed for residents and staff, the signs also contain maps and information for visitors.

Porcelain enamel panels, with profiles shaped like exclamation points, welcome students to housing complexes. Bright colors and playful type (Futura, Stencil, and Garamond faces) give them an inviting air.

Design
Patricia Bruning Design, San Francisco

Other design
Sandy & Babcock Architects; David Baker Associates

Clients
Sandy & Babcock Architects; University of California at Berkeley

Other planners
Scott Architectural Graphics, Santa Rosa, CA

Approvals from
University of California at Berkeley; Sandy and Babcock Architects; State of California

Funding
The project was paid for with university funds and will be maintained by the university.

Fabricator
Scott Architectural Graphics, Santa Rosa

Cutout letters mounted to a curved bar give this sign dignity, and match the architectural materials.

Regulatory signs and room markers are both functional and attractive. Nothing is left of the common "institutional look," although the porcelain enamel signs meet all regulations.

NEWTON, MA
NEXUS BUS SYSTEM

BOLD DESIGN; LIMITED BUDGET

A suburb of Boston, Newton came to designers with plans for a new bus system. The challenge was to show its relationship to Boston's "T" system while creating its own identity—and while sticking to a low budget. Designers coined the name, which implies that the system connects to something else, and helped organize various city departments so that all graphics except bus markings are made and maintained in-house. Graphic design took only six months, following 3 1/2 years of planning and four public hearings to iron out logistics.

X marks the spot for Nexus, a new intra-urban bus system that connects Newton, MA, with Boston's public transportation system. The prominent "X" recalls Boston's "T." Yellow-orange and lime-green, variations of two prominent "T" colors, give Nexus a contemporary and distinct identity.

Design
Daly & Daly Inc.,
Brookline, MA

Consultants
Alternate Concepts, Inc.
(transportation planning)

Client
City of Newton
Department of Planning
& Development

Other planners
City of Newton (Mayor's
office; Department of
Planning &
Development); Newton
Board of Alderman

Approvals from
Newton Board of
Aldermen; Nexus (mar-
keting and steering com-
mittees), City of Newton
Mayor's office

Funding
A combination of fund-
ing sources paid for the
design: transportation
demand management
funds, Congestion
Mitigation of Air Quality
(CMAQ) funds, block
grants, and private con-
tributions. Maintainance
will be paid for by gov-
ernment and private
grants, private contribu-
tions, and fare revenues.

Fabricators
City of Newton D.P.U.
Traffic Division sign shop
(signs); Invisuals, Inc.,
Boston (bus identity
graphics); City of
Newton print shop
(print graphics)

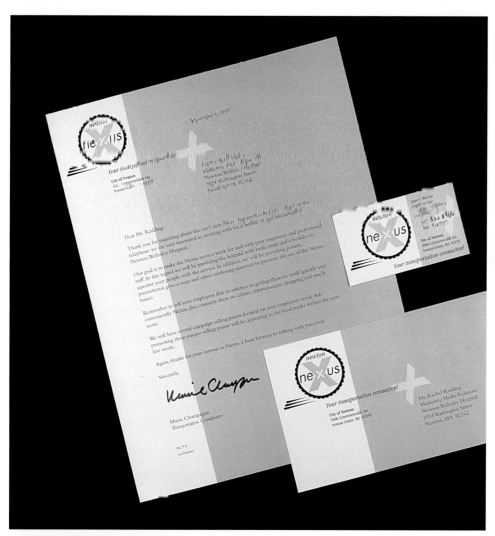

All print pieces are printed by Newton's city print shop, one solution to the project's low budget. For the system's start up, only about $20,000 went to outside vendors. While Futura is the primary system typeface, Garamond is also used extensively in print graphics because of its friendlier look.

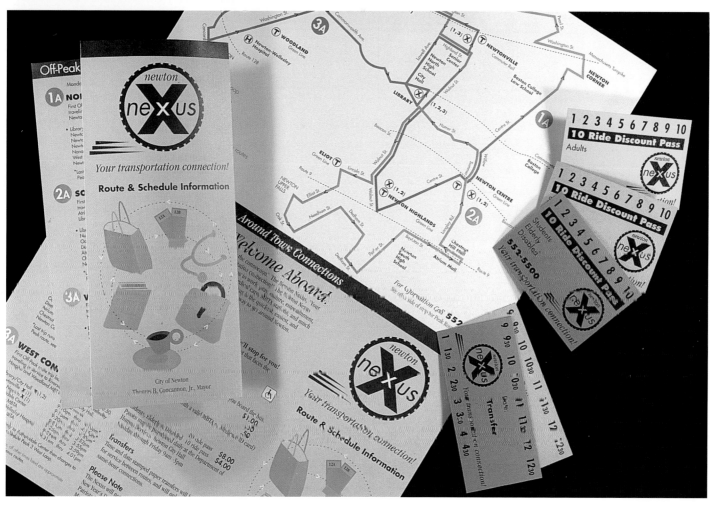

Stylish materials and bold design
make the Nexus driver's uniform
look like fashion apparel.

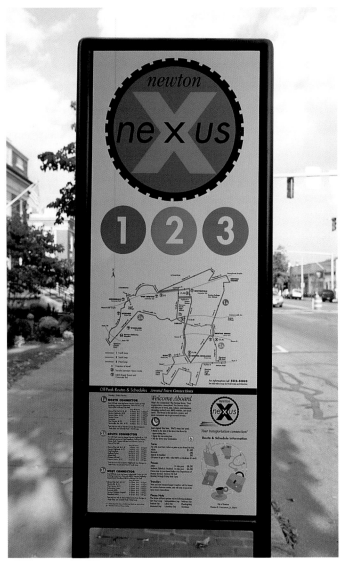

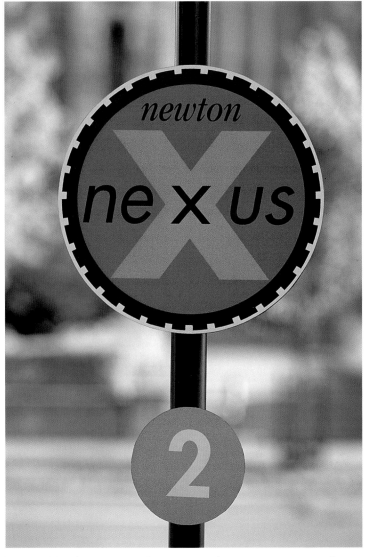

All signs are made of aluminum panels with vinyl graphics, and are fabricated by the city's sign shop. Futura, the system's main type face, works well in sign applications because of its readability and its many weights and styles, useful for organizing complex information.

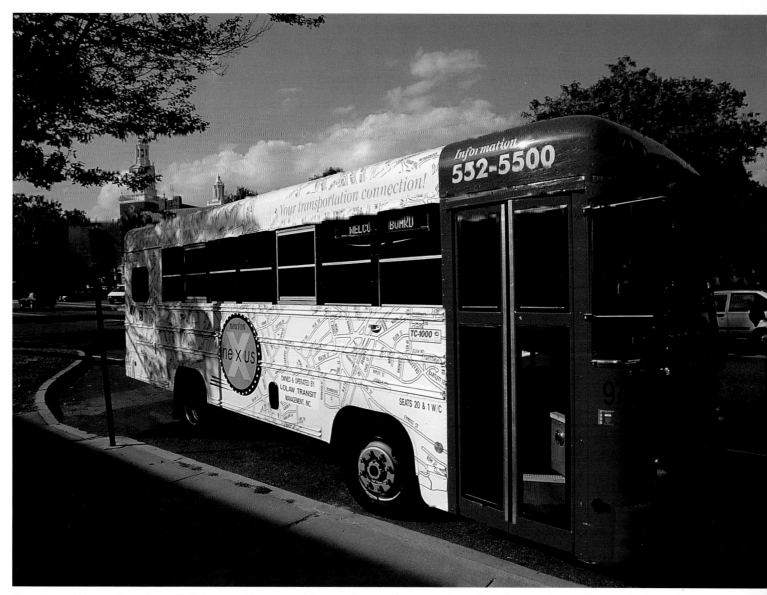

Outside vendors made and installed the complicated vinyl bus graphics, which cover the entire vehicle. Only the front of the bus is brightly colored, making it visible to waiting passengers but not screaming for attention from passersby. The rest of the bus is enveloped with a black-and-white map of Newton. Finding home on the map has become a favorite activity for riders.

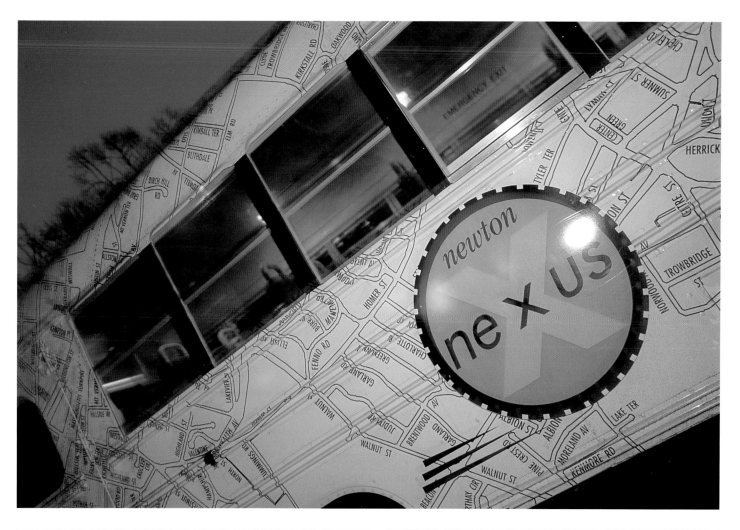

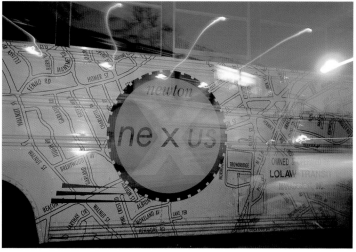

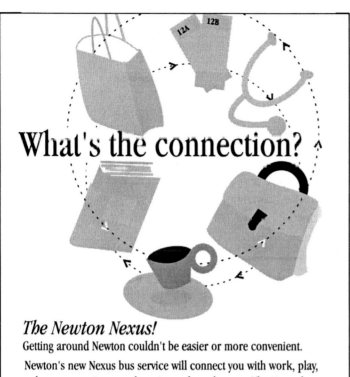

What's the connection?

The Newton Nexus!

Getting around Newton couldn't be easier or more convenient.

Newton's new Nexus bus service will connect you with work, play, culture, entertainment, shopping and much more. The Nexus buses will quickly and conveniently connect you with "T" stations, senior centers, libraries, schools, and shopping centers.

Just signal the bus. We'll stop for you!

Call for Information **552-5500**

Your transportation Connection.

Newspaper ads explained the new system and its relationship to the "T," and invited residents to signal the bus for a ride.

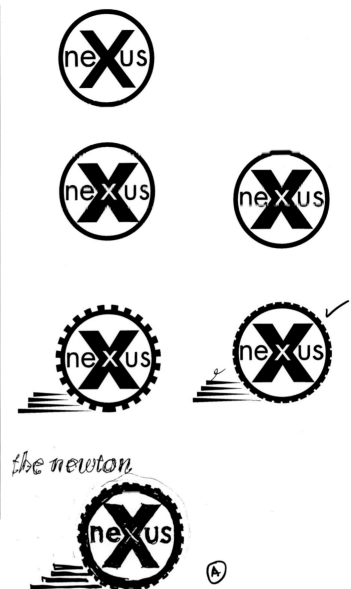

Sketches show the development of the Nexus logo. From the beginning, designers emphasized the "X."

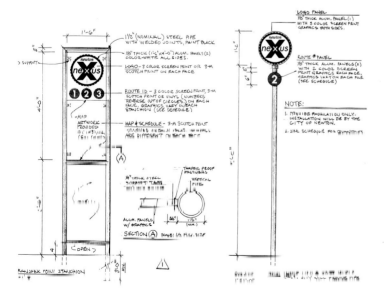

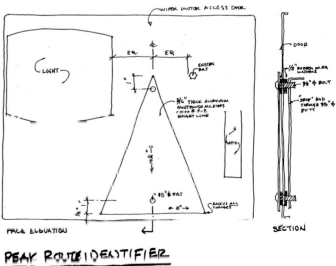

BIRMINGHAM, AL
AIRPORT ENTRY SCULPTURE

PUBLIC ART; A NEW CITY GATEWAY

After six years, six major presentations, and creative bidding arrangements (to maintain quality without disrupting the bid process, the sculpture project was awarded to the fabricator with stipulations that they use the design firm), this massive public art/landscape installation was finally completed. Designed to provide a gateway to the city from the Birmingham Airport, which had been completely renovated and upgraded, the project gives drivers a new view of both. When the airport needed a new access road in mid-1997, officials reassembled the design team to effectively relocate part of the sculpture.

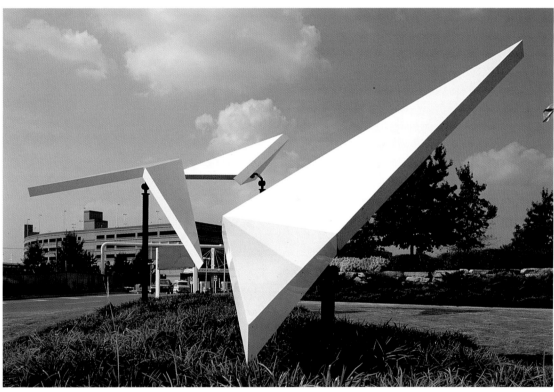

Abstract sculptures, climaxing with this trio of "gliders" meant to symbolize flight and speed, now greet highway drivers. The undulating landscape gives the airport, and the city that commissioned it, a new fac ︶.

Design
Lorenc Design, Atlanta (sculpture/landscape concept). Jan Lorenc, Chung Youl Yoo, Gaelle Husson, designers; for PBS&J (landscape architecture), Robbin Gregory, project manager; Ramon luminance Design, Atlanta (lighting)

Consultants
Irrigation Consultant Services (irrigation); Uzon & Case, Atlanta (structural engineering)

Clients
City of Birmingham; PBS&J

Other planners
Birmingham Airport Authority; City of Birmingham Planning & Engineering Department

Approvals from
City of Birmingham (Planning & Engineering; Office of the Mayor); Birmingham Airport Authority

Funding
Landscaping was funded by a city bond issue and a federal Intermodal Surface Transportation Efficiency Act (ISTEA) grant. Sculptures were paid for by the Airport Authority, which will maintain them. Landscaped areas without sculptures will be maintained by the city.

Photos
Rion Rizzo/Creative Sources

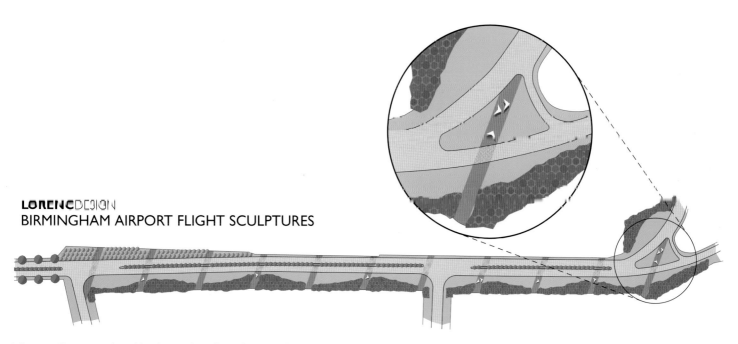

LORENCDESIGN
BIRMINGHAM AIRPORT FLIGHT SCULPTURES

The installation replaced broken sidewalk and tattered chain link fencing, all that separated drivers from solid blocks of rental car lots, with simple but dramatic landscaping. At $154,000, the sculptural elements added huge impact at only a fraction of its $750,000 budget.

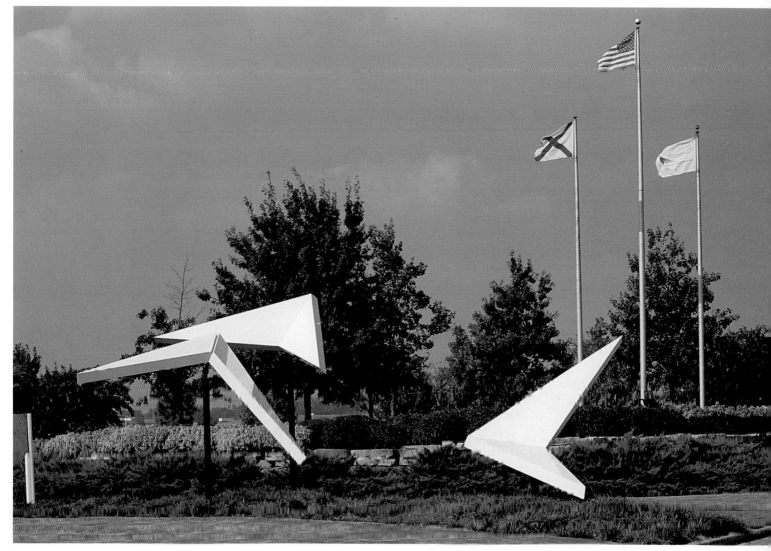

"Taking off" at the airport entrance, the final three gliders look ready to fly far above the adjacent flags. The sculptures are all set on coarse green swaths of monkey grass, which cut across the graded lawn at an angle to the highway. The shrubbery on the far side, which undulates across the straight landscape, will eventually grow to 17 ft.

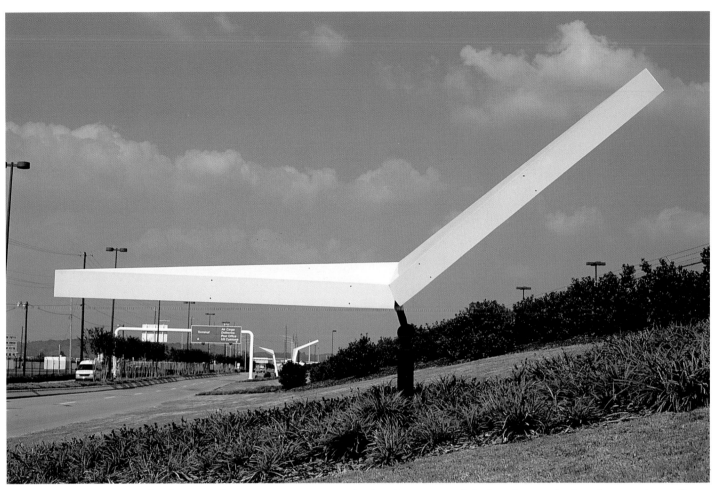

By day, the white wings made of painted aluminum create a constantly changing pattern of shadow that emphasizes the ground as well as the air. Their super glossy finish reflects changes in daylight.

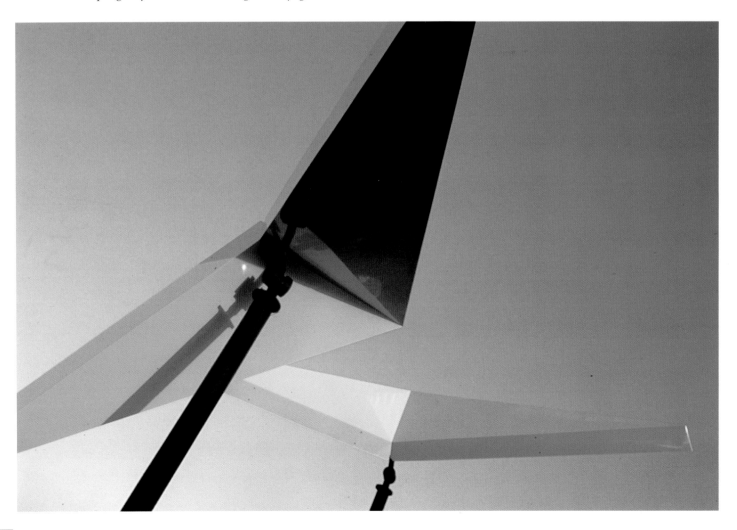

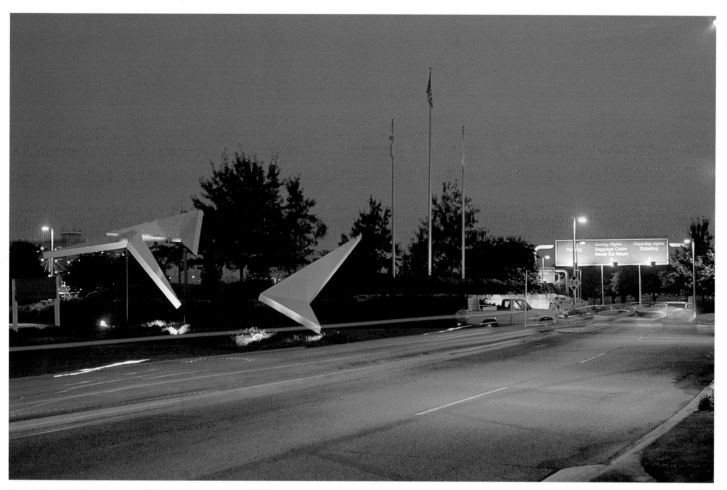

By night, the blue mercury lighting contrasts with the orange glow of high pressure sodium parkway lights, which the shapes also reflect. Lighting designers and structural engineers were integral partners in planning the sculptures' shapes, mounting hardware, and placement for maximum impact. Each glider was positioned, angled and welded into position in the field for last-minute adjustments.

BIRMINGHAM AIRPORT PARKING Feb. 18, 1997 LORENC DESIGN

When the airport changed an exit in 1997, planners consulted the designers about the best way to resite the sculptures. The new site, designers say, is better than the original.

SAN FRANCISCO, CA
EMBARCADERO HISTORICAL SIGNAGE

MULTIPLE APPROVALS; TRANSPORTATION FUNDS; TECHNICAL INNOVATIONS

Commissioned as a public art project, this installation stretches for two-and-a-half miles along San Francisco's waterfront. Part of a major project including new roadways, 25-ft.-wide sidewalks, tree plantings, pedestrian promenades, new streetcar and light rail service, new lighting, and street furniture, the graphics create an outdoor museum in an otherwise commercial setting. Words and images tell the city's story and reveal its lost heritage, immortalizing events and notables, extinct species, and some of the few known words of a vanished Native American language. Gradually implemented since 1991, the system will be complete in 1999.

Hollow pylons of porcelain enamel, a technical innovation created by the fabricator for this project, include graphics and interpretive copy—much of it poetry and literary prose. People often stop to read them on their way to work or to lunch.

Design
The Office of Michael Manwaring

Consultant
Nancy Leigh Olmsted (historian)

Clients
San Francisco Department of Public Works; San Francisco Municipal Railway (MUNI); San Francisco Art Commission

Approvals from
Above, the San Francisco Port Authority (Office of the Chief Administrative Officer)

Funding
Part of a major waterfront transportation project funded by a federal Intermodal Surface Transportation Efficiency Act (ISTEA) grant and local transportation monies generated by a special 0.05% sales tax

Fabricators
Thomas Swan Sign Co.; Fireform Porcelain Enamel Inc.; General Graphics; South Bay Bronze

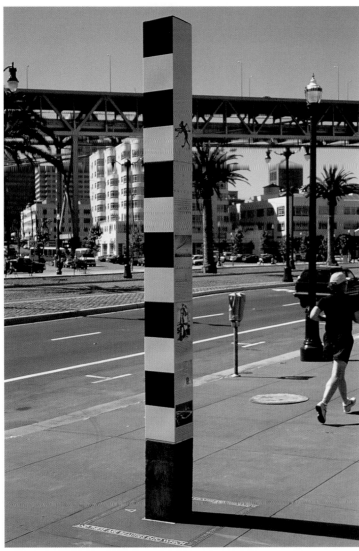

Black-and-white striped pylons must look bold to compete with the busy urban landscape. Yellow bands mark the interpretive panels. All pylons are placed on one side of the street, punctuated by a few plaques and podiums.

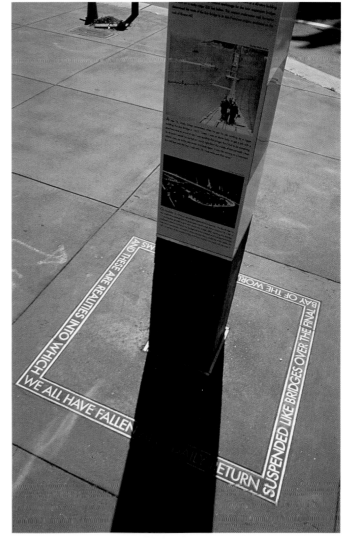

Bands of cast bronze, embedded in concrete, surround the pylons with poetry or prose. The project typeface, Futura, was chosen for its simple, direct character.

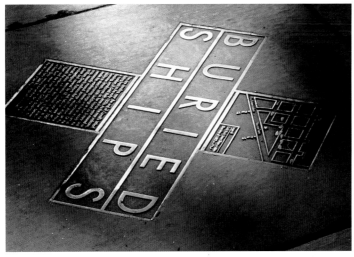

On the sidewalk opposite the pylons, brass plaques tell their own stories. Embedded, cast bronze pavers like this one commemorate vanished sites, people, and even ghost ships once said to haunt the bay.

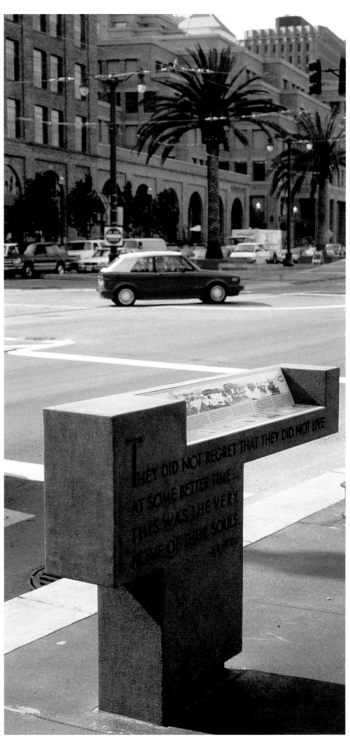

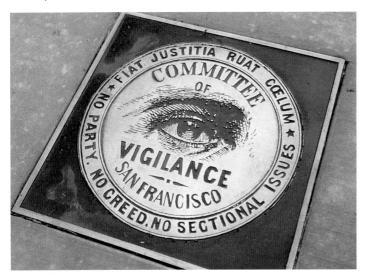

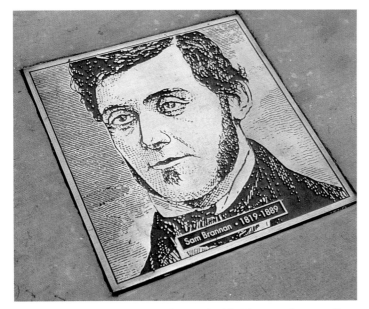

At each intersection, a series of six embedded bronze plaques tells the story of its street name in words and images.

Cast concrete "podiums" include incised quotations and porcelain enamel panels.

San Francisco Embarcadero
Historical and Interpretive Signage

Component locations

A Project of the
San Francisco Art Commission

Designer
Michael Manwaring

Historian
Nancy Leigh Olmsted

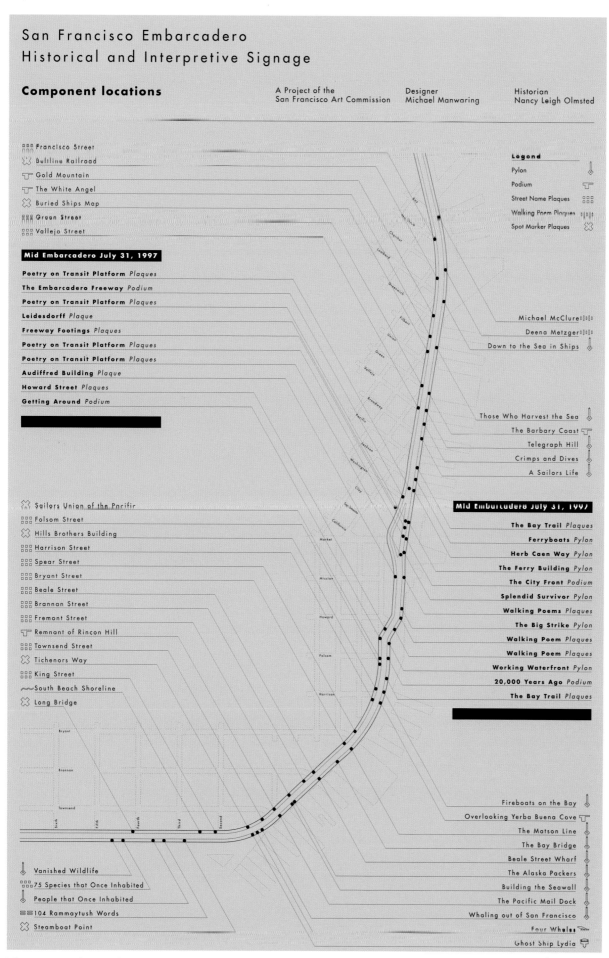

Francisco Street
Beltline Railroad
Gold Mountain
The White Angel
Buried Ships Map
Green Street
Vallejo Street

Mid Embarcadero July 31, 1997

Poetry on Transit Platform *Plaques*
The Embarcadero Freeway *Podium*
Poetry on Transit Platform *Plaques*
Leidesdorff *Plaque*
Freeway Footings *Plaques*
Poetry on Transit Platform *Plaques*
Poetry on Transit Platform *Plaques*
Audiffred Building *Plaque*
Howard Street *Plaques*
Getting Around *Podium*

Sailors Union of the Pacific
Folsom Street
Hills Brothers Building
Harrison Street
Spear Street
Bryant Street
Beale Street
Brannan Street
Fremont Street
Remnant of Rincon Hill
Townsend Street
Tichenors Way
King Street
South Beach Shoreline
Long Bridge

Vanished Wildlife
75 Species that Once Inhabited
People that Once Inhabited
104 Rammaytush Words
Steamboat Point

Legend

Pylon
Podium
Street Name Plaques
Walking Poem Plaques
Spot Marker Plaques

Michael McClure
Deena Metzger
Down to the Sea in Ships

Those Who Harvest the Sea
The Barbary Coast
Telegraph Hill
Crimps and Dives
A Sailors Life

Mid Embarcadero July 31, 1997

The Bay Trail *Plaques*
Ferryboats *Pylon*
Herb Caen Way *Pylon*
The Ferry Building *Pylon*
The City Front *Podium*
Splendid Survivor *Pylon*
Walking Poems *Plaques*
The Big Strike *Pylon*
Walking Poem *Plaques*
Walking Poem *Plaques*
Working Waterfront *Pylon*
20,000 Years Ago *Podium*
The Bay Trail *Plaques*

Fireboats on the Bay
Overlooking Yerba Buena Cove
The Matson Line
The Bay Bridge
Beale Street Wharf
The Alaska Packers
Building the Seawall
The Pacific Mail Dock
Whaling out of San Francisco
Four Whales
Ghost Ship Lydia

The site map shows where each element is located. All pylons appear on one side of the street, with a few other elements. Most plaques, including almost all street marker plaques, are located on the opposite side.

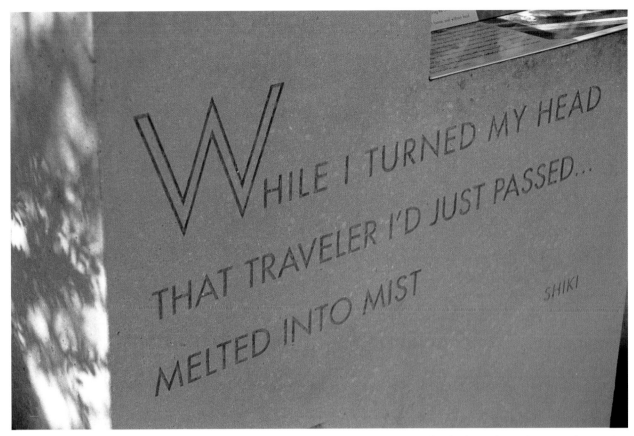

Through prose, poetry and images, almost every inch of each element "speaks." Like the best of art, these graphics invite viewers to think about the familiar in a new way.

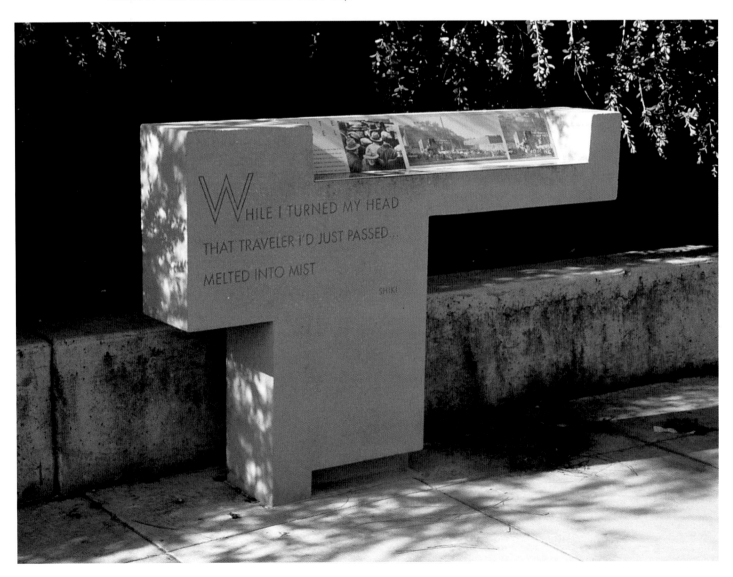

This diagram shows all nine graphic components. Truly a melding of words, images, forms, and space, the Embarcadero installation brings life to an otherwise unexceptional street.

MONTGOMERY, OH
WAYFINDING & MARKETING SIGNS

HISTORIC TOWN; MARKETING OBJECTIVES

New signs serve as both wayfinding and marketing for this small city, part of which is a Heritage District. A new city identity, applied to stationery, t-shirts, shopping bags, and other items, also appears on new directional signs. Sited to solve wayfinding problems, and part of a larger landscaping project, the signs match area architecture and maintain its look.

Design
Kolar Design, Inc., Cincinnati; with Human Nature (landscape architecture)

Client
City of Montgomery

Other planners
City of Montgomery (Beautification, Planning, Landmarks and Arts Committees)

Approvals from
City of Montgomery

Funding
The signs are being built and will be maintained with funds from the city's operating budget.

Fabricator
ARTISIGN Company, Inc.

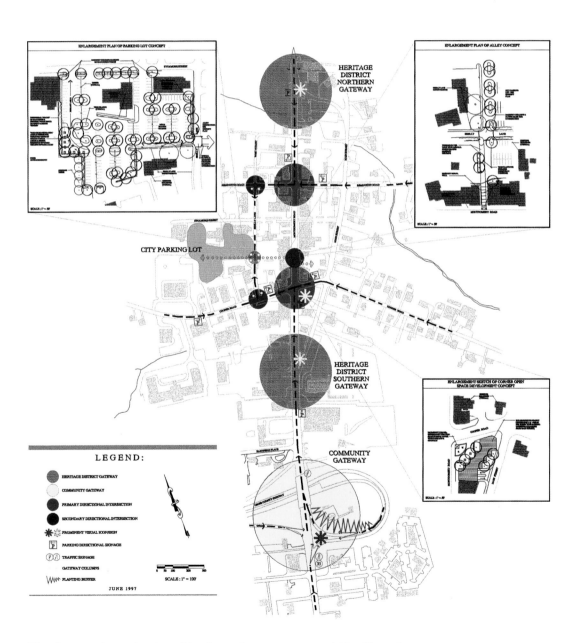

The city map shows the sites of landscape improvements, and identifies primary gateways and intersections.

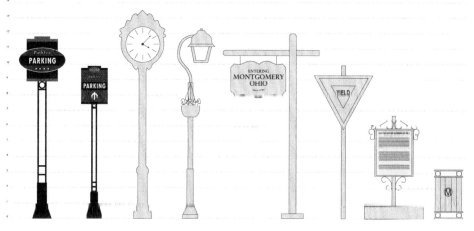

The new signs complement existing signs, clocks, and gas lights. Only 21 signs were needed for this project. Painted and screenprinted aluminum with vinyl lettering, they blend into the area with their classic colors and shapes.

The new Montgomery logo features a brick pattern and a gas lamp, both symbols of the city's picturesque architecture and historic ambiance. It can be reproduced in several colorways. The project typefaces, Sabon Bold Italic and Futura Condensed Bold, combine historic and contemporary design harmoniously.

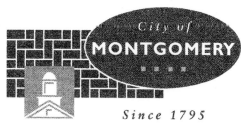

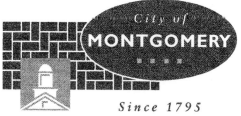

Also used for marketing, the new logo appears on stationery, souvenirs, and other applications.

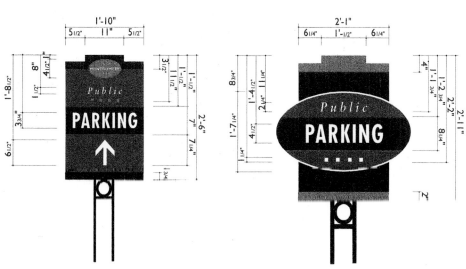

DESIGN EXPLORATION

The chart shows various designs developed to match the existing signs.

SAN FRANCISCO, CA
EMBARCADERO CENTER

GRAPHIC UPDATE; ONE OF THE FIRST U.S. MIXED-USE CENTERS

A 10-acre urban renewal project dating to the 1960s and used to spur renewal throughout San Francisco's Financial District, by the 1980s Embarcadero Center needed a graphic facelift. Its eight buildings on eight city blocks include five office towers, an arcade with 140 shops and restaurants, a historic building, and two luxury hotels. Phased in over five years, the new graphic program covers all public and private spaces. Designers developed a system of standard sign shapes, color-coding them to help people cope with the scale. By 1994 the ongoing, $3 million project had expanded to tenant sign standards, new logos for the Center and its retail areas, printed shopping and visitor guides, office forms, interactive directories, and all public information graphics for the Hyatt Regency San Francisco and Park Hyatt Hotels.

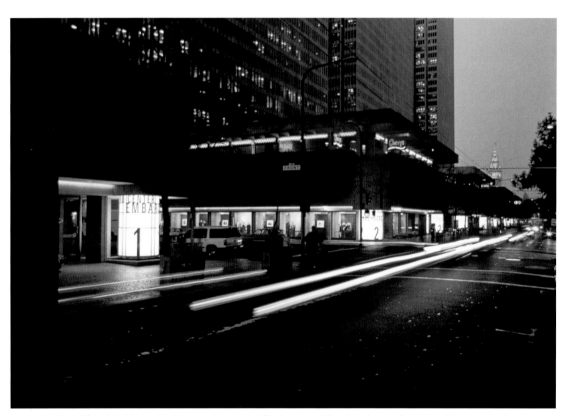

Exterior identification "lanterns" act as beacons. Their warm illumination welcomes visitors and invites them inside.

Design
Poulin + Morris, New York City

Other design
John Portman & Associates (design architects)

Clients
Pacific Property Services L.P.; The Prudential Realty Group; David Rockefeller & Associates

Funding
Private

Fabricators
Scott Architectural Graphics; Fireform Porcelain; Thomas Swan Sign Co.

Photos
John Sutton and Poulin + Morris

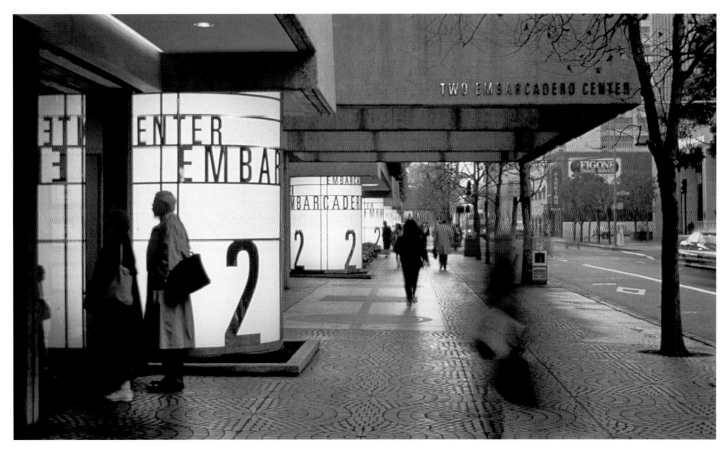

The project typeface, Univers, is readable in many sizes and adapts to many applications, such as these gleaming metal letters. The Univers family's many weights and styles allows a great deal of variety.

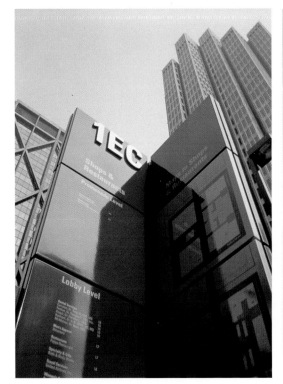

Made of porcelain enamel panels, kiosks can hold a great deal of information. Though four-sided, the signs are wedge-shaped rather than square. More timeless than contemporary, their style fits the 1960s buildings.

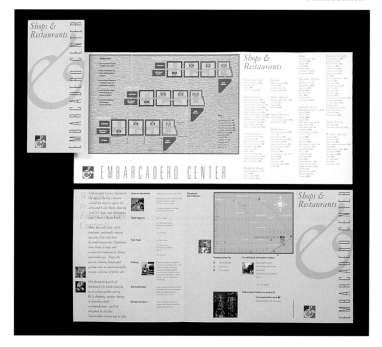

In one of many continuing projects for Embarcadero Center, designers created this guide to shops and restaurants.

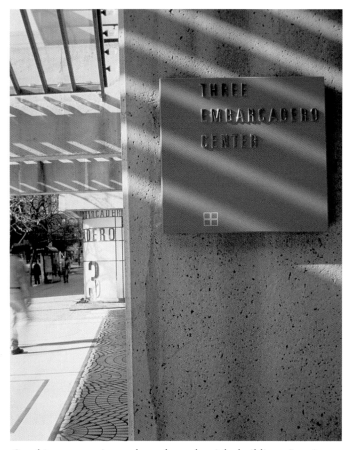

Graphics are consistent throughout the eight buildings. Interior signs match kiosks, which match wall-mounted signs. All are color-coded.

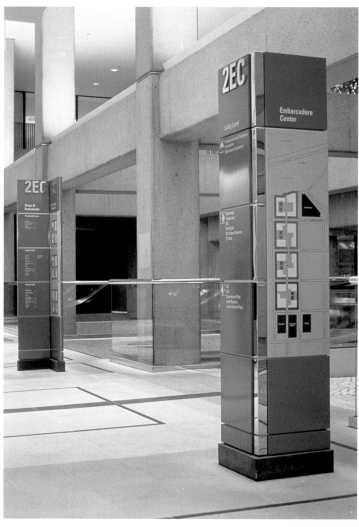

Kiosks are used inside as well as outside. Maps show how complex the site is, and how difficult it is to navigate. They also demonstrate that, however large, Embarcadero Center is still a private development. Only the sketchiest of outdoor directional information appears.

Garage murals share the same style and color-coding used in the rest of the signs.

A muted palette of primary and secondary colors matches the classic 1960s architecture, which features concrete and decorative paving.

Banner designs match the Embarcadero Center design sensibility.

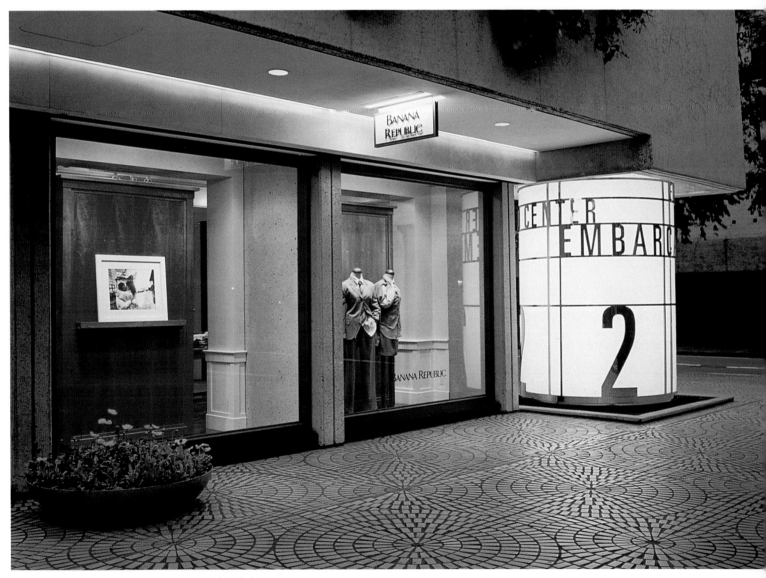

Designers created tenant sign standards that help corporate logos fit the Embarcadero look.

CHICAGO, IL
PARK DISTRICT FACELIFT

NEW POST-AND-PANEL SIGN SYSTEM

When Chicago's 552 parks needed a graphic facelift, designers delivered with a new post-and-panel sign system featuring a plum and straw color scheme, a trapezoidal grid, a contemporary typeface, and a set of custom icons. Easy to build and maintain, the steel and porcelain enamel signs are also rugged enough to deter most vandals. Awarded in 1995, the project was tested in Spring 1997 and is now being implemented throughout the system.

Comprehensive standards allow the Park District to commission and maintain the new system.

Design firm
Two Twelve
Associates, Inc.

Design director
David Gibson

Project manager
Andy Simons

Design team
Andy Simons; Cesar
Sanchez

Production
Patrick Connolly

**Cartographic
design**
Gerald Boulet

Manual design
John DeWolf

**Landscape
architect**
Johnson Johnson Roy

Client
Chicago Park District

Approvals
Chicago Park District

Funding
The system design and
installation is being paid
for by Capital
Improvement bonds.
Maintainance, which
will eventually be done
by the Park District, is
paid for with the same
funds.

Fabricators
Poblocki and Sons;
Western Industries

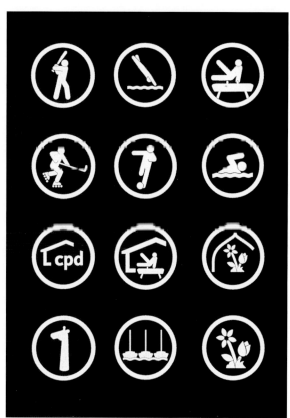

The project typeface, Scala, has a contemporary feel but does not sacrifice legibility for style.

A custom set of symbols is based on the AIGA transportation symbol style, adapted to the Chicago Park District's needs.

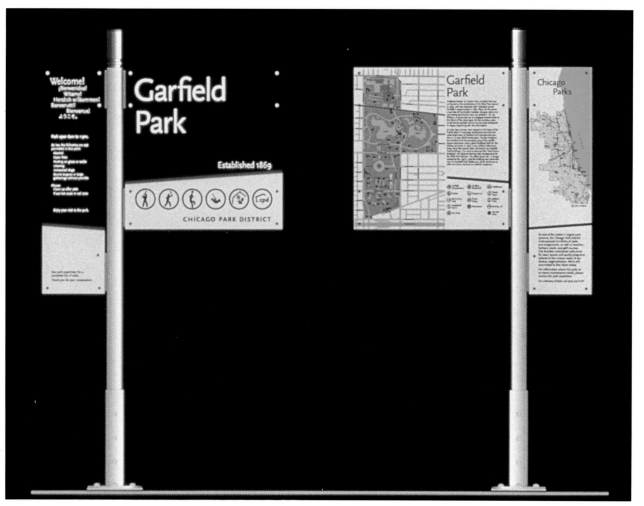

Each sign is divided into two trapezoids, including maps and informational panels. The color scheme, plum and straw, was the result of many rounds of color studies. Painted steel sign panels on steel posts deter vandals and hold up to Chicago's harsh weather. Maps are printed on even more durable porcelain enamel.

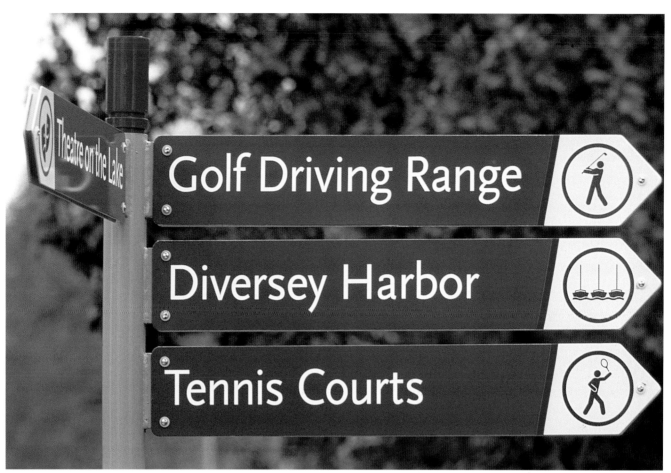

Blade signs continue the trapezoidal shapes. Red accents tie the program together, and also make a clean line between the purple and yellow tones.

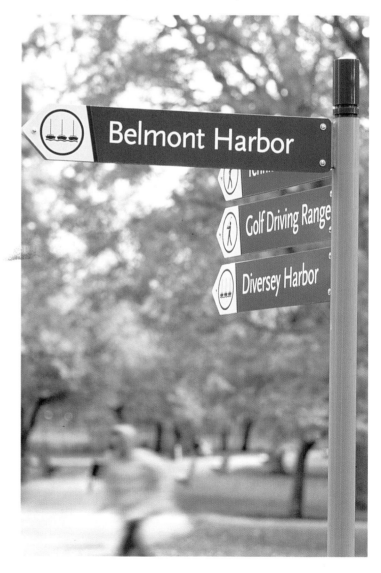

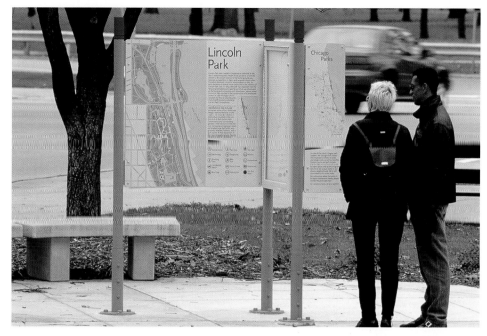

Three-panel welcome center signs greet both pedestrians and drivers. The driver side, in plum and straw, identifies the park and the year it was built, and lets users know about amenities with a string of icons. The pedestrian side includes maps and other information. A bulletin board panel opens on both sides for timely information.

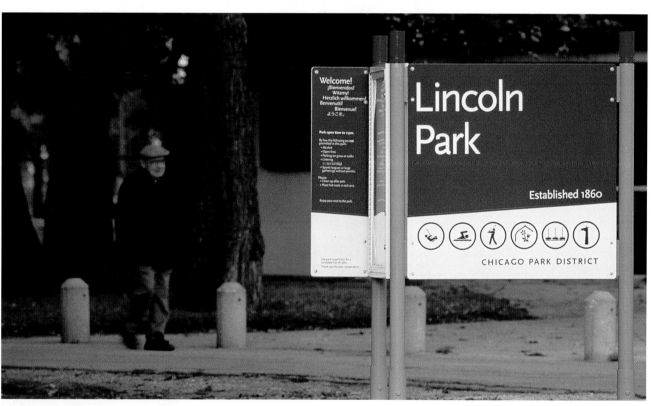

The color scheme works well with greenery, brick and other building materials, and even a gray Chicago sky.

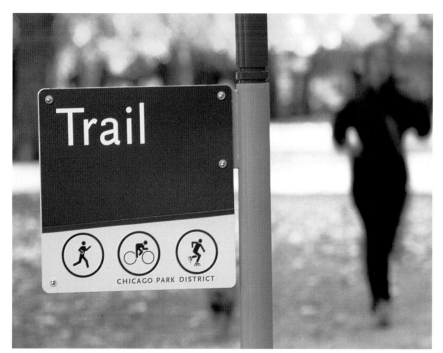

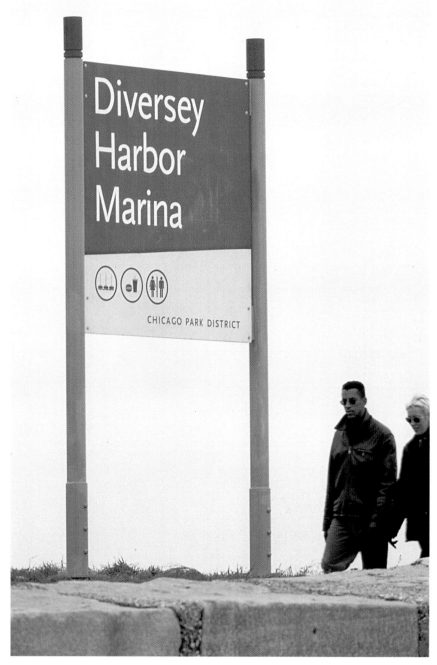

The new map style fits the overall design, so that no element looks out of place.

SYDNEY, AUSTRALIA
DARLING HARBOUR DIRECTIONAL SIGNS

TOP TOURIST SPOT; LOGO INSPIRES DIRECTIONAL GRAPHICS

One of Australia's largest tourist spots and a Sydney 2000 Olympic Games venue, Darling Harbour is home to museums, parks and gardens, an exhibition center, a convention center, shopping malls, excursion ships, seasonal festivals, luxury hotels, and many other attractions. New signs make the area even more accessible to growing crowds of both visitors and residents who gather for entertainment and relaxation.

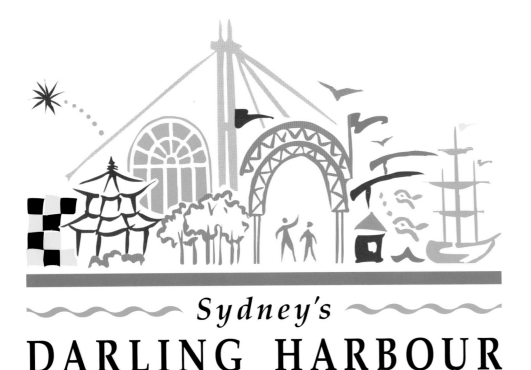

The Darling Harbor logo, designed by one firm, established the colors and design sensibility developed by the environmental graphic designers. The lighthearted profusion of images hints at Darling Harbour's many attractions.

Design

Anne Gordon Design Pty., Ltd., Sydney

Logo design

Minale, Tattersfield and Bryce, Sydney

Client

Darling Harbour Authority

Funding

The sign program was paid for with revenues generated by Darling Harbour's leased properties. It will be maintained by the Harbour Authority

Fabricator

Cunneen and Co., Sydney

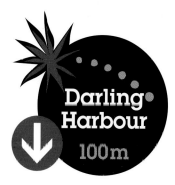

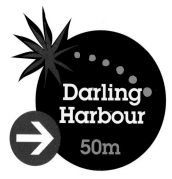

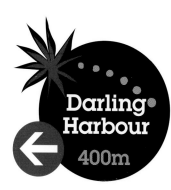

Each pole-mounted sign is made of two circular pieces of aluminum attached to an aluminum spacing ring. Colored circles with arrows made of 3mm aluminum plate (packed out), were applied for further dimension. A v-shaped bracket, welded inside the sign, allowed it to be fixed to either round or octagonal lamp poles.

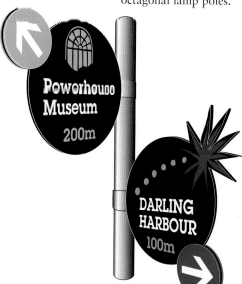

Round signs are lettered in Lubalin Graph, the typeface already used for directional information through the Darling Harbour Precinct. Colors for the arrow circles and attraction icons, and the icons themselves, were taken from the logo.

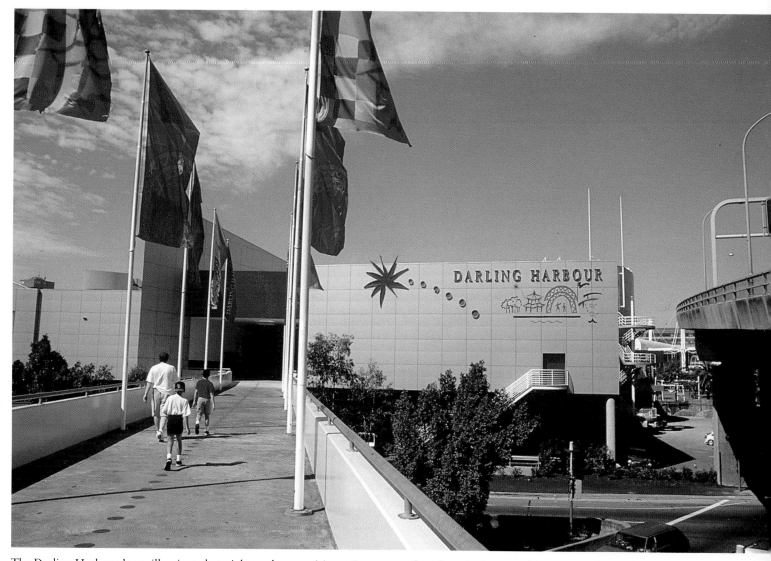

The Darling Harbour logo, illuminated at night, welcomes visitors. Banners are based on the logo graphics. Discs, echoing the circles from the logo's burst of fireworks, mark the path for pedestrians.

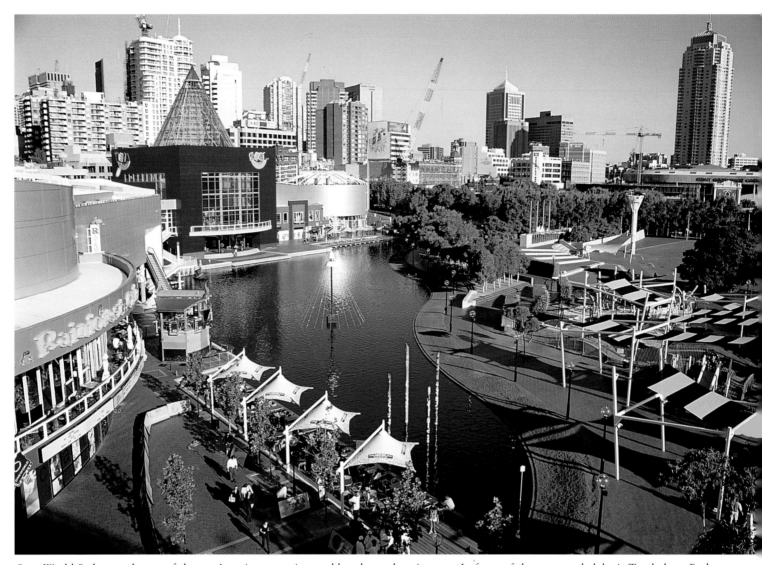

Sega World Sydney, only one of the area's major attractions, adds color and excitement. In front of the man-made lake is Tumbalong Park. It abuts the Chinese Garden of Friendship, where visitors can stroll among weeping willows and rest in tile-roofed pagodas.

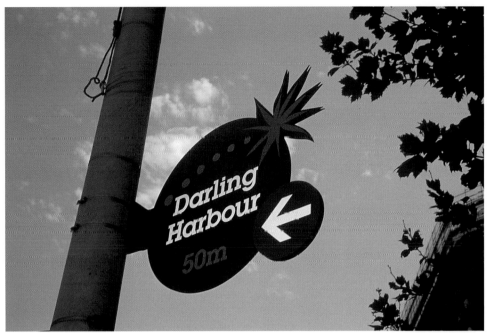

Aluminum directional signs for Darling Harbour include cut-out "bursts" of fireworks.

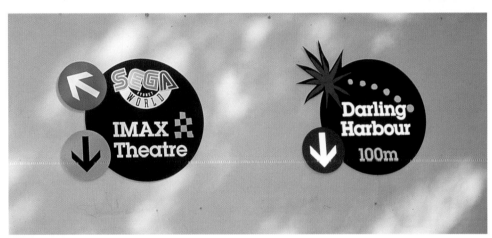

Black backgrounds help the rest of the colors to stand out.

Darling Harbour's many destinations are crowded together, making new directional signs imperative. Public and private buildings at the site include the Sydney Convention Centre (left), the Harbourside Shopping Centre, and, just visible to the right, the National Maritime Museum. Behind them are hotels and apartments.

SEATTLE, WA
BELL STREET PIER

INDEPENDENT TAX DISTRICT; DESIGN FOR A "WORKING" WATERFRONT

Home to a marina, a public plaza, a conference center, restaurants, retail, and a museum, Bell Street Pier needed attractive wayfinding and interpretive signs that fit its character as a working waterfront as well as a tourist attraction. The result was a bright, cheerful system of graphics that include 16-ft.-tall wayfinding posts recreating the structures that originally supported the piers. A related graphics program (also for the Port of Seattle and also designed by Team Design and Maestri) for the new Bell Harbor International Conference Center at the site has its own look, but coordinates with the Bell Harbor graphics.

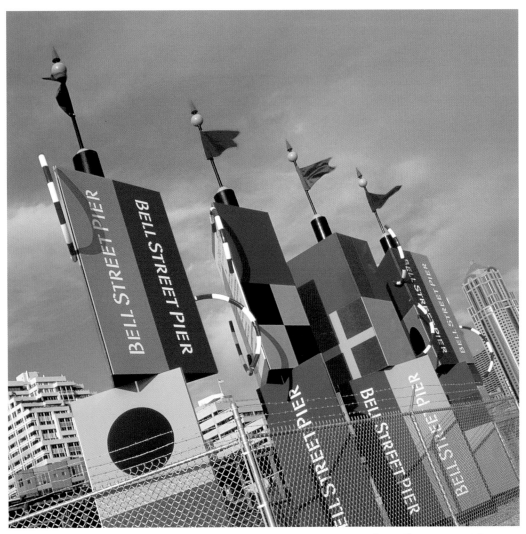

A colorful sign with images derived from maritime flags announces Seattle's Bell Street Pier. The typeface is a custom design meant to look like hand-stenciled letters on packing crates.

Design
Maestri Design Inc., Seattle, with Team Design, Seattle

Maestri Design Inc.:
Paula Rees, design director; Jeff Thompson, project manager; Linda Soukup, senior designer

Team Design:
Janet DeDonata, principal-in-charge; Deborah Brown and Paula Richards, senior designers; Troy Johnson, designer

Consultant
Christopher Baldwin, illustrator

Client
Port of Seattle

Approvals from
Port of Seattle (Commissioners and Development Administrator); City of Seattle Engineering Department

Funding
Signs were paid for with funds generated from the Port District, an independent taxing entity, and will be maintained by the city.

Fabricators
Trademarx, Seattle; Fireform Porcelain Enamel

Photos
(c) 1997, Steve Keating

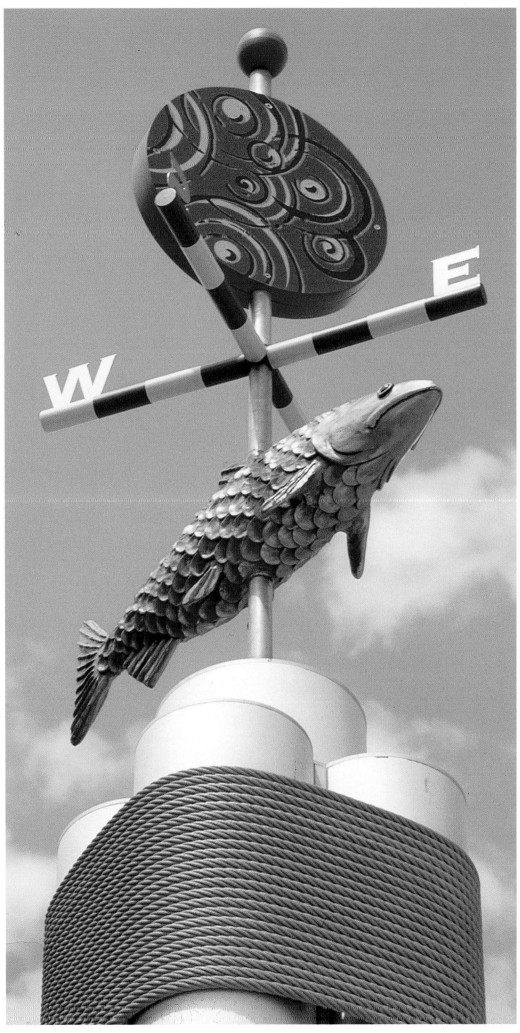

Sixteen-ft. wayfinding pylons replicate the wooden posts that once held up the pier, complete with stainless steel rope. They hold custom light fixtures, again with a maritime theme, and interpretive graphics. Taller pylons are topped not with lamps, but with fanciful weathervanes depicting sea creatures.

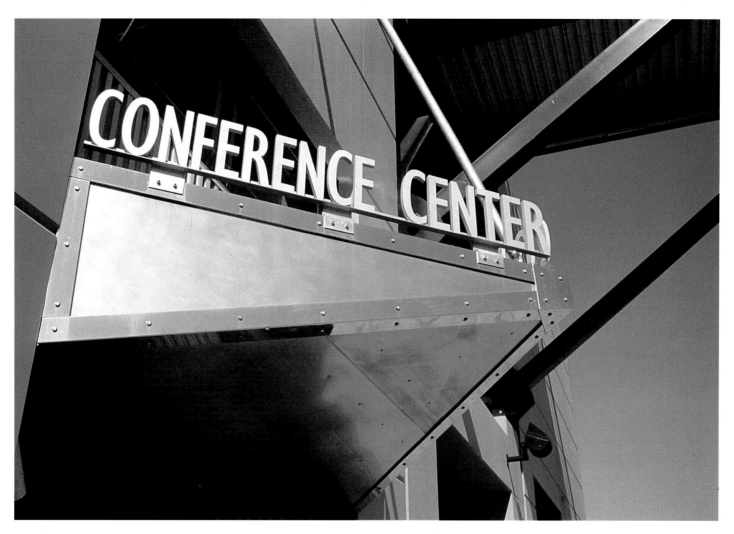

Graphics coordinate the visual styles of the pier and the conference center.

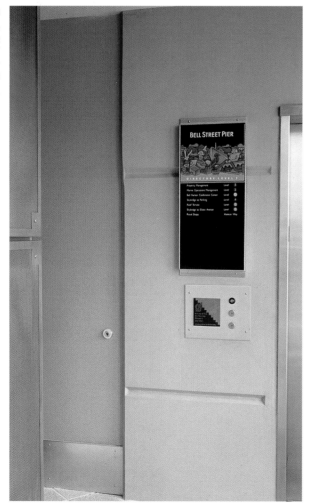

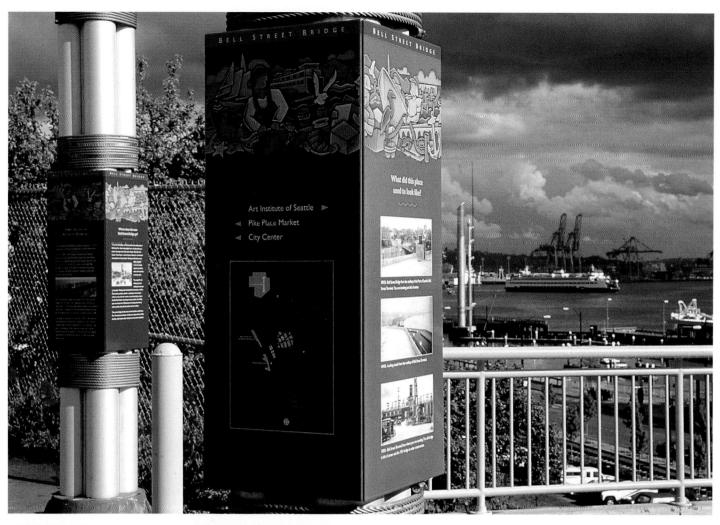

Sign panels made of porcelain enamel will retain their bright colors. They carry both directional and interpretive information, as well as photographs, diagrams, and a signature illustration.

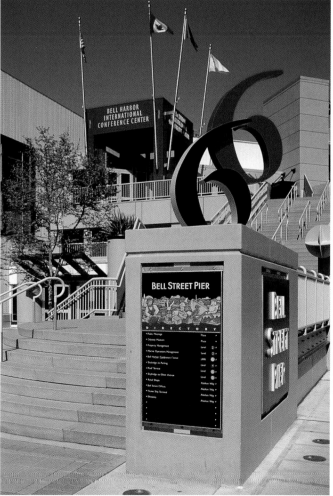

A monumental dimensional sign trumpets the pier's address outside the new conference center. The colorful illustration and striped lines are motifs that appear throughout the project.

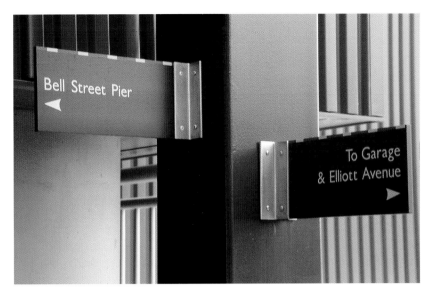

Small directional signs continue the project colors, striped lines, arrows, and typeface—Gill Sans.

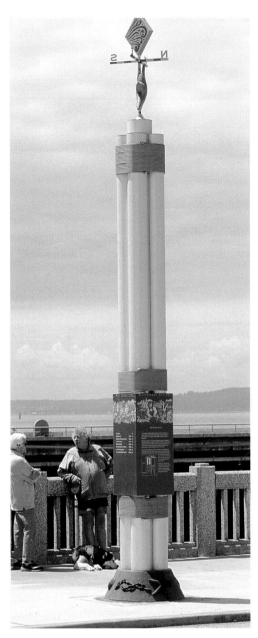

THE PACIFIC ROOM

THE MARINA ROOM

MEETING ROOMS
WATERWAY & PORT
ROOMS

THE COVE ROOM ▶

THE SOUND ROOM

MEETING ROOMS
PIERSIDE, SEAWAY,
CHANNEL &
COASTAL ROOMS

THE BAY AUDITORIUM,
HARBOR DINING &
THE INLET
PRIVATE DINING

Graphics for the bold new convention center have an industrial look that coordinates with the harbor graphics. Historical artifacts in massive display cases act as both art and wayfinding landmarks.

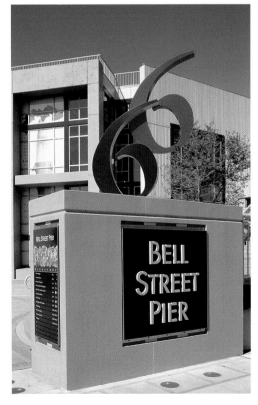

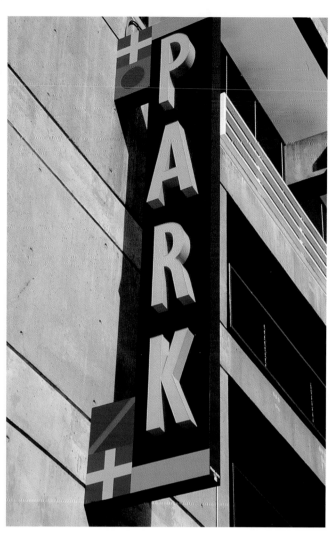

The graphic look extends to signs for a public parking garage and other buildings.

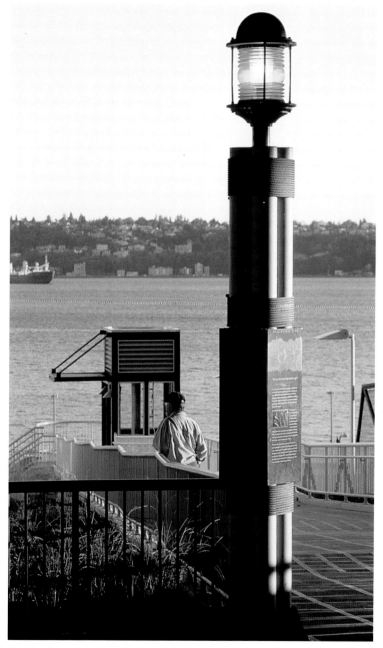

The long-vanished wooden posts that once held up the pier are now commemorated above the water in bright steel.

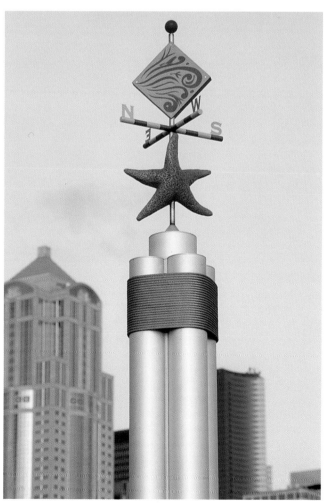

DESIGN FIRMS

Biesek Design 22, 30, 136

2829 See Canyon Rd.
San Luis Obispo, CA
93405

805-595-2640
805-595-7917 (fax)

Patricia Bruning Design 148

1045 Sansome St.
Suite 219 San
Francisco, CA 94111

415-296-0935
415-296-0935 (fax)

City of Cincinnati Office of Architecture and Urban Design 82, 86

705 Central Ave.
One Centennial Plaza,
Suite 405 Cincinnati,
OH 45202

513-352-3494
513-352-5336 (fax)

Cloud + Gehshan Associates, Inc. 76

919 South St.
Philadelphia, PA
19147

215-829-9414
215-829-9066 (fax)
cga_dsgn@op.net

Corbin Design 56, 116

109 East Front 304
Traverse City, MI
49584

616-947-1236
616-947-1477 (fax)

Communication Arts, Inc. 130

112 Pearl St.
Boulder, CO 80302

303-447-8202
303-440-7096 (fax)
www.communisboulder.com

Daly & Daly Inc. 150

233 Harvard St.
Brookline, MA 02146

617-738-7181

Design Pacifica International, LLC 128

821 NW Flanders
Portland, OR 97209

503-222-9494
503-222-5191 (fax)
www.pictograms.com

Firehouse Design Team 58

2701 Vine St.
Cincinnati, OH 45219

513-522-2295

Gillespies 12

2 Park Terrace
Glasgow G36BY
Scotland

0141 332 6742

Anne Gordon Design Pty. Ltd. 110, 178

1 Caledonia St.
Paddington
Sydney, NSW 2021
Australia

02 9327 7811
02 9327 7866 (fax)

Gresham, Smith and Partners 32, 66

1400 Nashville
City Center
511 Union St.
Nashville, TN 37219

615-770-8100
615-770-8103 (fax)

Hunt Design Associates 98, 138

25 North Mentor Ave.
Pasadena, CA 91106-
1709

626-793-7847
626-793-2549 (fax)

Kolar Design 166

308 E. 8th St.
Cincinnati, OH 45202

513-241-4884
513-241-2240 (fax)

BJ Krivanek Art+Design 40

2050 Walgrove Ave.
Los Angeles, CA
90066-3034

310-391-1897
310-391-5652 (fax)
bjkrivanek@aol.com

Landor Associates 102

Klamath House
1001 Front St.
San Francisco, CA
94111-1424

415-956-5436
415-955-1361 (fax)

Lorenc Design 156

724 Longleaf Dr. NE
Atlanta, GA 30342-
4307

404-266-2711
404-233-5619 (fax)

MTA New York City Transit Graphics Unit 36

130 Livingston St.
Rm #3070, 3rd Fl.
Brooklyn, NY 11201

718-694-5783
718-722-4369 (fax)

Maestri Design Inc. 122, 182

217 Pine St.
The Penthouse
Seattle, WA 98101-
1520

206-622-4322
206-622-6043 (fax)

Meeker & Associates Inc. 20, 64

22 Rockwood Dr.
Larchmont, NY 10538

914-834-1904
914-834-1927 (fax)

Kiku Obata & Co. 26, 92

5585 Pershing Ave.
Suite 240
St. Louis, MO 63112

314-361-3110
314-361-4716
kobata@aol.com

The Office of Michael Manwaring 46, 160

111 Crescent Rd.
San Anselmo, CA
94960

415-458-8100

Poulin + Morris 168

286 Spring St.
6th floor
New York, NY 10013

212-675-1332
212-675-3027 (fax)
pmdrscon@aol.com

Geoffrey Scott and Associates 90

2917 1/2 Main St.
Santa Monica, CA
90405

310-396-5416
310-399-5246 (fax)

Selbert Perkins Design Collaborative 16, 48, 118, 140

2067 Massachusetts
Ave.
Cambridge, MA
02140

617-497-6605
617-661-5772 (fax)

Signia Design 42

420 North Fifth St.
Minneapolis, MN
55401

612-333-1226
612-333-1229 (fax)

Skidmore, Owings & Merrill LLP 70, 74

One Front St.
San Francsico, CA
94111

415-981-1555
415-398-3214 (fax)

Sussman/Prejza & Co., Inc. 106, 112, 144, 146

8520 Warner Dr.
Culver City, CA 90232

310-836-3939
310-836-3980 (fax)

Thinking Caps 52, 54

815 North First Ave.
3W
Phoenix, AZ 85003

602-495-1260
602-495-1268 (fax)

Two Twelve Associates 172

596 Broadway
Suite 1212
New York, NY 10012

212-925-6885
212-925-6988 (fax)